Why Horror Seduces

WHY HORROR SEDUCES

Mathias Clasen

OXFORD
UNIVERSITY PRESS

Oxford University Press is a department of the University of Oxford. It furthers
the University's objective of excellence in research, scholarship, and education
by publishing worldwide. Oxford is a registered trade mark of Oxford University
Press in the UK and certain other countries.

Published in the United States of America by Oxford University Press
198 Madison Avenue, New York, NY 10016, United States of America.

Library of Congress Cataloging-in-Publication Data
Names: Clasen, Mathias F. author.
Title: Why horror seduces / Mathias Clasen.
Description: Oxford; New York, NY : Oxford University Press, 2017. |
Includes bibliographical references and index.
Identifiers: LCCN 2017005226 | ISBN 9780190666514 (pbk. : alk. paper) |
ISBN 9780190666507 (cloth : alk. paper) | ISBN 9780190666545 (Oxford scholarship online)
Subjects: LCSH: Horror tales, American—History and criticism. |
American fiction—20th century—History and criticism. |
American literature—Psychological aspects.
Classification: LCC PS374.H67 C53 2017 | DDC 813.009/164—dc23
LC record available at https://lccn.loc.gov/2017005226

CONTENTS

ACKNOWLEDGMENTS

This book is the result of years of research on, and a longstanding fascination with, horror and monsters. Thirty years ago, nobody could have predicted that I would write a book on horror. I was an anxious kid who'd give spooky stuff of any kind a very wide berth indeed. I wouldn't whistle past the graveyard, I'd stay the hell away from it. I'd get nightmares from the most innocuous ghost story. In the summer of 1992, when I was 14, some friends lured me to a screening of *Sleepwalkers*—a schlocky vampire/werewolf film based on a Stephen King script. I had to walk out of the movie theater about halfway through because I couldn't stomach it, and I've never quite recovered from that loss of face. Two years later, a new friend invited me over for a day of movie watching. That new friend, Mike, had gotten his hands on a LaserDisc edition of *The Stand*, another Stephen King adaptation. It completely blew me away, but in a good way. From that day, I was hooked on horror. I'd like to thank Mike for setting it all in motion on that fall day in 1994. I'd also like to thank the horror artists who deepened my appreciation of horror—above all Stephen King, Peter Straub, Dennis Jürgensen, and John Carpenter. Thanks for the countless nightmares, and for top-notch research material.

I'd like to thank also the many colleagues who have supported and helped me over the years, and who have critiqued my ideas and prompted me to refine them. Joe Carroll has been my toughest critic and strongest supporter from the beginning. He's the most ruthless and the most generous editor I know. Without his help and encouragement, this book would've never been written. Steven Pinker has been exceptionally helpful and inspiring, going out of his way on several occasions to support a young scholar. Jon Gottschall took me under his wing and introduced me to the small but welcoming world of evolutionary literary scholars when I was a wide-eyed graduate student—including Brian Boyd, Judith Saunders, Brett Cooke, Dirk Vanderbeke, and Marcus Nordlund. They have all been

helpful and supportive beyond the call of academic duty. I've benefitted enormously from my friendship with Emelie Jonsson, a young evolutionary literary scholar who's as generous as she is smart. I'd like to thank also Leda Cosmides and John Tooby, as well as their colleagues in the Center for Evolutionary Psychology at UCSB, for providing a hospitable and motivating intellectual environment during my visiting fellowship in 2011. Thanks to my friends and colleagues in the GotPop research network on popular culture at Gothenburg University, especially to Joe Trotta and Houman Sadri for stimulating conversation, and to monster scholars *extraordinaire* Todd Platts and Stephen Asma.

My colleagues in the Department of English at Aarhus University have patiently listened to my ideas about the evolved underpinnings of horror. Special thanks to my old supervisor, Peter Mortensen, who continues to be invariably supportive (despite his not unreasonable conviction that my literary tastes converge with those of a preadolescent boy). Thanks also to Ocke-Schwen Bohn who introduced me to evolutionary psychology during my undergraduate studies, and thanks to all the other colleagues—not least Jane, Martin, and Marianne—who make this a great department. Aarhus University has fostered an intellectual environment highly hospitable to interdisciplinary evolutionary work, and I thank my evolutionarily-minded colleagues for fruitful discussions and collaborations: Jesper Sørensen, Marc Andersen, Uffe Schjødt, Kristoffer Laigaard Nielbo, and Armin Geertz of the Religion, Cognition and Culture Research Unit; my colleagues in the Centre for Biocultural History; my old squad in Peter C. Kjærgaard's research group—Casper Andersen, Jakob Bek-Thomsen, Stine Sloth Grumsen, Hans Henrik Hjermitslev, and Prof. K himself; Andreas Roepstorff and his passionate team of researchers in the Interacting Minds Centre; and Michael Bang Petersen and his crew in the Politics and Evolution Lab. I'd like to thank also the many, many English students who have enthusiastically discussed my ideas with me, especially my MA students and the students in my elective courses "Fear for Your Life" (2016), "Fifty Years of American Nightmares" (2014), and "Demons, Depravity, and the Devil's Spawn" (2013).

I have been fortunate to have several specialists read the entire manuscript and give thoughtful and critical feedback. Joe Carroll and Emelie Jonsson read the whole thing and prompted me to constantly revise and improve. Some chapters they read several times as I struggled to bring out my ideas clearly and coherently. Jens Kjeldgaard-Christiansen also read the entire manuscript, offering excellent advice and suggestions and helping me with the figures for the book. The four anonymous reviewers, commissioned by OUP, each provided encouragement and helpful comments.

I'd like to thank my editors at OUP, Norman Hirschy and his assistant Lauralee Yeary. They have been exceptionally supportive, helpful, and pleasant to work with throughout the process. Norm is not a big horror buff, but that never dampened his invigorating enthusiasm for the project. I enjoyed exchanging with Lauralee recollections of horror stories that profoundly disturbed us as kids. Growing up thousands of miles and several years apart, we were both terrified by that *X-Files* episode about a monster that would squeeze itself through mail slots or air vents and erupt into unsuspecting folks' apartments and rip out their livers and eat them. No fava beans or anything fancy like that, just raw predatory hunger. It's a potent scenario that resonates with an ancient alarm system in human nature.

Finally, the biggest thanks of all go to my family—Laura, Tobias, and Camilla—without whom life would be a "barren, cheerless trial," to quote Robert Neville. Knowing that I don't like to tackle the stuff alone, they have patiently sat with me through many horror films, they have played horror video games with me, and they have accompanied me through haunted attractions. I'm particularly obliged to my wife, Camilla, who somehow manages to be unconditionally supportive and pointedly critical at the same time, and who invariably lets me snuggle up when my research gives me nightmares.

Chapter 10 was published in a slightly different form (under the title "Hauntings of Human Nature: An Evolutionary Critique of King's *The Shining*") in the journal *Style* 51(1) (2017):76–88. I'm grateful to the editor, John Knapp, and the publisher, Penn State University Press, for allowing me to include the essay here.

Introduction

Horror, Fear, and Evolution

When was the last time that you were really afraid? And I mean truly, heart-thumpingly, hair-raisingly horrified, not just anxious over an important meeting or nervous that you might have left the keys in the front door. I'm willing to bet that for a lot of you, the last time you were really afraid was in the darkness of a movie theater, in front of the TV or computer screen, or in bed with a novel. Those of us who live in controlled and relatively safe environments come face to face with true fear primarily when we seek it out, for example in fiction. Many of us flock to see horror films in the cinema, eagerly await the next Stephen King novel, and with some trepidation download the latest survival-horror game on our laptops. Why? Well, that's one of the questions that this book seeks to answer. Another is the question of how horror fiction even works, given that we know that it's fiction, it's make-believe, it's actors acting afraid, computer-generated monsters, pixels on a screen, ink on paper, clever programming. Yet still the well-told horror tale, in whatever medium, can evoke very real and very strong emotional and physiological reactions in us, essentially sending us on a backwards evolutionary roller coaster ride, straight back to our deep ancestry as hunted prey. And we love it.

Horror in whatever medium is one of the most consistently popular and profitable genres (Prince 2004). In the United States alone, in the period 1995–2015, horror films grossed close to eight billion dollars. That's the number 8 followed by nine zeroes, and it's excluding the sometimes overlapping genres of thrillers and suspense films, which together grossed another fifteen billion dollars in this period (The Numbers 2015b). Even

cheaply made horror films can make it big at the box office. Some of the most striking box office hits are horror films. The independent 2009 picture *Paranormal Activity* (Peli 2009) had a production budget of $15,000; worldwide, the film grossed more than *thirteen thousand* times its production cost, or close to $200,000,000 (The Numbers 2015d). The 1999 horror film *The Blair Witch Project* (Sánchez and Myrick 1999) tells a similar story, produced for $600,000 and grossing about $250,000,000 worldwide (The Numbers 2015a). Moviemakers hoping for a high return-on-investment can do much worse than to invest in horror films. On a list of the most profitable movies ever, about a quarter of the films are bona fide horror flicks—with titles such as *Jaws* (Spielberg 1975) and *Insidious* (Wan 2010) figuring prominently (The Numbers 2015c).

One 2013 study sampled the Danish population and found that out of about five hundred respondents, 47 percent claimed to like horror in whatever medium. 32 percent said they like horror in some contexts—they'll watch horror films in the company of good friends but would never do it alone, for example. Only 21 percent said that they don't like horror at all (Johansen 2013). A new study paints a similar picture. Together with two colleagues, the media researcher Jens Kjeldgaard-Christiansen and the psychologist John A. Johnson, I'm conducting a large-scale survey of Americans' horror preference and personality. We're asking a representative sample of more than 1,000 Americans about their relationship to horror—their usage patterns, their preferences, their personality profile—and we're crunching the numbers as I write this. One thing is clear, though: Most respondents say they like horror. We gave the survey participants a statement—"I tend to enjoy horror media"—and asked them to indicate the degree to which they agree with the statement, ranging from 1 (strongly disagree) to 5 (strongly agree). More than half, or 54.4 percent, agree with the statement, selecting 4 or 5. 17 percent neither agree nor disagree, and only 28.6 percent respond in the negative range (1 or 2). Most people, Americans as well as Danes, really do like being scared by fictions, even stories about ridiculously improbable events and characters such as wood-dwelling witches, demonic possessions, and vengeful sharks. The question remains: Why? Why does horror seduce?

The paradox of tragedy—the appeal of artworks that evoke negative emotions—has puzzled philosophers for millennia (Smuts 2009). Literature and film scholars have grappled with the issue for decades. Horror scholars specifically have attempted to explain our strange fascination with horrifying stories, often by reaching back to Freud's outdated ideas about how the mind works. According to a Freudian theory of horror, the genre disturbs us by metaphorically confronting us with repressed material such as

infantile sexual and/or murderous impulses. We thrill at the sight of a limb chopped off by a chainsaw-wielding maniac because such an act evokes the infantile fear of castration; supposedly, the limb—an arm, say—is a symbol for the penis. There is, in the Freudian view, a pleasure associated with confronting "forbidden," repressed material, but also a price to pay, namely the negative emotions produced by the story. On this account, we are drawn to the genre *despite* the negative affect it produces (Carroll 1990, 168–178, Freud 2003 [1919], Schneider 2004). But Freudian psychoanalysis has crumbled under more than a century of scientific scrutiny, which has falsified or failed to find evidence for the psychological mechanisms and processes that Freud posited. Building a theory of the attractions of horror on the foundation of orthodox psychoanalysis is like building a house on sand. Freud and his followers put together a model of the psyche which we now know to be wrong in almost all substantial aspects. No, the Oedipus complex—the cornerstone of the psychoanalytical edifice—doesn't seem to exist (Daly and Wilson 1990). No, little girls don't really suffer from penis envy. No, dreams aren't encrypted communiqués from some officious, homunculian archivist residing in the subconscious. Dreams serve functions, certainly, such as memory consolidation and experience simulation (Gottschall 2012), and they often deal in metaphor, as does all human cognition, and we may gain insight into our own mental lives by analyzing the content and emotional tenor of a dream. But coded messages from the unconscious? There's just no evidence to support such a function. The list of falsified (or non-verified) Freudian propositions goes on. It really is an impressively long list (Erwin 1996, Macmillan 1997). Is there a scientifically robust alternative to Freudian psychoanalysis and models of psychological function built on Freudian assumptions? Yes. Over the past few decades, scientists have made huge advances in building a model of the mind that integrates findings from evolutionary biology, social and affective neuroscience, human behavioral ecology, cognitive and evolutionary psychology, and many other scientific fields. This model has the strength of being vertically integrated—that is, sustained and constrained by converging evidence from a wide range of disciplines and sciences. What's more, it is crucially relevant to making sense of the forms, the functions, and the appeals of scary entertainment.

In this book, I situate the study of horror fiction within the larger framework of the evolutionary social sciences. I define horror as the kind of fiction that is manifestly designed to scare and/or disturb its audience. I use the word fiction in a broad sense, to encompass fictional storytelling in literature, film, television series, and computer games. Many critics distinguish between supernatural horror and psychological horror. Supernatural

horror involves some kind of suspension or breach of physical law, usually embodied in or caused by some kind of supernatural agency such as an uncanny monster or a ghost. Stanley Kubrick's *The Shining* (1980) is a case in point, as is Bram Stoker's *Dracula* (1997). Psychological horror, on the other hand, does not involve violations of physical law, but features naturalistic (if often implausible) menaces and scenarios. Thomas Harris's *The Silence of the Lambs* (1988) is a pertinent example, as is Alfred Hitchcock's *Psycho* (1960). In this book, I focus mostly on supernatural horror, which is doubly paradoxical: It is weird enough that people are attracted to the kind of entertainment designed to make them feel bad . . . but why would educated, enlightened audiences thrill to stories that feature monsters that have shambled straight out of the darkest lore of prescientific superstition? My argument is that we cannot begin to answer this question, or the questions raised above, without situating our investigation within the best current scientific understanding of how the mind works.

My central claim is that horror fiction is crucially dependent on evolved properties of the human central nervous system, and thus that a nuanced and scientifically valid understanding of horror fiction requires that we take human evolutionary history seriously. While evolutionary psychology has received considerable criticism over the years—some of it justified, some of it misguided (Laland and Brown 2011, Kenrick 2013)—evolutionary social scientists have made massive advances in identifying and explaining the functional structure of the mind. They argue that our species' evolutionary history has resulted in a species-typical psychological architecture, and I argue that this architecture fundamentally constrains our horror stories and the types of monsters that we imagine and are captivated by. Horror fiction targets ancient and deeply conserved defense mechanisms in the brain; when it works, it works by activating supersensitive danger-detection circuits that have their roots far back in vertebrate evolution, circuits that evolved to help our ancestors survive in dangerous environments. Humans have an adaptive disposition to find pleasure in make-believe that allows them to experience negative emotions at high levels of intensity within a safe context. And that is what horror offers.

Horror stories are particularly efficient in targeting evolved danger-management circuits when those stories reflect or respond to salient sociocultural anxieties. We are born to be fearsome, but the things we fear are somewhat plastic and modulated by culture. That is why horror fiction changes over time and from culture to culture—why, say, vampires are popular at one time, in some cultures, and zombies are popular at other times. Works of horror do not change arbitrarily, nor do they vary endlessly. Rather, works of horror vary within a possibility space constrained

by human biology. That variation is explicable in terms of cultural configurations. One culture will be particularly receptive to, say, slasher films set in suburban environments; others, to stories of exotic menaces in exotic locations. Hence, the analytical framework that I develop and promote in this book is *biocultural*: It accounts for the ways in which specific works of horror reflect or engage with sociocultural issues, but it locates such analysis within a framework informed by evolutionary social science.

The book consists of three parts. In Part 1 I give a brief introduction to horror and academic approaches to horror, and then lay out my theoretical framework. I explain the evolutionary processes that gave rise to negative emotions, how those emotions are targeted by fictional stories, why such stories work, what their psychological effects are, and why so many people are attracted to them. Part 2 consists of analytical applications of that theoretical framework to one particular cultural domain: modern American horror fiction. This delimitation allows me to get into focus the interactions between historical context and evolved psychological mechanisms in the imaginative expression of horror scenarios. Part 2 opens with a brief historical overview of American horror for context. I then analyze a selection of well-known post–World War II novels and films to show how those works are structured to target fears and anxieties—fears and anxieties that loomed large in the works' cultural context while having deep roots in evolved dispositions—and how an evolutionary perspective helps us get a fix on their meaning. This part of the book is organized by work, rather than, say, thematically, which allows me to go into my discussions of these significant works in depth and to show how an evolutionary approach works in interpretative practice. I focus on highly popular, canonical works—the kind of works that consistently make Best of Horror lists—because such works presumably resonated, and continue to resonate, with a large number of people, which suggests that they were and are particularly effective at fulfilling their function. I have aimed for diversity in the selection of analytical cases, choosing novels and films that play on different fears, target different subsets of negative emotions (ranging from terror, fear, and dread to shock, disgust, and loathing), and feature different kinds of monsters. In some cases, both novel and film versions exist—in such cases I've chosen the version that I find most aesthetically accomplished and interesting. (For example, I think—uncontroversially— that Spielberg's *Jaws* is better than Benchley's novel and, perhaps more contentiously, that King's *The Shining* is vastly superior to Kubrick's adaptation in its sensitive depiction of Jack Torrance's psychological trajectory.) My cases are Richard Matheson's *I Am Legend* from 1954 (novel), Ira Levin's *Rosemary's Baby* from 1967 (novel), George A. Romero's *Night of*

the Living Dead from 1968 (film), Steven Spielberg's *Jaws* from 1975 (film), Stephen King's *The Shining* from 1977 (novel), John Carpenter's *Halloween* from 1978 (film), and Daniel Myrick and Eduardo Sánchez's *The Blair Witch Project* from 1999 (film).

In Part 3, I draw up conclusions and point the way for future studies, as well as possible future developments of horror fiction. Looking over the recent history of horror, from literature to film and finally interactive entertainment, one can trace a tendency toward ever-increased immersion and agency on the audience's part. I predict that future technological developments will sustain ever greater immersion—but also increased audience segmentation as some forms of horror become so effective that they appeal only to a highly exclusive niche audience. Virtual reality technology, for example, will allow players to project themselves ever more fully into the fictional universe, and that won't be appealing to everybody or even to most horror fans. I also look at the increasingly popular "haunts": commercial horror venues with live actors where audiences pay good money to be scared witless. Like horror computer games, such attractions let audiences sustain the illusion that they are, literally, protagonists in a horror story. Our appetite for being scared in safe contexts is being satisfied in ever more effective ways, and that is unlikely to change. Technological developments may create vicarious horror experiences so intense that only a small fraction of people will seek them out, but given the horror genre's intimate connections with basic human dispositions, our appetite for horror will not go away anytime soon. In one form or another, horrifying fiction has probably been with us for tens of thousands of years, and as long as we are who we are, members of the fearful species *Homo sapiens*, horror will stay with us. Given recent advances in the sciences of human nature, we are now in a position to explain why that is.

An Evolutionary Theory of Horror

CHAPTER 1

Sizing Up the Beast

What Horror Is, and How It Is Studied

Horror scholars like to suggest that the horror genre came into being with the emergence of the Gothic novel in the late eighteenth century (Bloom 2010, Botting 1996, Kendrick 1991, Punter 1996, Skal 2001). The eccentric British writer Horace Walpole is supposed to have more or less singlehandedly invented the genre with his Gothic romance novel *The Castle of Otranto* in 1764, a short pseudodocumentary novel about bizarre, ghostly happenings in an old, decaying castle (Walpole 1996). Walpole's novel made popular several of the elements that would come to characterize the Gothic novel—the exotic setting in a faraway land in a faraway past; the creepy old castle; the dark and secret passageways; the innocent heroines chased by malicious villains; uncanny, inexplicable events contributing to a darkly melodramatic atmosphere, and so on. The Gothic novel had its heyday roughly from 1790 to 1830, a period in which writers such as Ann Radcliffe, M. G. Lewis, and Charles Maturin published spooky stories that were very widely read. Such novels tended to revolve around mysterious, apparently supernatural events and creatures and provided safe thrills for thousands of readers. The Gothic novel remained popular during the nineteenth century—"the great age of the Gothic," according to Clive Bloom, who identifies this kind of writing as "the [nineteenth] century's most popular genre" (2012, 212).

The Gothic novel is clearly an ancestor of many of today's horror stories, which recycle and rework tropes that were established at least two centuries ago. Creepy old buildings? Sure, they're in just about any haunted

house story you can think of, from Henry James's 1898 psychological ghost story *The Turn of the Screw* (1969) to the popular television series *American Horror Story* (Murphy and Falchuk 2011–) and the film *The Conjuring* (Wan 2013). Supernatural happenings and spooky monsters? Horror is saturated with them, for example, the television series *Supernatural* (Kripke 2005–). Ominous atmospheres, secret identities, heroines in peril, underground labyrinths? Yup, plenty of those still around; the critically acclaimed first season of the television series *True Detective* (Pizzolatto 2014) used them all. But what made the Gothic novel emerge when it did, and why did it become so popular? A common hypothesis in academic horror/Gothic study is that the Gothic novel arose as a consequence of Enlightenment repression. The narrative goes something like this: Following on the heels of the scientific revolution, which posited a rationally intelligible universe and proposed to replace dogmatic belief and unscientific intuition with empirical observation and experimentation, the Age of Enlightenment swept across Western Europe from about the middle of the seventeenth century and until the late eighteenth century. Enlightenment thinkers put a premium on reason, rationality, and science, and fought a hard battle against superstition and scholarly and religious orthodoxy. In this intellectual climate, basic human passions were suppressed: violent emotion, wild imagination, untamed fancy. Those passions found an outlet in Romanticism, an artistic and cultural movement that flourished in Europe from the late eighteenth century and well into the nineteenth century and that celebrated strong authentic emotion, sublime and semireligious experience, and unschooled flights of fancy. The darker Romantic aspects, the more violent and unsettling tendencies and preoccupations, then found an outlet in Gothic fiction (Baldick and Mighall 2012, Jackson 1981, Punter 1996). The narrative is neat, but also simplistic.

There is probably some truth to the notion that the Gothic novel resonated with Romantic passions, central aspects of evolved human emotive and imaginative registers, which may have been at least partially curbed in the Enlightenment. And there's certainly a lot of truth to the idea that modern horror is descended from the Gothic novel. Some critics even use the term "Gothic" to describe modern horror, such as the stories of Stephen King (Hoppenstand and Browne 1987, Sears 2011), or use Gothic as an umbrella term that encompasses horror. Other critics claim that "Gothic" and "horror" are synonymous, or at least register that they are often used synonymously (Bloom 2012). My view is that "horror" is the umbrella term, a category that encompasses those kinds of fiction that are designed to instill negative emotion such as anxiety and fear in their audiences, and that Gothic fiction is merely one such kind. The Gothic is a set

of conventions that serve a certain set of functions very well, including eliciting a certain kind of emotional response in its audience and engaging with a certain set of themes. The Gothic is an historical phenomenon, just one historically specific incarnation of horror, like the slasher film, whereas horror is a functional designation, one that transcends history.

Critics agree that horror is notoriously difficult to define (Bloom 2012, Hutchings 2004), but they also tend to agree that the genre is affectively defined—that is, according to intended audience reaction (Cherry 2009, 54, Reyes 2016). As the critic Douglas E. Winter put it in his introduction to the celebrated 1988 horror anthology *Prime Evil*: "horror is not a genre, like the mystery or science fiction or the western. It is not a kind of fiction, meant to be confined to the ghetto of a special shelf in libraries or bookstores. Horror is an emotion" (1988, 12). Winter perhaps overstated his case. He was writing in the late 1980s when many horror aficionados felt that the horror genre was under attack from the twin evils of commercialization and literary ghettoization, resulting in a glut of subpar publications churned out by hack writers and greedy publishers and resulting also in critical dismissals of horror as a worthy literary form. But his point remains: Horror is affectively defined. And it is certainly true that consumers of horror expect to be scared or at least unsettled when they buy a ticket to a horror film or pull a paperback off the shelf labeled "Horror" in a bookstore.

In our survey on horror preference and personality, we asked respondents how frightening they prefer their horror media to be. We would expect most respondents to indicate a preference for frightening horror, but that's not a given. Perhaps people seek out horror exclusively to be stimulated intellectually or aesthetically, or because of peer pressure, or because their curiosity overrides their aversion toward negative emotions evoked by artworks. However, as it turns out, only 3.8 percent say they prefer horror that is not at all frightening. 17.2 percent want their horror media to be mildly frightening, 38 percent want moderately frightening horror, 25.5 percent want highly frightening horror, and 15.5 percent want it to be extremely frightening. Clearly, to the vast majority of horror consumers, negative emotional stimulation is a primary and irreducible attraction of the genre. The striking theatrical trailer for *Paranormal Activity* (Peli 2009) illustrates the point. This short trailer alternated shots of a theater audience watching the film with scenes from the film itself. In grainy, green-tinged night-vision images, the trailer showed an audience recoiling in fear, covering their eyes, laughing nervously, and screaming in terror (see Figure 1.1). Interspersed were snippets from enthusiastic reviews, including approbations such as *"Paranormal Activity* is one of the scariest

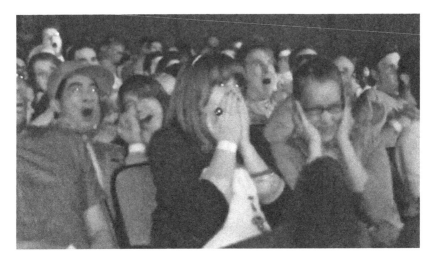

Figure 1.1: Screenshot from the theatrical trailer for *Paranormal Activity* (Peli 2009), showing audience members screaming, squirming, and shutting their eyes, implicitly offering the best possible review of the film. Horror audiences expect to be scared, and the scariness of a horror work is often used as a selling point in marketing.

movies of all time" and "genuinely horrifying." The "scariness" of a horror novel, film, or video game is frequently used as an explicit selling point in marketing campaigns, and as a stamp of approval by critics and consumers (Clasen 2016).

Much horror scholarship sees horror as a purely cultural phenomenon, something that is exclusively shaped by specific cultural conditions and can be exhaustively explained with reference to those conditions. But the implied notion that horror, by way of the Gothic romance, is a purely cultural invention, the fortuitous byproduct of a certain set of cultural configurations, is untenably reductive. Reductive, because it fails to take into account the deep-seated psychological dispositions upon which horror stories depend and problematic, moreover, because the hypothesis in its strong version ignores horror's roots in older storytelling traditions. Walter Kendrick, for instance, writes that "scary entertainment, as we know it today, showed its first stirrings in the middle of the eighteenth century" (1991, xxii). Yet the roots of modern horror can easily be traced much further back than 1764. One well-known horror scholar, James B. Twitchell, in his influential 1985 book *Dreadful Pleasures* writes that "modern works of artificial horror originated in the late eighteenth-century discovery that by inducing extreme feelings of dreadful pleasures, both print and illustration could arouse and exploit powerful feelings deep within the human spirit." He avoids the culturalist fallacy by conceding that "we can trace the

artifice of horror back well before the turn of the nineteenth century," and goes on to note that "the place to start any comprehensive study of horror (of which this is not one!) would be back in the cave, where doubtless our . . . ancestors nestled among the rocks to watch the flickering shadows play on the walls, pretending that they were watching the forms of charging beasts, the first 'creature features'" (4). Twitchell spends a couple of pages discussing horror elements of Stone Age cave art, such as the weird composite monsters drawn on cave walls by humans tens of thousands of years ago (Wengrow 2014), but then leaves prehistory behind and skips ahead to the horror of the eighteenth, nineteenth, and twentieth centuries.

In contrast to the critics locating the emergence of horror in the eighteenth century, the American writer and theorist of horror, H. P. Lovecraft famously claimed in his treatise *Supernatural Horror in Literature* that "the horror-tale is as old as human thought and speech themselves," which was "naturally [to be] expected of a form so closely connected with primal emotion" (1973, 17). Lovecraft was writing this in the late 1920s, and later in the twentieth century it became fashionable for those few academics who wrote about horror and the Gothic novel to divorce the genre from "primal emotion" and instead focus on the cultural forces that allegedly paved the way for, and gave shape to, such stories. That divorce was fueled by a general intellectual tendency to downplay or ignore biological underpinnings of culture, a tendency that in academia held sway over the social sciences and the humanities for most of the twentieth century and in some disciplines continues to do so (Carroll 2011, Pinker 2002). Lovecraft, however, was more right than he could have known. He was using common sense—folk psychology—and a deep knowledge of literary tradition to arrive at his theory of horror, but recent advances in neuroscience and the cognitive science of religion have vindicated his theory and provided a deeper explanatory framework for his observations (Clasen 2017). Lovecraft posited a natural basis for the appeal of horror stories and claimed that people are biologically susceptible to superstitious fear, a tendency that supernatural horror stories, including the "weird tales" penned by Lovecraft and his ilk, exploit. As he wrote, "sometimes a curious streak of fancy invades an obscure corner of the very hardest head; so that no amount of rationalization, reform, or Freudian analysis can quite annul the thrill of the chimney-corner whisper or the lonely wood" (1973, 13). People are indeed "trip-wired" for agency detection (Atran and Norenzayan 2004, 714), for imposing pattern on random visual or auditory noise and for inferring agency behind otherwise inexplicable events such as a weird sound in the dead of night; over evolutionary time, we evolved to react fearfully to even ambiguous stimuli that might suggest danger (Atran and Norenzayan 2004, Marks and Nesse 1994).

Even as the horror story is essentially an ancient art form—probably as old as our ability to create and share imaginative scenarios—the academic study of horror took off only fairly recently, in the late 1970s. The rise of academic horror study followed closely on the tail of a commercial boom in horror fiction, the third Golden Age of Horror in the English-speaking world (Luckhurst 2005). The first two Golden Ages were the massive popularity of the Gothic romance around 1800, and again at the late-nineteenth-century Victorian *fin de siècle* with the publication of such classics as Robert Louis Stevenson's 1886 novel *The Strange Case of Dr. Jekyll and Mr. Hyde* (2002), Oscar Wilde's 1890 novel *The Picture of Dorian Gray* (2003), Bram Stoker's 1897 novel *Dracula* (1997), and many others. The third Golden Age was signaled spectacularly by such well-known and well-produced films as Roman Polanski's *Rosemary's Baby* (1968) and William Friedkin's *The Exorcist* (1973). Stephen King's debut in 1974 with *Carrie* (1999), and his massive subsequent output of commercially successful horror fiction, also did much to popularize the genre. In the 1970s, the upsurge of horror fiction was a cultural trend that could hardly be ignored. Add to that the rise of media studies and cultural studies with their focus on pop culture and low- and middlebrow entertainment, and even respectable academics could spend armchair hours mulling over the cultural significance, ideological ramifications, and psychosexual import of horror stories.

The number of scholarly publications on horror and Gothic fiction has exploded over the last few decades. There are now dozens of new books—anthologies, monographs, readers, companions—coming out every year. There are several peer-reviewed academic journals devoted to the study of scary entertainment, such as *Gothic Studies* and *Horror Studies*. There are regular conferences and meetings for academics interested in these topics. It has become quite legitimate for academics to work professionally with horror fiction, and academics are applying a range of theoretical perspectives to horror.

In a review article from 2009, Jerrold E. Hogle and Andrew Smith note that "serious critical attention to 'Gothic' in literature and film" was "signalled most powerfully by David Punter's *The Literature of Terror*" (1), which was published in 1980 and reissued in an updated two-volume version in 1996 (Punter 1996). Punter's book, subtitled *A History of Gothic Fictions from 1765 to the Present Day*, traced the historical development of Gothic and horror fiction and documented how, for all its surface melodrama and outrageous supernaturalism, the genre engages with real and important psychological and social issues. Punter implicitly challenged a widespread perception of the genre as mere escapism. He invoked Freudian

psychoanalysis to get into focus the strange, norm-breaking sexuality and repressed psychological complexes that seem to lurk in these texts, and he invoked Marxist social theory to get into focus the class struggle that plays an important role in much Gothic fiction. While Punter received some criticism for not being quite Freudian enough, and for not being quite Marxist enough (Kosofsky Sedgwick 1982)—for using psychoanalysis and historical materialism in a superficial way, merely as stepping stones for traditional literary and cultural analysis—he was widely praised for demonstrating that Gothic and horror fiction is worthy of serious, sustained academic attention. As Gina Wisker puts it, Punter's study "made horror criticism respectable" (2005, 232).

Another early and highly influential study, Robin Wood's "An Introduction to the American Horror Film" (1979), also used psychoanalysis and Marxism in its attempt to invest horror with real-world importance, particularly as an ideological vehicle. Wood claimed that horror films can be either progressive or reactionary in the way that they engage with "the Other" as it is represented in the figure of the monster (1979, 11). Monsters, in Wood's Freudian perspective, are embodiments of whatever a culture represses or oppresses. For example, a culture may repress homosexuality, women, and/or the proletariat. These repressed concepts are then transcoded into monstrous agents in horror films. From this perspective, a film such as *The Exorcist* (Friedkin 1973) invests female sexuality with a horrifying quality. Regan gets possessed by the demon as she is on the cusp of puberty—possibly because her father is not around and her mom is sexually and politically liberated—and starts masturbating with a crucifix and using very nasty language. The film thus perpetuates a pernicious reactionary sexual politics, according to which female sexuality should be kept on a very tight patriarchal leash lest it turn monstrous. Wood, like Punter, provided an argument for how and why to take horror films seriously. However, he was more interested in using his horror film analyses as radical weapons in an ideological war than he was in the films as objects of disinterested academic inquiry. He added to his theoretical brew of Freudo-Marxism a good dose of ideological critique, arguing for the necessity of this particular concoction thus: "It is here, through the medium of psychoanalytic theory, that Feminism and Gay Liberation join forces with Marxism in their progress towards a common aim, the overthrow of patriarchal capitalist ideology" (Wood 1979, 7). Wood's focus on horror monsters as ideological acts allowed him to get a fix—biased as it was—on the politics of horror, but also made him invest those monsters with untenable psychosexual significance and overlook their literal, visual significance.

Wood wanted to change the world, and he saw his study of American horror films as a means to that end. His essay is symptomatic of a greater trend in literary and film study in the late twentieth century, a trend that Jonathan Gottschall calls the "liberationist paradigm" (2010). Gottschall argues that academic literary study has since its inception been concerned with providing for itself a rationale, a raison d'être, sometimes feverishly so. While the scientists are busy sending people to the moon, and the biologists are helping cook up vaccines against deadly diseases, what good are academic literary scholars? It is out of such feelings of inferiority and insufficiency, says Gottschall, that literary scholars in the late 1960s started embracing an "active commitment to achieving radical or progressive political ends *through* scholarly means" (462). Wood certainly was driven by such a commitment. In a retrospective essay published 25 years after *The American Nightmare*, the book in which his essay was printed, Wood reflected: "What was crucially determinant of *The American Nightmare* was our political commitment—leftist, radical, and with at least an interest in Marxist ideology and especially the confluence of Marx and Freud in 1970s thought. That commitment was vastly more important to us than any desire to tell 'the whole truth and nothing but the truth' about the horror film" (2004, xiv). That kind of rationale for film study issues a blanket invitation for distorted, biased scholarship. Political activism certainly has its place in the world, but it should not be the driving force of film or literary study—our aim *should* be to get at the truth of our objects of study.

In Gottschall's analysis, a commitment to the liberationist paradigm is usually bound up with a commitment to poststructuralist epistemology and social constructivism, with their concomitant rejection of biology as a significant causal factor in human social and imaginative life (2010). As I mentioned above, humanists have been busy for decades ignoring biology or actively denying it any shaping role in human lives. Academic horror study is no exception. Poststructuralist thinking, primarily Foucauldian cultural critique, has blended with Freudian psychoanalysis and Marxist social theory to produce paradigms that have become highly influential in the field of horror study, paradigms that focus on excavating the ideological and psychosexual dynamics of horror texts. Take as an example the influential work of Barbara Creed on the "monstrous-feminine," defined by Creed as "what it is about woman that is shocking, terrifying, horrific, abject" (1996, 35). Creed builds on the work of the theorist Julia Kristeva, who in turn built on Lacan, who reinterpreted Freud. Creed then adds a dose of radical feminism to critique the gender politics of horror films. According to Creed, horror films tend to depict feminine monsters that threaten patriarchy or "the order of the phallus" (43), in a Lacanian turn of phrase

derived from Kristeva. Like so many other critics adopting a Freudian or neo-Freudian perspective, Creed sees repressed complexes everywhere; she claims that the "horror film's obsession with blood, particularly the bleeding body of woman, where her body is transformed into the 'gaping wound' [i.e., a menstruating vagina], suggests that castration anxiety is a central concern of the horror film" (44). The argument is unconvincing because it rests on a flimsy symbolic correspondence that can be legitimate only if predicated on an a priori acceptance of a whole string of dubious Freudian assumptions (Tudor 1997, 450–451).

A Freudian perspective on horror can thus have a profoundly distorting quality. Consider this claim: "horror cinema *always* trades on irrationality, and irrationality, in psychoanalytic terms, is always sexual in origin" (Dumas 2014, 22). That may be true in psychoanalytic terms, but then those terms are false. As I discuss in later chapters, the fear of dangerous, supernatural, or psychotic agents—what Dumas means by "irrationality"—has roots in psychological dispositions that evolved in response to threats in the environment, not in psychosexual repression. Moreover, the claim that horror always trades on irrationality is so broad as to be virtually meaningless. It doesn't tell us anything interesting about the genre. Consider also this statement: "one might say that *all* violence in horror films is always about castration and punishment, and therefore always about gender" (Dumas 2014, 26). It's another Freudian distortion. Freud himself (2003) reduced the fear of amputation generally to the specific fear of castration, but the claim rests on a putative symbolic correspondence—losing an eye is sort of like losing the penis—and no empirical science. Taken to its logical conclusion, this idea should make females (and other individuals who have no penis) impervious to horror stories that dwell on cut-off limbs. That's clearly not the case.

As another example of the distorting effect of a psychoanalytical perspective, consider Barbara Creed's assertion that the shark in *Jaws* (Spielberg 1975) is really a "toothed vagina/womb" (Creed 1996, 56). The great white has teeth, yes, and a lot of them. Its mouth is concave, as is a vagina, and cavernous, as is a womb. But does the shark register, even subconsciously, as a toothed vagina/womb for even a fraction of viewers? Is there any empirical evidence to suggest, even circumstantially, that the sight of a shark evokes in spectators, consciously or subconsciously, the notion of a vagina/womb with teeth? And if that is not the case, what epistemological or interpretive value could Creed's reading have? I see very little. Nonetheless, the reading is representative of psychoanalytical interpretive scholarship. In the psychoanalytical perspective, horror is not really about horrible things, it's about repressed desire presented in metaphorical

guise, which allegedly explains why we react with horror to symbolic depictions of our most secret, repressed fantasies.

It is a curious fact that Freud's legacy is clearly registered in horror study today—in orthodox as well as revisionist versions (Schneider 2004). While orthodox psychoanalysis has been relegated to the historical curiosity cabinet in psychology departments, it somehow survives in literary university departments and, to a lesser extent, film and media departments. Perhaps this is because Freud's theory has tremendous creative, generative power; it is like a Rube Goldberg contraption with a receptacle for texts at one end and an interpretative spout at the other, churning out thrillingly arcane and counterintuitive explanations. It is not hard to see why some literary and media critics find the Freudian framework appealing: it gives them an illusion of privileged access to a hidden layer of textual reality, discernible only to highly-trained specialists. It also allows them to talk endlessly about sexual organs, but with straight-faced gravitas. Mark Jancovich has a different explanation. He claims that psychoanalytical approaches to horror "reinvent horror with seriousness. Through psychoanalysis, the fantastical nature of many horror plots can be read not as escapism, but as an attempt to deal with repressed materials" (2002, 21). Psychoanalysis when wedded to ideological critique, such as Marxism or gender politics or queer theory, lets critics feel that they get a handle on the deep structure of horror and connect it to burning political questions.

Psychoanalysis naturally has a place in interpretive practice insofar as the work under discussion is shaped by psychoanalytical thinking; Freud's theory profoundly influenced twentieth-century intellectual life, and obviously many artists were inspired by his ideas regardless of their scientific validity (Schneider 2004). Making sense of those artists' works requires an understanding of psychoanalysis. But something must be wrong if a literary or media scholar can legitimately use orthodox psychoanalysis as an *explanatory paradigm*, just as something would be wrong if a professional astrophysicist could legitimately pursue astrological studies. As a minimal epistemological requirement, literary and media theories that build on extraneous theories (e.g. from psychology, sociology, or linguistics) should use only theories that have been empirically validated in their home disciplines. If orthodox psychoanalysis has been rejected as an explanatory paradigm in psychological science, might it somehow be true or valid in literary and media study nonetheless? I don't see how. Literary and media theorists who talk about minds talk about the same ontological entities as psychologists do. Claiming that orthodox psychoanalysis is valid as an explanatory paradigm within literary and media study is a sophistical maneuver that only makes sense if one supposes that "science and literature

occupy themselves with ontological and epistemic realms that are radically separate from one another" (Carroll 2008, 329), if those minds that are absorbed in storyworlds and enjoy films are radically, qualitatively different from those minds that psychologists study. That is clearly not the case.

Punter's and Wood's pioneering efforts made horror an acceptable area of academic study. Many of their successors got lost in thickets of radical speculation, but the fact remains that by the end of the twentieth century, a multitude of critical offshoots from the liberationist paradigm were crowding the scene of academic horror study—"revisionist psychoanalysis and Marxism, feminism and gender studies, post-structural deconstruction, 'new' historicism and cultural studies, and the even more recent extensions of all these, especially the latter, into queer theory, critical race studies, postcolonial criticism" (Hogle and Smith 2009, 1, see also Baldick and Mighall 2012, Brewster 2014, Hogle 2006, Hughes 2006). In my view, it is a good thing that horror fiction is now being taken seriously as an object of academic analysis, but theoretical pluralism is not unconditionally desirable. Jonathan Gottschall makes a strong case for "shrinking the space of possible explanations" in humanities scholarship (2010, 464). One way of shrinking possibility space is by weeding out those approaches that rely on defunct theories from other disciplines. If psychology and psychiatry have abandoned orthodox psychoanalysis because it is scientifically invalid, literary and film scholars shouldn't use orthodox psychoanalysis as an explanatory paradigm. If economists have abandoned Marxism, then so should humanists, and so on. In line with Gottschall's argument, I think it is problematic that the currently most prevalent academic approaches to horror either operate on false epistemological assumptions and are based on theoretically obsolete psychological foundations—or ignore the psychological underpinnings of horror, as is the case in most historicist approaches.

Scholars of horror who build their theories and interpretive practice on scientifically defunct theories of mental functioning, such as psychoanalysis, would benefit from leaving Freud and his followers behind, turning instead to modern naturalistic psychology when they explore the psychological underpinnings of the genre. Rather than being compelled to recycle epistemologically and ontologically dubious claims about Oedipus complexes, vagina/wombs, and the transcendent significance of the Phallus, they could have recourse to the latest findings and theories in evolutionary psychology, human behavioral ecology, affective and cognitive neuroscience, and so on (Carroll 2010). Likewise, scholars who ignore biology and the evolutionary underpinnings of mental functioning, including many gender-oriented horror scholars (e.g., Grant 1996, Humphrey 2014) and

those horror scholars who work in a historicist (e.g., Loewenstein 2005, Phillips 2005, Skal 2001) or philosophical framework (e.g., Carroll 1990, Schneider and Shaw 2003), would benefit from the deeper explanatory reach provided by an evolutionary paradigm (Clasen 2012d). Historicist horror scholars, in Phillips's phrasing, tend to look for ways in which horror films "resonate" with aspects of their culture, typically widespread anxieties that in these films are given metaphorical expression (2005, 7). As an example, Phillips reads Romero's bleak *Night of the Living Dead* (1968) as an imaginative response to the sociopolitical tensions of the late 1960s. There is some truth to such a symptomatic reading, but as I show in my chapter on the film, an evolutionary approach can subsume such a reading within a more comprehensive and analytically rich framework. Yes, Romero's film did register a certain disillusioned *Zeitgeist*, but it did so within an emotionally and imaginatively engaging representation that effectively targets evolved mechanisms for survival in dangerous environments. That's why the film retains at least some of its power to engage and disturb, even in sociopolitical environments far-removed from the American late-1960s.

In this book, and building on previous research efforts—my own, as well as those of others (Boyd 2005, 2009, Clasen 2004, 2007, 2010a, 2010b, 2012a, 2012b, 2012c, 2012d, 2012e, 2016, Carroll 1995, 2004, 2011, Carroll et al. 2012, Carroll 2012b, Gottschall and Wilson 2005, Gottschall 2012, Grodal 2009, Plantinga and Smith 1999, Swanger 2008)—I argue for a biocultural approach to horror. Such an approach integrates attention to cultural particulars within a biologically informed framework. I do so partly to take advantage of advances in the evolutionary social sciences and partly as a corrective to academic horror studies that have for a long time been mired in untenably reductive, monocausal explanatory paradigms (versions of cultural constructivism) and a reliance on arcane and unscientific psychologies. But given that academic horror study is home to a wide variety of critical schools and approaches with different aims, methods, and theoretical convictions, do we really need yet another approach, the biocultural one? The rhetorical question is ill-conceived, because bioculturalism is *not* just another approach. It is an attempt to subsume viable existing approaches within a framework that is vertically integrated with the social and ultimately the natural sciences (Carroll 2010). Such a framework can only improve our understanding of horror fiction, and that is why we need it.

I see my work on horror fiction as a response to E. O. Wilson's call for consilience (Wilson 1998), the integration of all knowledge into a unified framework that is causally connected from the most basic levels of physics to the most complex levels of human culture. Adopting the biocultural

approach or subscribing to consilience does not mean that one believes that the arts can be reduced to psychology, or physiology, or molecular biology, or particle physics. Each level of complexity has emergent properties; the arts have properties that are not reducible to psychology, and psychology operates with categories that are not reducible to brain chemistry (Boyd, Carroll, and Gottschall 2010). But the mind is a product of the brain, and the arts are products of minds (Carroll 2013). Thus, an accurate understanding of minds and brains, and of the evolutionary forces that shaped them, can only enrich horror study. An effort to ground academic horror study in unified causal explanation will bring that study into line with the other sciences and make it enlightening to those who want to understand the structure and function of horror fiction.

How Horror Works, I

The Evolution and Stimulation of Negative Emotion

Humans are fearful creatures. We fear getting killed, being assaulted, contracting diseases, losing loved ones, going insane, losing status, being humiliated. We fear all-out nuclear war, terrorist attacks, natural disasters. We fear monsters and psychos. We even fear invisible agents such as angry deities or malevolent spirits. We humans may consider ourselves the masters of creation, top dogs in the food chain, the last alpha predator around. But in actuality we are weak, vulnerable creatures. We lack the deadly muzzle of feline predators, the poison of slithery snakes, the physical strength of other big mammals. We can't even see very well in the dark. Humans do have big brains, of course, and pride ourselves on those brains—calling ourselves *Homo sapiens*, wise man. Yet a paradoxical aspect of our big brains and our uniquely developed imaginations is that we face not only real and plausible dangers, but also imaginary ones—dangers that exist in our minds only (Dozier 1998), but are no less terrifying for that. People in the industrialized world may have eradicated most natural dangers, at least those stemming from predators and poisonous animals, and driven back the darkness of the night with electrical lights, but our minds churn out horrors around the clock. As the philosopher Stephen T. Asma puts it: "Neocortical expansion creates space for reflective symbolic counterfactual thinking, and along with that great privilege comes relentless horror" (2015, 957). Why, then, in the face of such "relentless horror" did we evolve to become so fearful? And how is our horror entertainment designed to elicit negative emotions such as fear and anxiety?

Like all other organisms on the planet, humans are the result of an evolutionary process of selection and adaptation. As Charles Darwin documented a century and a half ago, all organisms evolve in an adaptive relationship with their environments (Darwin 2003 [1859]). Because of random mutations—copying errors introduced into the genetic material—some organisms are born with traits that make them better adapted to their environments than their peers. Those fortunate organisms have better odds of surviving and reproducing, thus passing on their better-adapted genetic material to the next generation. Given sufficient time and sufficiently strong selection pressures, highly complex adaptations can arise and spread to an entire species. Take the human heart, for example, or stereoscopic vision; both are universal traits of *Homo sapiens*. Those traits are clearly adaptive and arose because of genetic mutations accumulating over time, eventually producing complex, functional mechanisms.

Anatomically modern humans—*Homo sapiens*, our species—emerged around 200,000 years ago (Wade 2006). But the human story is much older than that. Our story takes its beginning with the advent of life on earth, about 3.5 billion years ago. Only some 200 million years ago did the first mammals emerge, and only about 2.5 million years ago did the genus *Homo* evolve. In the mind-numbing perspective of deep (geological) time, modern humans really have not been around for very long. Nonetheless, much of our anatomical rigging has been carried along over millions, even billions of years of evolution. The genus *Homo* evolved from other, earlier species that in turn evolved from earlier species. A line of evolutionary descent stretches from modern humans all the way back to the earliest life forms, and many of the evolved structures that we find in humans exist in identical or similar variants in other species. For example, many other species have hearts and stereoscopic vision like us. We still carry along ancient mammalian adaptations for mother-infant bonding, and we share basic fight-or-flight responses with reptiles and fishes (Shubin 2008). Indeed, the neurobiological hardware underlying human emotions—such quintessentially *human* traits—has deep roots in mammalian phylogeny.

Fear—the "oldest and strongest emotion of mankind," as Lovecraft pointed out (1973, 12)—originates in a mammalian defensive system, which evolved in response to threats in mammals' environments (Öhman 2008). All animals are equipped with evolved mechanisms that enable them to deal with recurrent threats to their survival. In humans and other mammals, negative emotions serve such functions; they evolved to protect organisms from harm, to motivate organisms to steer clear of things that could harm them. People may consider fear and anxiety to be nuisances, unpleasant emotions that diminish their well-being and stand in the way

of their ambitions, but if our lineage had not evolved negative emotions, we would not be here today. A fearless hominin in ancestral environments would soon be a dead hominin in ancestral environments, given that such environments teemed with danger.

Across millions of years, humans and hominins (and earlier mammals before them) came into the world facing potentially lethal danger from predators, invisible pathogens and toxins, hostile conspecifics (members of their own species), social exclusion, and perilous features of the landscape such as cliffs and deep water (Dozier 1998, Pinker 1997). Theirs was a world shimmering with threat. We can reconstruct some of those threats from the archeological record, which occasionally throws up hominin fossils with clear marks of predation, such as skulls with puncture marks made by the huge fangs of saber-toothed cats (Hart and Sussman 2009). Such paleontological finds indicate that our ancestors—or more precisely, those of our ancestors' peers who probably didn't become ancestors— occasionally ended their days as meals for carnivorous predators. In the evocative phrasing of science writer David Quammen: "Among the earliest forms of human self-awareness was the awareness of being meat" (2003, 3).

Another line of evidence comes from studies of present-day hunter-gatherers. Anthropologists and paleoanthropologists often use hunter-gatherers as proxies for our evolutionary ancestors, given that our ancestors spent more than 99 percent of human evolutionary history living in hunter-gatherer societies (Cosmides and Tooby 1997). In the perspective of human evolution, agriculture and modern technology are very recent inventions and thus have not been around long enough to profoundly shape our nature. Most human adaptation has occurred in response to the challenges posed by more "primitive" forms of existence (Pinker 1997, Wade 2006, but see also Cochran and Harpending 2009). What, then, can we learn by looking at modern-day hunter-gatherer societies? One of the most striking facts of modern hunter-gatherer societies is that very few individuals die from sheer old age. One study examined causes of death in seven groups of hunter-gatherers and forager-horticulturalists, comprising more than 3,000 individuals. Very few of those individuals died from old age; in fact, only 9.5 percent of deaths were attributed to senescence. The vast majority—72.4 percent—died from disease, with accidents accounting for another 5.2 percent and violence (including predation) making up 11 percent of deaths (Gurven 2012, 297). To the extent that present-day hunter-gatherer communities mirror ancestral human and hominin communities, these numbers corroborate the archeological evidence indicating that our ancestors led dangerous lives indeed.

Such existence has left deep grooves in human psychology. We evolved to be ever on the lookout for dangers around us. Psychologists Arne Öhman and Susan Mineka have carefully delineated what they call an evolved "fear module" (2001), an evolved defense system underpinned by dedicated brain structures such as the amygdala. The function of the system is to protect the organism from harm, and the system has a number of design characteristics that reveal its evolutionary pedigree (LeDoux 1996). One such feature is the domain-specificity or "selectivity" (Öhman and Mineka 2001, 485) of the system, the fact that we tend to react more fearfully to certain kinds of stimuli than others, and that the stimuli to which we react fearfully tend to be evolutionarily relevant stimuli, not necessarily those kinds of stimuli that are truly dangerous to us in the modern world. It is much easier for humans to learn to fear snakes, say, than to learn to fear lawnmowers, despite the fact that lawnmowers are much more dangerous to us in the industrialized world—but this is a topic for the next chapter.

Most striking, perhaps, is that the human fear system evolved to be hypersensitive to cues of danger. That is why we humans scare so easily, why we tend to jump at shadows. The biological logic underlying this design characteristic is encapsulated in the aphorism "Better safe than sorry." In a dangerous and unpredictable environment, a false negative—assuming there is no danger when in fact there is—is vastly more costly than a false positive—assuming there is danger when in fact there is none (Marks and Nesse 1994). In other words, in terms of survival it is much better to react fearfully toward an ambiguous cue that *might* indicate danger, such as a rustling in the leaves during a twilight stroll in the woods, than it is to disregard such a cue. As Shakespeare had Theseus exclaim in *A Midsummer Night's Dream*, "in the night, imagining some fear, / How easy is a bush sup-posed a bear!" (1.5.22–23). The default setting of the fear system, then, is to jump at shadows. If we hear a strange sound in the dead of night, the fear system is designed to cause a series of physiological and cognitive changes that ready us for fight or flight and force us to pay close attention to the cue. The heart rate goes up and glucose is released into the bloodstream for an instant energy fix in anticipation of combat or evasion. Blood is diverted from the digestive system—irrelevant when you're facing a preda-tor or an oncoming boulder—to the large muscle groups, which may cause dry mouth and a butterfly sensation in the stomach. Pupils dilate to take in as much visual information as possible. Goose bumps erupt, which is an atavistic relic from a time when we were covered with fur and piloerec-tion caused the fur to stand on end, defensively making us look bigger and more fearsome. Attention is sharply focused on the threat, all other con-cerns momentarily forgotten (Dozier 1998). All of these physiological and

cognitive processes happen swiftly and automatically, outside of conscious control (Dozier 1998, Öhman and Mineka 2001).

The hypersensitivity of the fear system may appear to generate irrational behavior. When we hear that weird noise in the dead of night, a careful weighing of the odds would tell us that some non-agentic, mechanical event—such as floorboards settling or the engine in the refrigerator kicking in—is likely to have caused the sound, not an intruding, malicious agent. But statistical probability is not the principle by which the fear system operates; its motto is "Better safe than sorry." Better to proceed from the assumption that some dangerous agent has intruded on your home and to ramp up the fear response to make you ready for fight or flight, just in case. Moreover, such automaticity and hyperreactivity are not, in fact, irrational in a dangerous, unpredictable environment—quite the opposite. When we react with fear or anxiety to a cue that turns out to be harmless, we will have wasted a little energy and some time, that's all. But if we fail to react to a cue that turns out to indicate the presence of some predatory agent, we may be meat, quite literally. Hence, when the stakes are high and time is of the essence, automatic, swift, defensive behavior initiated by the fear system is adaptive.

Fear is the prototypical negative emotion and a true human universal, one that is found in all normally-developed members of the species *Homo sapiens* (Brown 1991, Ekman 2005). It is closely related to anxiety, also a negative emotion that evolved to protect us from harm. But where fear is the adaptive response to immediate threat, anxiety is the adaptive response to a distant, potential, or abstract threat (Öhman 2008). Fear and anxiety generate similar physiological changes but different behaviors. Fear gets us ready to fight or flee, whereas anxiety makes us carefully probe and investigate our surroundings. Dozier sees anxiety as a subtype of fear and argues that anxiety is a future-oriented emotion, an emotion that occurs in response to anticipations of danger or threat, whereas fear is generated in response to immediate danger or threat (1998, 16).

Another striking feature of the human fear system is its encapsulation, its relative imperviousness to cognitive control (Öhman and Mineka 2001). When the fear response gets going, it is very hard to consciously extinguish. Imagine, for example, an arachnophobe spotting a moving object out of the corner of his eye. It appears to be a big spider scurrying across the floor. The arachnophobe reacts with acute fear—heightened pulse, sweaty palms, sinking feeling in the pit of his stomach, possibly jumping away from the spider, and maybe emitting a high-pitched warning call in the process— only to realize that it is a fat dust bunny propelled across the floor by a draft wind. Even then, his heart keeps hammering away and his consciousness

is cleared of all but the notion of the nasty spider. Something similar happens when people who are afraid of heights refuse to step onto the Grand Canyon Skywalk, a transparent platform that sits about 800 feet above the floor of the canyon, and a similar principle is at work when people refuse to eat chocolate that is shaped to resemble a dog turd (Bloom 2010, Rozin, Haidt, and McCauley 2005). We know that the glass enclosure is safe and lives up to a thousand regulations, and we know it's just chocolate, not dog pooh . . . but try telling that to ancient defensive mechanisms deep within the brain, mechanisms that evolved to trust no one and nothing but the appearance of things.

Knowing that something is safe while feeling that it is unsafe produces a peculiar frisson. We may rationally realize that airplane travel is the safest mode of transportation in the modern world and at the same time tremble with terror as we step onto a plane. Rush W. Dozier, Jr. outlines the neurobiological foundation of this paradox and explains the parallel processing taking place in the brain when we perceive something that looks dangerous but which we know to be safe. Deeply conserved, primitive circuits located primarily in the limbic system—an evolutionarily ancient structure that we share with other mammals—perceive a cue that might signal a threat and set into motion the fear response. Meanwhile, evolutionarily younger structures located in the prefrontal cortex—a part of the brain that, among other things, is responsible for controlling emotional responses and inhibiting impulses—carefully assess the cue and can modulate the response produced by the old fear system. We can rationally override an aversive impulse and decide to climb onto the diving board fifteen feet above the surface of the water and plunge to what the limbic system considers certain death, but which we know to be a thrilling few seconds of freefall to safety. But there is only so much the prefrontal cortex can do in terms of keeping the fear system on a leash. As Dozier says, "there is a constant struggle between our frontal lobes and limbic system to control our behavior" (1998, 68)—a constant struggle between primitive emotional prompts and rational decision-making.

Darwin, in his book *On the Expression of the Emotions in Man and Animal*, describes a striking experiment that he conducted in the London Zoo: "I put my face close to the thick glass-plate in front of a puff-adder in the Zoological Gardens, with the firm determination of not starting back if the snake struck at me; but, as soon as the blow was struck, my resolution went for nothing, and I jumped a yard or two backwards with astonishing rapidity. My will and reason were powerless against the imagination of a danger which had never been experienced" (1998 [1872], 43–44). Darwin's anecdote illustrates the relative impotence of the prefrontal, rational

mechanisms in the face of a full-blown fear response orchestrated by the limbic mechanisms. He knew that the "thick glass-plate" would protect him, but his limbic system didn't care. In its view, a rapidly approaching snake is a rapidly approaching snake, glass or no glass.

Particularly accomplished fright scenes in a horror novel or film, or an especially hair-raising sequence in a horror computer game, work in a manner similar to Darwin's puff adders. They successfully target ancient, evolved defense mechanisms and short-circuit prefrontal mechanisms. Horror fiction, in other words, works by throwing a live wire into ancient structures in the audience's central nervous system. It captures and holds our attention by engaging the fear system, which, when we are immersed, does not really care that it's fiction, make-believe, and illusory sleights-of-hand. We *know* that it's fiction, which is why we don't flee the cinema in abject terror or throw aside the Stephen King novel in self-defense. But occasionally, real effort is necessary in managing the primitive fear response engendered by a film, novel, or computer game. As the tagline for the 1972 rape-revenge horror film *Last House on the Left* (Craven) admonished: "To avoid fainting keep repeating, it's only a movie . . . only a movie . . . only a movie." And of course, movie history tells us that on some spectacular occasions, horror film audience members are overwhelmed by their fear systems and faint, attack the screen, or flee the movie theater in terror—as happened upon the theatrical release of *The Exorcist* in 1973 (Kermode 2003).

The horror genre, then, achieves its peculiar affective goal by targeting an evolved defense system, the fear system. That is why psychologists who study emotion are fond of using clips from horror films in their studies. When they want to examine fear in human subjects, they expose these subjects to clips from films such as *The Shining* (Kubrick 1980) and *The Silence of the Lambs* (Demme 1990) (Gross and Levenson 1995, Rottenberg, Ray, and Gross 2007). Doing so is effective because fiction produces emotions—not "quasi-emotions" (Walton 1990), but genuine emotional responses (Hartz 1999, Mellmann 2002). A good story can make us sad, happy, surprised, disgusted, afraid, and so on; what we feel when absorbed in such stories is real sadness, real happiness, real surprise. Horror fiction aims to instill negative emotion by having us hold in our minds fear- and anxiety-inducing thoughts—from simple images (a gigantic spider!) to complicated scenarios (what if a secret military experiment breaches the barrier between dimensions and unleashes monsters from another reality upon ours, with chaos and social disintegration as a result?). Films and computer games, being visual media, can directly feed us fearsome visual stimuli—such as a depiction of a scary monster—which are processed by some brain structures as though they were real (Grodal 2009, 101–102), whereas

horror literature provides us with verbal descriptions that direct and constrain what we imagine, thus putting images into our heads, as it were. But horror in all media works by targeting the same evolved mental systems. As the neuroscientist Jeff Zacks observes, "when you read a book, you construct a model of the situation described in the book that is in important ways similar to the model you would build if you watched a movie of the same situation" (2015, 42). Representations engendered by films are, on a neurobiological level, like representations engendered by literature.

It is no surprise that looking at an image of something nasty, say a photograph of a mangled corpse, produces a strong emotional and physiological response. But even holding a nasty image in one's mind can evoke a forceful response. Remember those urban legends about psychopathic people handing out razor blades buried inside apples for Halloween? Imagine biting into such a nice, red apple. It's unpleasant to even think about. That's because our imaginations evolved to enlist appropriate emotional responses when we cognitively entertain hypothetical scenarios—this is part of the imagination's functional design. The imagination allows for "intellectual simulations and forecasting, the working out of solutions to problems without high-cost experimentation in actual practice," as Denis Dutton puts it (2009, 105–106). Such simulations are not merely intellectual and cognitive, like the kinds of scenarios we might imagine an advanced computer coldly and rationally running through. When we entertain hypothetical scenarios, when we imagine alternative pasts or possible futures, we *feel* the emotional import of such scenarios (Tooby and Cosmides 2001, Boyer 2007). We don't have to have personal experience with sticking our hands into a terrarium full of tarantulas, stripping naked in school, or jumping off the Grand Canyon Skywalk to realize that such actions are, generally speaking, unwise. Just *imagining* doing so elicits an emotional response that tells us: "No. Just no."

Horror fiction typically is designed to draw us in and keep us engaged. It does so by drawing up a recognizable fictional universe (the setting tends to be fairly naturalistic even in stories that feature supernatural monsters); giving us an "anchor" in the fictional world (one or more characters from whose perspective we experience story events and/or with whom we can empathize); and exposing that anchor to nasty events. This structure allows for audience transportation, that is, it allows audiences to project themselves into the fictional world and feel *with* and *for* the protagonists. We mirror Danny's terror in *The Shining* (Kubrick 1980) and hope he escapes his crazy dad; we feel sorry for—and grossed out by—demon-possessed Regan in *The Exorcist* (Friedkin 1973); and we are anxious with Agent Starling as she nervously investigates a dark storage facility with an unsteady flashlight

in *The Silence of the Lambs* (Demme 1990). Moreover, horror fiction is particularly well-equipped to grab and hold our attention because of the genre's typical subject matter. Evolution has designed us to pay close attention to cues of danger in the environment—even fictional environments—and our attention is riveted by the kinds of situations represented in horror.

A genre-typical scene from the 2007 horror film *Cloverfield* (Reeves 2007) will illustrate the idea that horror fiction exploits evolved defensive psychological machinery. In this film, a giant monster from space is wreaking havoc on Manhattan. A group of protagonists attempts to escape the island. They travel poorly-lit subway tunnels, carrying along a camcorder with an attached and ineffective light source (see Figure 2.1). Visibility in the tunnels is exceptionally poor. Suddenly, the characters notice scores of rats running in the same direction as them. "It's like they're running away," says one character. "From what?" asks another. An unidentified, distant source then emits a jarring, disconcerting sound, apparently from behind the characters. They, and the audience, know that something is approaching and frightening the rats, but the poor visibility prevents identification of the potential threat. When the characters think to enable night vision functionality on the camcorder, they and the audience see several dog-sized, spider-like organisms with sharp teeth approaching in the tunnel. The monsters attack the characters who scramble for safety. One character is severely injured.

Figure 2.1: Protagonists fleeing an enormous monster in *Cloverfield* (Reeves 2007). The spectator is visually aligned with the characters through point-of-view cinematography. It feels as if we're in the dark subway tunnel with the characters, anxiously looking out for danger. This claustrophobic scene exploits evolved fears of the dark and of predation.

The mise-en-scène tells us that we are in a confined location with few possibilities for escape. Adding the knowledge that a dangerous monster is loose, we realize that this is a potentially catastrophic situation and mirror the characters' anxiety. Cinematography (the use of a hand-held camera, operated by a character) and narration (restricting the audience's knowledge to what the characters know) keep the audience in the dark, along with the protagonists. Darkness and visually obstructed scenery are mainstays of horror fiction. Humans, with our poor night vision, are especially vulnerable to ambush in the dark, and research has demonstrated that darkness increases anxiety. This is an adaptive response to a potentially dangerous situation, given that darkness makes threat-detection much more difficult. The startle reflex—a defensive, hardwired reaction—is enhanced by fear and aversive states, a phenomenon known as "fear-potentiated startle." In one study (Grillon and Davis 1997), subjects in a dark environment reacted more violently—with greater startle—to aversive acoustic stimuli (brief, loud bursts of white noise) than did subjects in a well-lit environment. Darkness sets the fear system on edge; when people talk about fear of the dark, they usually mean fear of what dangers may *hide* in the dark. As Lovecraft observed, "the oldest and strongest kind of fear is fear of the unknown" (1973, 12). Nowhere is the unknown more forcefully present than in the dark. In the *Cloverfield* example, characters are confined in dark tunnels, and cues of approaching danger (the jarring noise) engage the spectator's fear system. We are kept on the edge of our seat, anxiously scanning the virtual environment for signs of danger along with the characters in the film. The horror cliché of depicting characters anxiously investigating a visually obscure and threatening environment is an efficient way of creating cognitive and emotional engagement in the audience because of the design features of evolved neurocognitive defense mechanisms.

Taken alone, such scenes are rarely *that* scary because horror stories tend to be structured to build increasingly strong emotional responses over the course of the story—again, by exploiting evolved aspects of the human fear system. When we are exposed to stimuli that produce fear or anxiety, we become sensitized to such stimuli and react more strongly to subsequent stimuli. That is why many horror stories begin with a strong opening that suggests the presence of some kind of more or less vaguely defined threat. The first footage we see in *Cloverfield* is text on a black background, suggesting an amateur (and thus authentic) video recording. The first shot has text that says "PROPERTY OF THE UNITED STATES GOVERNMENT." This is replaced by a shot that says "DOCUMENT #USGX-8810-B467 DIGITAL SD CARD MULTIPLE SIGHTINGS OF CASE DESIGNATE 'CLOVERFIELD'."

Figure 2.2: A pumpkin with glowing eyes from the title sequence of Carpenter's *Halloween* (1978). The slow track-in and eerie music establish an unsettling atmosphere of apprehension. Many horror films open with the suggestion of some more or less vaguely defined threat, thus priming viewers' fear system through sensitization.

The third and final shot of the opening has text that says "CAMERA RETRIEVED AT INCIDENT SITE 'US-447' AREA FORMERLY KNOWN AS 'CENTRAL PARK'." Within a few seconds, the film lets us know that we are about to be told the story of some hugely destructive event, something that destroys Central Park and requires serious military intervention. But we don't know what that might be; our interest is piqued. Similarly, *The Exorcist* grabs its audience by portraying weird disturbances—noises from the attic, strange omens—a few minutes into the film. Less overtly, *Halloween* (Carpenter 1978) suggests menace in its opening title sequence, which features a slow track-in on a pumpkin against a pitch-black background. The pumpkin's eerily glowing eyes and mouth and the unsettling music let the audience know that something nasty is going to happen in this film (see Figure 2.2).

These films, and countless films like them, attempt to sensitize the audience to danger early on. Literary fiction uses the same tactic, early in the story introducing clear or ambiguous signs of danger, and horror video games tend to open with some backstory or background information about the gameplay universe which suggests a world fraught with danger. It is an effective narrative strategy because sensitization lowers the threshold for fear (Dozier 1998). Fear generates more fear and increases our attention to threats in the environment (Öhman 2008). This extends to fictional environments. The well-constructed horror tale has us anxiously scanning the fictional environment for threats, and our emotional reactions increase in

intensity as the story progresses. Seeing a YouTube clip of the infamous spider-walk scene from *The Exorcist* (Friedkin 1973) is much less horrifying than seeing the sequence in context, primarily because of the cascading effect generated by horror fiction. (A secondary reason is that we don't really empathize with the characters if we haven't seen the bits that came before, and lack of empathy means lack of emotional investment.) The film has sensitized us to fear, it has gradually built up an atmosphere conducive to anxiety (we know that something is wrong in the fictional world, that something nasty is likely to happen soon). An even more striking example is the final scene of *The Blair Witch Project* (Sánchez and Myrick 1999), where two of the protagonists enter a dilapidated house in the woods. It's dark, they are afraid, and the film has given us reason to believe that something nastily dangerous is in the house. When seen in context the scene is utterly terrifying; when seen in isolation, much less so. Suspense, expectations, and empathy have been built up during the film—by the time we reach the end, we are invested in the characters, anxious about whatever is hunting them, unsure of what will happen but expecting the worst.

Horror entertainment is designed to scare us, unsettle us, disturb us. Given that our evolved constitution provides only a limited number of ways in which to scare and unsettle us—the things that scare us are distributed in a possibility space constrained by natural dispositions—the monsters and scary scenarios of horror entertainment are likewise nonrandomly distributed and tend to be exaggerations or embellishments of historically prevalent dangers. The big, attacking spiders in the *Cloverfield* subway scene are a case in point. Spiders play no real role in present-day mortality statistics in the industrialized west, so why would they figure so prominently as horror monsters in our scary entertainment? Only by looking at the deep history of human evolution can we begin to answer that question.

How Horror Works, II

Spooky Monsters, Scary Scenarios,

and Terrified Characters

The most effective monsters of horror fiction mirror ancestral dangers to exploit evolved human fears. Some fears are universal, some are near-universal, and some are local. The local fears—the idiosyncratic phobias such as the phobia of moths, say—tend to be avoided by horror writers, directors, and programmers. Horror artists typically want to target the greatest possible audience and that means targeting the most common fears. As the writer Thomas F. Monteleone has observed, "a horror writer has to have an unconscious sense or knowledge of what's going to be a universal 'trigger'" (qtd. in Wiater 1997, 119). All common fears can be located within a few biologically constrained categories or domains. Over evolutionary time, humans and their ancestors have faced potentially lethal danger in the domains of predation, intraspecific violence, contamination-contagion, status loss, and in the domain of dangerous nonliving environmental features (Barrett 2005, Boyer and Bergstrom 2011, Buss 2012, 71–103, Marks and Nesse 1994). In other words, they faced danger from predatory animals (ranging from mammalian carnivores to venomous animals such as spiders and snakes); from hostile members of their own species; from invisible pathogens, bacteria and viruses; from loss of status, ostracization, and ultimately social exclusion, which in ancestral environments could mean death; and they faced the risk of lethal injury following dangerous weather events such as violent thunder storms, falls from cliffs,

and other potentially hazardous topographical features. The selection pressures from these types of danger have resulted in domain-specificity in the reactivity of the fear system, meaning that the system has evolved special sensitivity toward such dangers. Sometimes such sensitivity allows the fear system to unreasonably expand a category and target an innocuous object, such as expanding the category of "dangerous animals" to include moths. As I mentioned earlier, in the domain of survival the golden rule is "better safe than sorry."

The most basic, universal, genetically hardwired fears are the fears of sudden, loud noises and of looming objects—those are the fears that we aim to evoke when we hide behind a door, waiting to spook an unsuspecting friend by jumping at them with a roar. Sudden, loud noises and looming objects will cause an involuntary startle response in humans and in many other species as well. You can sneak up behind a rat and yell at it, and its reaction will be similar to your own, if somebody sneaks up behind you and yells at you. You can also try the experiment with a dog or a squirrel or a human infant; it's guaranteed to work. The startle reflex is primitive and swift, and very effective in orienting the organism toward, and preparing it for, danger. Horror video games and horror films, in particular, exploit this innate fear when they resort to "jump scares," such as having a monster jump out of a closet without any warning and frightening the viewer or player.

The jump scare arguably achieved its purest mediated form in the phenomenon known as the "Internet screamer," which is an animated file—typically a short film—that shows a static peaceful scene for a while and concludes with an unexpected, shocking element, often a disturbing image and a loud noise. Screamers started circulating the Internet in the mid- to late-1990s. One of the most well-known screamers, called "What's Wrong with this Picture," was an image of a peaceful dining room. Viewers would scrutinize the image, looking for whatever was supposed to be "wrong" with it in the manner of a "spot the difference" game. After about thirty seconds, the image would abruptly shift to briefly showing a black-and-white close-up of a screaming woman with black holes for eyes, accompanied by the sound of a scream. Those viewers who were caught unawares—and there were plenty of us back in the early 2000s, when this prank started circulating the Internet—were in for a very nasty scare. Nowadays, YouTube overflows with "reaction videos" showing footage of people being scared witless by screamers. Apparently, there is a peculiar pleasure in watching other people react with violent negative emotion to a basically innocuous stimulus. It may be a form of *Schadenfreude*, a pleasure in seeing others

humiliated and reduced to the most basic behavioral response by their primitive biological hardwiring. Even the high and mighty, the urbane and sophisticated, the meek and innocent—even they jump and scream when they play the "Scary Maze Game," a simple piece of online software that has players focused on moving a dot through a maze on the screen, only to be unpleasantly surprised by a flash of diseased-looking Regan McNeil from *The Exorcist* accompanied by a loud scream. One 52-second-long YouTube video, showing a boy reacting with abject terror to the Scary Maze Game, has been viewed more than twenty-seven million times at the time of writing ("Scary Maze prank—The Original" 2006).

In critical computer-game parlance, the strategy of using the sudden, unmotivated appearance of a monster to scare players has become known as the "Monster Closet" tactic. A narratively unmotivated Monster Closet is by many reviewers and gamers perceived as insultingly gratuitous and cheap, but there is no denying that it can be highly effective. The tactic achieved notoriety in the 2004 survival horror first-person shooter game *Doom* 3 (Willits), which featured monsters literally jumping out of closets, spooking the player. Gratuitous jump scares also tend to be frowned upon by horror film fans, who see it as a primitive, artless way of scaring them. One of the most famous jump scares in horror film history, however, is not only surprisingly effective in generating a startle response but is narratively and thematically motivated—artful, in other words. It is from the final scene of Brian De Palma's *Carrie* (1976). The film's protagonist, abused and telekinetic Carrie, has killed herself after wreaking havoc on her school and killing most of her tormentors. The only survivor of Carrie's high school massacre, Sue, dreams that she is visiting Carrie's grave. As Sue is placing flowers on the grave, a bloody hand shoots up from the soil and grabs Sue's arm. The scene has terrified countless viewers—the movie is almost over, Carrie is dead, the scene has a slow, peaceful, dreamlike quality which is supported by the calm musical overlay . . . and then that bloody arm erupts. More than giving viewers a jump scare, however, the scene serves a function in suggesting Sue's guilt and the psychological trauma she herself has suffered. Carrie may be dead and the mayhem may be over, but Sue will forever be haunted by her role in pushing Carrie over the edge.

Other fears are universal but relatively transient. As developmental psychologists have demonstrated, children reliably develop highly specific fears along a predictable developmental trajectory. And as evolutionary psychologists have demonstrated, these predictable fears emerge when children are most vulnerable to the dangers targeted by the fears—or more precisely when children would have been most vulnerable to such dangers in ancestral environments, the kinds of environments in which our species

evolved. These environments in significant respects diverged from modern environments, but the fears persist. For infants, incapable of self-propelled motion and self-defense, the most dangerous situations—in ancestral environments and now—are the absence of caregivers and the presence of potentially hostile strangers. Hence infants reliably develop separation anxiety and stranger anxiety, which persist until the toddler years (Boyer and Bergstrom 2011, 1035). As children begin to move about on their own, they reliably develop fear of heights (Boyer and Bergstrom 2011, 1037). At around age 4–6, as children begin exploring their environments more extensively and thus become more vulnerable to predation, they typically become obsessed with death, afraid of monsters lurking in the dark, and preoccupied with dangerous animals such as lions and tigers. In middle to late childhood, fears of injury, accidents, and contagion emerge, and in late childhood and particularly early adolescence, social threats become "salient" to children—children tend to become highly anxious of losing status, losing friends, being ostracized, and so on, at precisely the developmental stage where peers begin to be more important to them than parents, and when their major challenge is to "find a specific social niche and build stable networks of reciprocity" (Boyer and Bergstrom 2011, 1037).

The evolutionary logic behind this preset developmental schedule is clear: Children evolved to develop domain-specific fears at the phase where they would typically encounter, or be particularly vulnerable to, such evolutionarily recurrent dangers. Some people may feel that they grow out of these fears—that they no longer need to check under the bed for lurking monsters before they go to sleep—but most of the fears begin in childhood and persist in somewhat modified forms throughout life (Boyer and Bergstrom 2011, 1038). Stephen King, in a foreword to a collection of stories, told readers that when he goes to bed at night, he is still "at pains to be sure that my legs are under the blankets after the lights go out. I'm not a child anymore but . . . I don't like to sleep with one leg sticking out . . . The thing under my bed waiting to grab my ankle isn't real. I know that, and I also know that if I'm careful to keep my foot under the covers, it will never be able to grab my ankle" (1978, 5–6). King is joking, but all the same, who hasn't at some point conceded to a fearful, apparently irrational impulse from the limbic system, an ancient and anxious voice from the deepest recesses of the brain telling us to avoid a shortcut across a graveyard after dark or to keep the feet inside the bed covers when we're alone? Not that *we* believe in ghosts or monsters or zombies, naturally, but . . . better safe than sorry, right? We may rationally dismiss the ostensibly childish fear targets—the monsters, the creepy strangers, the dangerous animals—but they at the very least live on in horror stories, even horror stories for

adults, featuring giant monsters, psychos in hockey masks, and creepy-crawlies hiding in the dark.

Those fears that are near-universal are known as "prepared fears" (Seligman 1971). They are not hardwired in the same way as the fears of sudden, loud noises and looming objects are. Nobody *learns* to flinch at a rapidly oncoming basketball. Prepared fears are innate, though, in the sense that they are genetically transmitted but require environmental input for their activation. The human fear system, in this aspect, is relatively open-ended—that is, it is set up for environmental calibration. The evolutionary logic underlying this design characteristic is as follows: Humans evolved to be adaptable (Wade 2006). Our species thrives in all climate zones, from the tropical to the arctic. Yet while some dangers are constant across time and space—the danger of choking, say, or of drowning—there is some environmental variation in threat distribution. There's no sense for an Inuit child in being afraid of tigers or scorpions, whereas a child from rural India doesn't need to worry about polar bears. And because our genes can't "know" in what sort of climate and ecology we'll grow up, those genes make us able and eager to learn about threats in our local environments. Humans quickly absorb local culture, including norms, language, knowledge about dangers, the sorts of things people in your culture consider edible or not, and so on. Learning, in fact, is an "evolutionarily derived adaptation to cope with environmental changes that occur within the life span of individuals and allows individual organisms to tailor their behavior to the specific environmental niche they occupy" (Öhman and Mineka 2001, 487).

So, because different environments have somewhat different dangers, not all human fears are instinctual and hard wired. We need to learn what to be afraid of, but such learning takes place within a biologically constrained possibility space. While different environments feature different threats, some threats have been evolutionarily persistent enough, and serious enough, to have left an imprint on our genome as prepared fears, as potentialities that may be activated during an individual's life in response to personal or vicarious experience, or culturally transmitted information. This explains why there may be surface variation in people's fears but a stable, underlying structure of fear distribution. The 2012 ChildFund Alliance report "Small Voices, Big Dreams," which quantified children's fears and dreams based on responses from 5,100 individuals from forty-four countries, found that the most common fear among children across developing and developed countries is the fear of "dangerous animals and insects" (Childfund Alliance 2012, 10). Even children growing up in industrialized, urban environments free of nonhuman predators easily acquire fear of

dangerous animals because such prepared learning is part and parcel of human nature. One study asked suburban American kids about their fears and found that they do not "fear the things they have been taught to be careful about," such as "street traffic," but "claim that the things to be afraid of are mammals and reptiles (most frequently): snakes, lions, and tigers" (Maurer 1965, 265).

Prepared fears include the fear of snakes, spiders, heights, blood, closed-in spaces, the dark, thunder, public or open spaces, social scrutiny, and deep water (Dozier 1998, 83, Marks and Nesse 1994, Seligman 1971). Those are typical phobia objects, quite easy to acquire and very difficult to extinguish. A phobia can be defined as "fear of a situation that is out of proportion to its danger" (Marks 1987, 5), which suggests the very weirdness of phobias: They are extremely real, often crippling, to sufferers, even though phobias either don't correspond to real-world dangers or exaggerate actual risks wildly. Almost nobody dies from being bitten by snakes or spiders—the most common phobia objects—in the industrialized world. According to recent statistics from the National Safety Council of the United States, the lifetime odds of dying from a motor vehicle accident for a person born in 2007 were 1 in 88. In contrast, the odds of dying from contact with venomous spiders were 1 in 483,457, and the odds of dying from contact with venomous snakes or lizards were 1 in 552,522 (National Safety Council 2011, 35–36). We should be terrified of cars and worry much less about snakes and spiders. But since the threats targeted by phobias have been lethal to humans and our hominin (and mammalian) ancestors for millions of years, we are still born with the evolved propensity to easily acquire fear of such targets.

A list of Stephen King's "personal terrors" was published in 1973. This list strikingly reflects the species-typical distribution of evolved fear objects much more so than it reflects the objects, creatures, and situations that a twentieth-century inhabitant of Maine, USA, *ought* to fear:

1. Fear of the dark
2. Fear of squishy things
3. Fear of deformity
4. Fear of snakes
5. Fear of rats
6. Fear of closed-in spaces
7. Fear of insects (especially spiders, flies, and beetles)
8. Fear of death
9. Fear of others (paranoia)
10. Fear for someone else (quoted in Spignesi 1991, 4).

Personal terrors they may be, but King's list could be anybody's list—an American's list, an Asian's list, an African's list, a European's list. It could be the list of someone living a thousand or fifty thousand years ago. Individuals of the species *Homo sapiens* tend to be afraid of the same things. People in the industrialized world may no longer face the threat of predation from carnivores, and we may no longer be in any real danger from venomous spiders and snakes, but these animals live on as ghosts in the human central nervous system. Not everybody develops phobia of snakes and spiders, of course, but almost everybody pays special attention to these animals. Snakes in particular have become integral in mythologies, religions, and superstitions around the world, even in snake-free territories such as Ireland (Cooke 1999).

In an astounding recent experiment, a group of scientists did their utmost to frighten a hapless middle-aged woman (Feinstein et al. 2011). The research team showed her clips from famous horror films (only those clips that had been found to reliably horrify a control group); they took her on a tour of a commercial "haunted house"; and they brought her into a pet store that sold dangerous, exotic animals such as constrictors and tarantulas. This woman, known in the neurological literature only as "S.M.," is not any random middle-aged lady, though. She has a rare genetic disorder that results in focal bilateral amygdala lesions. Her amygdalae—the "ancient, ever-watchful eyes of the emotional system of the brain," in Dozier's phrase (1998, 28)—are calcified; they don't work. She is clinically fearless. And indeed, the research team failed miserably in their attempts. S.M. laughed at the monsters in the haunted house, found the horror film clips interesting but not scary, and was "spontaneously drawn to the snake terrariums" in the pet store, where she "also attempted to touch a tarantula, but had to be stopped because of the high risk of being bitten" (Feinstein et al. 2011, 34–35). Strikingly, S.M. exhibited no fear at all, but she was quite interested in those objects and situations that instill fear in neurologically normal individuals. As the research team argued in their published account, "fear-inducing stimuli are still capable of eliciting changes in attention and arousal through structures other than the amygdala" (37).

Fear-inducing stimuli, in other words, don't just make us cover our eyes or run away screaming, they grab and hold our attention. From an evolutionary perspective, this makes good sense. Given that most of our species' evolution took place in environments that were much more dangerous than current environments, natural selection would favor those individuals who paid special attention to threats around them (New, Cosmides, and Tooby 2007, Wilson 1984). We are endowed with what the communication theorist Pamela J. Shoemaker calls the "surveillance function" (1996), a

propensity to be always on the lookout for potential dangers in our environments. Psychologists have amassed a wealth of evidence supporting this idea. Several studies have shown that people are faster at detecting an image of a snake embedded in an array of mushrooms and flowers than they are at detecting an image of a mushroom or a flower in an array of snake images (see Lobue and DeLoache 2008, Penkunas and Coss 2013, and Öhman, Flykt, and Esteves 2001). Snakes and spiders in particular grab our attention (New and German 2015, Rakison and Derringer 2008). The structure of our fear system and the evolutionary history that gave rise to this system explain not only why we pay special attention to possible dangers around us, but why we are fascinated with the monsters of horror. They are not only terrifying—they are captivating (Asma 2015, Saler and Ziegler 2005).

Prepared fears—those powerful, near-universal fears that reverberate with deeply conserved dispositions in human nature, that catch and hold our attention—are also the fears most often targeted by horror across media. Horror in film and interactive entertainment uses primitive, fear-inducing auditory and visual stimuli to provoke a jump scare. But in all horror media, from literature and graphic novels to painting and death metal music, we find stimuli that mirror or mimic prepared fears. Predators, both human predators and what David Quammen calls "alpha predators," figure prominently in our horror art. Quammen's alpha predators include tigers, bears, crocodiles, the great white shark, lions, and pythons. This grouping of organisms has "no taxonomic or ecological basis"—rather, its "reality is psychological, as registered in the human mind" (2003, 5), and these animals are vastly overrepresented in horror. Most of us have never encountered an alpha predator in the real world outside of a zoo, but we have certainly encountered many on screen and page. The profusion of more or less exaggerated and embellished alpha predators in horror stories reflects our evolved psychological constitution, not present-day ecological actuality.

Some horror antagonists are fairly faithful representations of actual alpha predators, such as the homicidal lions eating railway workers in *The Ghost and the Darkness* (Hopkins 1996), or the huge man-eating crocodile in *Lake Placid* (Miner 1999). Some horror stories are less realistic, if more effective, in their representation of alpha predators, such as the great white shark in *Jaws* (Spielberg 1975), which seems to have zoologically implausible motive dispositions such as vengeful feelings and a sense of territoriality. Some horror monsters are enlarged predators, such as the giant snakes in *Tremors* (Underwood 1989), the 35-foot-long serpents with six inch teeth in Dan Simmons's *Summer of Night* (1991), or

the giant spiders that make life miserable for the characters in Stephen King's stories. In *Needful Things*, King offers a chilling description of a spider "as big as a cat" (1992, 676). In *It*, he ups the ante considerably and writes of a spider "perhaps fifteen feet high" (1981, 1004). In the scene from *Cloverfield* that I discussed in the previous chapter, the protagonists are attacked by dog-sized spider-like creatures. In the video game *LIMBO* (Jensen 2010), the young protagonist is chased by an enormous spider (depicted in Figure 3.1). And then of course there's the eponymous antagonist of the 2013 film *Big Ass Spider!* (Mendez), which should speak for itself. Those monsters are conceptualized to match input specifications of evolved threat-detection mechanisms—they look just like the sorts of things that we're biologically prepared to fear, only much more predatory and much, much bigger.

Most horror monsters, in fact, exhibit what ethologists call "supernormal" traits (Barrett 2010)—they're bigger, more dangerous, or cleverer than the real-world organisms that they mirror; they may even be equipped with supernatural abilities. Equipping a monster with supernormal traits makes it more salient and allows it to more strongly activate the human fear system. Take the example of the evil clown, by now a mainstay of horror fiction. Common sense and a lack of archeological evidence suggest that our ancestors were probably not hunted down and eaten by evil clowns at any point in prehistory. Nonetheless, the evil clown is an effective horror

Figure 3.1: The protagonist in the horror video game *LIMBO* (Jensen 2010) comes across an enormous and venomous spider. Like most other horror monsters, this antagonist is an exaggeration of an evolutionarily relevant threat. Spiders are potent fear targets, especially gigantic ones.

monster, and we can make sense of its effectiveness by considering the figure in light of evolved defensive dispositions. The evil clown is a super-charged version of the conspecific predator, a homicidal human exhibiting unpredictable, psychotic behavior. The clown masks its inner life, its intentions and motives, by obscuring its face with paint, thus making it unreadable and unpredictable. Humans decipher other humans' inner states from reading their faces. We are extremely quick to detect an angry face in a crowd of neutral faces—much more quick than we are to detect a happy face in a crowd of neutral faces, as laboratory experiments have demonstrated (Öhman, Lundqvist, and Esteves 2001), because an angry person could be a threat to our biological fitness. When we are blocked from reading a face, the result is unease or even dread. That's why many human or humanoid horror monsters besides clowns have highly distorted faces or wear masks. Just think of masked Michael Myers, the disturbingly impenetrable and inhuman killer of *Halloween* (Carpenter 1978), or the equally implacable and robotic Leatherface from *The Texas Chain Saw Massacre* (Hooper 1974). The unpredictability and psychotic nature of the evil clown make it a highly salient and very nasty antagonist. It may even have traits that facilitate predation, such as claws and fangs and supernatural means of locomotion—all of which are enjoyed by the most famous evil clown of them all, Pennywise the Dancing Clown from King's *It* (Clasen 2014), depicted in Figure 3.2. Common to horror monsters is that they

Figure 3.2: Evil clowns, such as Pennywise from *It* (Wallace 1990), probably didn't systematically hunt down and eat our evolutionary ancestors. Nonetheless, they exhibit features that target the evolved human fear system, such as Pennywise's predatory attributes. Moreover, the evil clown tends to mask its intentions through face paint or a mask, thus becoming unpredictable and unsettling.

are well-designed to target defensive mechanisms in human psychology, whether they actually preyed on our ancestors on not. Fictional monsters, in other words, need not be biologically plausible to command attention and evoke a strong emotional response in audiences.

Horror monsters are almost always conceptually as well as perceptually disturbing. Monsters are frightening to behold, whether on screen or in the mind's eye, and they are disturbing to consider, to entertain mentally as concepts. We may have become habituated to the notion of a zombie this far into the zombie craze of the 21st century, but still . . . not only do zombies look creepy and gross, the very *idea* of a reanimated, decomposing, contagious, and predatory corpse is disturbing. It's an impossible concept, being alive and dead at the same time. This is what Noël Carroll means when he writes that horror monsters are "categorically interstitial" (1990, 32), and what the anthropologist David D. Gilmore has in mind when he observes that monsters around the world, in folktales and legends, are "hybrids" (2003, 6): monsters combine traits from normally distinct ontological categories, which makes them unnatural and counterintuitive. A monster can combine animal and human traits, as some vampires do, and as the werewolf does. A monster may have shape-shifting capacities, which is not what we intuitively expect of organisms in the real world, and it can have other such supernatural capacities. Why would so many horror monsters have counterintuitive traits? Recent research in the cognitive science of religion offers some answers (Grodal 2009).

Successful supernatural concepts—those supernatural concepts that are repeatedly and faithfully transmitted—tend to be minimally counterintuitive agents, or MCI agents. MCI agents "largely match intuitive assumptions about their own group of things but have a small number of tweaks that make them particularly interesting and memorable," in the words of psychologist Justin Barrett who coined the term (2004, 23). An example would be a statue that weeps blood, a tree that thinks and speaks, or a person with no physical presence—a ghost. Those are all striking, salient concepts. Experimental research has documented, in fact, that minimally counterintuitive objects are much easier to remember and transmit than are very bizarre concepts or humdrum ones (Atran and Norenzayan 2004, Boyer 2001, Norenzayan et al. 2006). They pop out from a background of mundane, ontologically obedient objects. Take Stephen King's haunted car in *Christine* (1983). The car, Christine, is an inanimate object—a mechanical vehicle—that has been infused with malicious intent and agency. It actively desires to kill people. Now that's a striking idea. Or consider the vampire. It's a living dead organism that infects living organisms with its weird mode of being, an ontological bastard, an impossibility—and one

that has been marvelously successful in terms of cultural transmission (Bahna 2015, Clasen 2012a). Everybody knows what a vampire is, even though it doesn't actually exist. Making a monster minimally counterintuitive, then, is an effective way of making it salient and attention-demanding, a way of exploiting evolved cognitive architecture.

Belief in supernatural agents is a predictable and natural byproduct of ordinary human cognition. As I mentioned earlier, we are tripwired for agency detection, prone to seeing intentional agents behind nonintentional phenomena such as unexpected noises and inexplicable events. A weird sound from the basement? *Somebody* must be down there. You escaped a terrible accident unscathed? *Somebody* must be watching over you. We project agency into our surroundings, including invisible agency such as ghosts, demons, angels, and gods. Disembodied human spirits are particularly easy and compelling to imagine because people are natural-born metaphysical dualists (Bloom 2004). We intuitively assume that people consist not just of matter, but also contain an immaterial soul (or spirit, or self). It is no great leap of faith to assume that once the body dies, the soul may stick around—still perceiving, thinking, and moralizing. Researchers in the cognitive science of religion have demonstrated that when we make sense of, and relate to, such supernatural agents, we use ordinary mental machinery that evolved for social interaction—we use our folk psychology (Boyer 2001). We negotiate and haggle with gods, offering sacrifice or prayer; we intuitively assume that they *want* things, that they pass judgment on us, that they can be bargained with—that they have mental processes and motives much like our own, in other words. Supernatural agents can be angry or happy, they can be good or evil, they can be all-knowing or startlingly stupid. Except for one or a few salient violations of the ontological category to which they belong—which makes them minimally counterintuitive—they tend to live up to most of our intuitive expectations for people (Boyer 2001). This applies to supernatural agents in horror too. When we imagine those agents, we use mental mechanisms that evolved for social interaction. That is why it is so easy to imagine those agents despite their lack of referents in empirical reality. Most of us don't believe that we have had firsthand experience with demons or ghosts, yet we can easily mentally simulate such experience and entertain as rich concepts such agents. We assume that supernatural agents, including the ones in horror, have intelligible (if evil) motives and, frequently, the ability to interact with physical reality even if they are themselves immaterial. The evil spirits in *The Shining* (King 2011 [1977]), for example, have human-like mental states: They *want* to recruit Danny and *believe* they can get to him through Jack Torrance. They are able to animate the topiary animals and to make the

elevator run in the middle of the night. Satan in *Rosemary's Baby* (Levin 1997 [1967]) wants a son and strikes a deal—quid pro quo, standard social contract—with the Satanists. We're talking counterintuitive, supernatural agents here, but still they behave pretty much like ordinary folk with ordinary minds—with some striking exceptions that make them salient and particularly frightening.

Counterintuitive monsters can target the fear system more effectively than ontologically mundane agents, but they can also evoke a broader set of emotions and thoughts. C. S. Lewis, in his 1940 book *The Problem of Pain*, proposed an intriguing thought experiment:

> Suppose you were told there was a tiger in the next room: you would know that you were in danger and would probably feel fear. But if you were told 'There is a ghost in the next room,' and believed it, you would feel, indeed, what is often called fear, but of a different kind. It would not be based on the knowledge of danger, for no one is primarily afraid of what a ghost may do to him, but of the mere fact that it is a ghost. It is 'uncanny' rather than dangerous, and the special kind of fear it excites may be called Dread. (Lewis 2001 [1940], 5–6)

Lewis has a good point. Ghosts are more cerebrally frightening than they are viscerally frightening. They are, presumably, a uniquely human phenomenon. While macaques dislike looking at photoshopped images of zombie macaques (Steckenfinger and Ghazanfar 2009), they don't have stories and beliefs about spooky macaque revenants. Macaques are not metaphysical dualists, and the notion of a disembodied agent probably does not make a lot of sense to them—or to dogs, frogs, or jellyfish. To humans, though, ghosts are counterintuitive and violate basic premises of materialistic science, even as they confirm a deep-seated intuition about the autonomy of the soul. They can make us doubt our beliefs and even sanity. That is the horror of a story such as Shirley Jackson's *The Haunting of Hill House* (2006 [1959]). The weird happenings in Hill House are profoundly ambiguous. We are drawn into a fictional world where there *may* be malicious disembodied agents targeting the characters . . . or a psychotic protagonist, Eleanor, who has disturbing delusions. But we, the readers, are inside her head, so it is very difficult to know. The putative ghosts in Jackson's novel are cognitively threatening first and foremost; the protagonist's possible insanity evokes the dread of mistrusting the information relayed to one by one's senses; and the difficulty of choosing between a supernatural and a psychopathological interpretation of the novel's events creates further uncertainty and dread. The dread aroused by Jackson's story encompasses Lovecraft's fear of the unknown, a cognitive fear that arises when we receive ambiguous

signals that may indicate some kind of danger (Carleton 2016), whether it is the danger of insanity or counterintuitive agents with ill will. Some fictional ghosts, of course, are also physically dangerous, such as the many aggressively hostile ghosts in the television series *Supernatural* (Kripke 2005–). But perhaps the most horrifying thing about ghosts, apart from the fact that they should not exist, is that there is no way to escape them. There is no way to have a fair fight with a ghost (Clasen 2016).

Supernatural horror monsters, then, are typically minimally counterintuitive reflections of ancestral threats which makes them peculiarly fascinating to a vulnerable prey species such as ourselves, even though such monsters by definition don't exist outside of fiction, delusion, and dream. They are also often "impure," in Noël Carroll's word (1990, 27), or outright disgusting. One would hesitate to share a toothbrush with Stoker's Dracula or one of the zombies from *The Walking Dead* (Darabont 2010–). This is yet another way in which monsters target evolved defensive mechanisms. Disgust evolved to protect the organism from harm, specifically the harm incurred by the ingestion of pathogenic substances—so-called micropredators, the sort of infectious microorganisms that are themselves invisible to the naked eye but extremely dangerous to us (Tybur et al. 2013). Val Curtis, a scientist specializing in hygiene, epidemiology, and disgust, has collected data on disgust responses around the world. She finds that people, no matter what their cultural background, tend to find the same objects and situations disgusting. Among those universal disgust triggers are "faeces, vomit, sweat, spit, blood, pus, sexual fluids, wounds, corpses, toenail clippings, rotting meat, slime, maggots, lice, worms, rats, and people who are ill" (Curtis, Aunger, and Rabie 2004, 131). Yummy. The common denominator here is substances that signal, suggest, or are associated with the threat of contagion. Feces, for example, are "the source of over twenty known bacterial, viral, and protozoan causes of intestinal tract infection" (Curtis and Biran 2001, 23). No wonder natural selection designed us to find the smell and sight aversive. It is not that feces are inherently disgusting in any meaningful way; for flies, a nice pile of freshly steaming stool is just about the most savory thing you can come across. We humans, however, are differently constructed. We also don't like putrefying meat—another potent source of disease—which is one reason why we bury or burn our dead, and one reason why the modern zombie is such a powerful monster (Clasen 2010). It is bad meat that wants to eat and infect *you*.

Some horror monsters elicit disgust without being physically gross. They don't drip slime or ooze pus, but they still make people squirm in revulsion. Most viewers will be intensely disgusted by the callous rapists in Wes Craven's rape-revenge film *Last House on the Left* (1972) as they

brutally molest two teenage girls. Depictions like that powerfully tap into evolved moral psychology. Antagonists, in their flagrant violation of moral norms, elicit our visceral condemnation (Kjeldgaard-Christiansen 2016). Likewise, the psychic "vampires" in Dan Simmons's horror/sci-fi novel *Carrion Comfort* (2009 [1989]) are not gross, but they evoke moral disgust as they exert psychic control over innocents and force them to perform degrading acts and drain them of life force. We're disgusted by Carrie's tormentors as they set her up for the ultimate humiliation (King 1999 [1974]). We're disgusted by handsome Guy Woodhouse in *Rosemary's Baby*, and we're disgusted by the cowardly politicians of Amity in *Jaws* (Spielberg 1975). Researchers have identified three evolved disgust systems—pathogen disgust (described above), moral disgust, and sexual disgust (Tybur et al. 2013). Disgust originally evolved to protect us from pathogenic microorganisms, but was coopted by other cognitive systems to mobilize our condemnation of norm violations (moral disgust) and to protect us from genetically harmful reproductive activities (sexual disgust) such as incest. Sexual disgust is relatively rarely evoked by mainstream horror, whereas pathogen and moral disgust are frequently evoked in the depiction of repulsive antagonists. And some monsters, of course, aren't disgusting at all—the shark in *Jaws* is a case in point. But all disgusting monsters exploit psychological machinery that evolved to keep us safe from infection, from inbreeding and other deleterious reproductive activities, and to keep our groups functioning by mobilizing visceral repulsion in response to antisocial behavior.

In sum, then, horror fiction is designed to elicit negative emotions in its audience, and it does so prototypically by featuring human characters (or in video games, the "avatar," the in-game entity controlled by the player) in dangerous situations involving horrible monsters. Such monsters tend to reflect evolved, prepared fears, notably the fear of predators. In horror film and horror literature, directors and writers usually go to great lengths to show the audience not just the horrible monsters, but the fearful reactions of protagonists, as well. Dwelling on characters' emotional expressions allows for emotional contagion, meaning that the audience's reaction to the monsters and aversive situations on screen or page is scaffolded by the negative emotion that they adopt from characters (Coplan 2006). In *The Exorcist*, for example, director William Friedkin repeatedly shows us Chris McNeil's reaction to the sight of her possessed, diseased-looking daughter before he shows us little Regan herself—as in Figure 3.3. Such reaction shots are extremely common in horror films, and have an analogue in horror literature where characters' reactions to the nasty elements are frequently described in evocative detail.

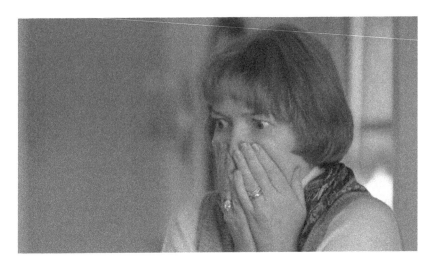

Figure 3.3: Chris McNeil in *The Exorcist* (Friedkin 1973) looking horrified. Reaction shots like this one are frequent in horror film and have an analogue in horror literature, where authors frequently depict characters' reactions to the horrors in great detail. Such depiction strengthens the viewer's or reader's response to the horrors depicted because it taps into an evolved disposition to mirror other people's emotional states.

Noël Carroll rightly emphasizes the crucial role of audience instruction in horror fiction (1990, 88–96): the reader or viewer needs a character through whose eyes and mind the horrors are experienced, and with whom to empathize, and the reactions of this character toward the horrors depicted in the story or film become emotional cues for the reader. Such a transfer of emotion from character to reader is possible because humans have an adaptive capacity to mirror the emotional states of other humans, including fictional ones. This phenomenon is known as "emotional contagion" (de Gelder et al. 2004). For example, the emotion of disgust is processed by a brain region called the anterior insula. Whether we ingest something disgusting, watch somebody else do it, or even imagine taking a bite out of a maggot-infested lump of meat causes activation in the anterior insula (Jabbi, Bastiaansen, and Keysers 2008). This capacity for emotional contagion is obviously adaptive: if we mirror the disgust of somebody else eating bad meat, we don't have to sample it ourselves. And if we react to a sudden expression of wide-eyed fear on the face of a conspecific, perhaps we react in time to evade the pouncing predator. Emotional contagion allows for swift response to a threat that one has not personally observed, and it accounts for the way that we mirror the emotional responses of even fictional characters. We use the same psychological mechanisms to understand and make sense of fictional characters as we use to understand and make sense of actual people in the real world

(Carroll et al. 2012). Our relations to fictional characters—so-called para-social relations (De Backer 2012)—can be as real and as strong as relations to real people (Dibble and Rosaen 2011). We can feel powerfully for, and with, characters in horror stories. Horror writers and directors know this, intuitively at least, and capitalize on our evolved capacity for emotional contagion by providing representations of characters' reactions to monsters and horrible events: reaction shots in films, descriptions of reactions in literature. Elaborate reaction depictions are generally eschewed in horror video games because the player *is* the protagonist—such depictions are unnecessary, and impractical given the widespread use of first-person point-of-view in horror video games. Occasionally, however, a horror video game will use feedback devices such as a graphic indication of the avatar's "sanity" or "health," or provide sounds of an avatar's frightened breathing, to reinforce the player's emotional response.

What, then, does watching such films, reading such stories, and playing such video games do for us, and to us? I have explained why we pay attention, why we are emotionally and cognitively engaged by even outlandish stories about highly implausible monsters and scenarios, but what psychological effects does our proclivity for horror have? And might our appetite for danger scenarios serve a biological—adaptive—function? Those are the topics of the next chapter.

Fear for Your Life

The Appeals, Functions, and Effects of Horror

Why are so many people attracted to horror in literature, film, and video games? The horror writer Peter Straub rightly says that there are many answers to the question. "One would be that people desire extremity of circumstance in perfect safety, so that they can feel all sorts of dangerous and despairing and frightening moments without in the least being in danger." But that can be only part of the answer, according to Straub—and, I'd add, it just begs the question of *why* people would want to feel "dangerous and despairing and frightening moments" while in perfect safety. Straub thinks that a more adequate answer to the question is this: "Horror stories are about engagement. About actual experience, instead of simulated, false experience . . . it's about discovering one's ability to feel in certain ways, and deepening and widening one's emotional experience by that means" (Clasen 2009, 40). I think that is true, and I will argue that an evolutionary analysis can help us understand how the genre works to widen one's emotional experience and why many of us are attracted to such mediated experience—and to the elicitation of negative emotion in safe contexts generally.

Straub's "extremity of circumstance in perfect safety" brings to mind the activities offered by rollercoasters and extreme sports, and such activities surely share some appeal with horror in different media. The pleasures afforded by rollercoasters and skydiving are primarily the elicitation of strong emotions and physiological arousal within a safe context (Kerr 2015). As Rush W. Dozier, Jr. argues, people manipulate fear to produce

pleasure. When we step on a rollercoaster, we "increase our fears artificially and then enjoy the sensation of our body pushing the fear back down to normal levels through the secretion of natural opiates and other fear-suppressing chemicals" (1998, 165). We artificially provoke—and enjoy—a release of endogenous morphine-like substances produced in the brain. Such an explanation cannot exhaustively account for the appeal of horror, though. If all we wanted from horror stories was the relief of the film, the novel, or the game to be over, we'd be better off not seeking it out in the first place. And if all we wanted was a kick of adrenaline and a jolt to the nervous system, there are quicker and easier ways to get such stimulation than to wade through 1,095 pages of *It* (King 1981), sit through two hours of *Alien* (Scott 1979), or spend eight or nine hours completing *Amnesia: The Dark Descent* (Grip and Nilsson 2010). A thirty-second Internet screamer gets the job done admirably. But the experience of being absorbed in a fictional universe and made to feel afraid as a result of this mediated experience has value and appeal in and of itself. There's bound to be a neurochemical payoff—what we call "pleasure"—but it is not the pleasure of the termination of the experience, it is the pleasure of experiencing strong and rich emotions in a safe context. That is a primary and irreducible appeal of horror.

Horror, of course, is a many-headed beast, difficult to pin down and to make stay down. Different works of horror may offer somewhat different pleasures: The epic scope and postapocalyptic grandeur of Stephen King's *The Stand* (1980) is different from the creeping terror provided by a short story such as King's "The Raft" (1986), a story about teenagers caught on a raft on a lake, preyed upon by a weird monster. Both works, however, engage our attention and encourage emotional involvement by inviting us to share the perspective of plausible and sympathetic protagonists in highly dangerous situations, faced with hostile monsters and adverse supernatural forces. Both works stimulate negative emotion such as anxiety and dread. They both target evolved cognitive and emotional mechanisms. More pointedly, the pleasure afforded by a simple survival horror computer game, such as *Slender: The Eight Pages* (Hadley 2012), is much less rich than the pleasure afforded by an accomplished and complex horror novel such as Peter Straub's *Ghost Story* (1979)—simple survival horror games have almost no narrative content, hardly anything in the way of symbolic figuration, no profound character depiction, and very little in the way of meaning, though both target evolved cognitive and emotional mechanisms. Narrative horror—stories and films—offer the same appeals as do simple survival horror games, but they offer much more than that. They offer the appeals of story generally: the opportunity to see

the world through another person's eyes, to see different worlds, to peer inside fictional people's heads, to engage with interesting characters, to model hypothetical scenarios in imaginatively engaging and emotionally compelling ways.

Fiction is a human universal, found in all documented cultures (Brown 1991, Carroll 2006). Normally developing children spontaneously and with delight construct imaginary worlds, and adults spend vast amounts of time in lands of make-believe (Gottschall 2012). We seem to be hardwired with a penchant for fiction. Is this because fiction is biologically adaptive, that our appetite for fiction helps us survive and reproduce, or is our love-affair with fiction an evolutionary byproduct? This is a live debate in evolution-ary literary study (Carroll 2012a). Some evolutionary social scientists claim that our appetite for fiction is an evolutionary byproduct, a functionless biological accident—that our appetite for fiction serves no adaptive pur-pose, but that we cook up and consume stories as a means of artificially stimulating evolved pleasure circuits (Carroll 2012b, Pinker 2007). As the psychologists Eric Youngstrom and Carroll E. Izard claim, "Horror films, sad songs, elegiac poetry—all of these serve no obvious biological function in terms of survival or sexual selection. Instead, these are 'junk food of the mind'—things that achieve their popularity by pandering to evolved pref-erences for approach and avoidance" (2008, 376).

Other scholars and scientists, however, have argued that our appetite for fiction is biologically adaptive (Carroll 2011, Dutton 2009, Gottschall 2012, Tooby and Cosmides 2001). According to these theorists, our involvement in fictional worlds is not a frivolous waste of time; it's a crucial way in which we make sense of the world, ourselves, and each other. Imagine a new spe-cies of *Homo* that because of a genetic mutation has absolutely no appetite for fiction (Gottschall 2012). In contrast to *Homo sapiens*, who spends vast amounts of time in made-up worlds—we daydream, night-dream, read and listen to stories, attend plays and movies, watch television, listen to jokes and tall tales—our story-less cousins care only about the factual world. They have no time for the Crusoes or the Simpsons. Would they be better adapted than us, undistracted by "junk food of the mind" as they are; would they survive and reproduce at greater rates than us and eventually outcom-pete us? Probably not. Fiction is not just "junk food of the mind." Fiction helps us make sense of the world, including our inner, mental world; it helps us assign value to behavioral alternatives and intelligently choose between such alternatives; it helps us gain a better understanding of what makes people, groups, and societies tick (Gottschall 2012). Fiction is con-densed and engaging simulation of social and psychological interactions (Mar and Oatley 2008). Fiction allows us to vicariously lead countless lives,

it frees us from the phenomenological present and throws us into possible and impossible futures, pasts, and parallel universes. Horror fiction can do all of those things and is particularly well-equipped to allow readers and viewers to vicariously live through the worst, to model threatening scenarios, and to get imaginatively compelling experience with extreme situations and intense negative emotion. In video games, players get experience with their own reactions to extreme situations; in literature and film, readers and viewers get experience with their own reactions as well as characters' reactions to extreme situations. This is all part of what Straub calls "deepening and widening one's emotional experience."

Stephen King says that "fiction is the truth inside the lie" (1981, 7). That observation works on several levels. A story about fictional characters engaged in fictional events may contain profound moral or existential or psychological truths. Also, on a literal level, made-up stories can contain true factual information; readers learn about chaos theory and paleoarchaeology from Michael Crichton's *Jurassic Park* (1990), and about working-class conditions in nineteenth-century England from Dickens's *Hard Times* (2003 [1854]). Stories engage our emotions, and emotional engagement enhances recall—when an event is drenched in emotion, it is more effectively stored in our memory (Gottschall 2012). Historically, narratives such as those found in myth and folklore have served the function of transmitting information about adaptively crucial issues such as hazards in the physical and social environment in an emotionally compelling way (Scalise Sugiyama 2001, Scalise Sugiyama and Scalise Sugiyama 2011)—information about dangerous animals, information about risky social interactions, information about local norms, information about features of the landscape that may present opportunities or dangers, and so on. Learning about danger in one's environment via narrative is preferable to learning about danger by personal experience and direct observation, because such direct learning can be extremely risky. As Arne Öhman and Susan Mineka observe, "if effortful trial-and-error learning was the only learning mechanism available, most animals would be dead before they knew which predators and circumstances to avoid" (2001, 487). Thus, if a child grows up in an environment in which wolves pose a threat, it is better to tell the child an engaging and memorable story about a dangerous wolf and a careless girl in a red hood than it is to let the child wander off and figure out on its own what happens when you stray from the path. The biologist Hans Kruuk makes a similar argument, saying about the overrepresentation of deadly carnivores in imaginative culture—there are more dangerous monsters and predators in our art than there are in our actual surroundings—that "there may be a survival value in this aspect of our

culture. We are teaching others what is lethal in the environment, how its deadly forces work, and one might call it a cultural alarm system" (2002, 179). People evolved to be curious about danger, and fictional stories about danger prime, satisfy, and even exploit that curiosity.

If fictional horror stories can teach us about real-world danger, what kinds of lessons do we draw from such stories? Do modern-day horror stories transmit adaptively useful information? Surely there is no great need for us to be educated on the perils of demonic possession, furious poltergeists, or chainsaw-wielding rednecks. Nonetheless, the writer Joe Hill suggests in an essay on the usefulness of horror that "while the vast catalog of horrific fantasies may not be able to offer us simple answers to our biggest questions, it does occasionally remind us of small yet undeniably useful truisms: always look in the back seat before you get in the car; don't insult hillbillies with more power tools than teeth; whatever was making that awful noise out in the woods, you can check it out in the morning" (2014). That may sound like a stretch. Very few people get disemboweled by murderers hiding in the backseat of their cars, and let's be honest, how many hillbillies with power tools are actually out to get us? Yet as Hill also says in the essay: "I suggest to you that the compulsion to peer into the darkness, and wonder about what's there, is a distinctly useful and adaptive trait. And as it happens, the fiction of the horrific is unusually well tuned to address the most frightening and fascinating unknowns"—such as the meaning of life and death and of being human. This statement rings true. Yes, horror can offer practical advice that could, conceivably, be useful in the real world. Don't go alone to investigate a strange sound in the basement when it's dark. Stay away from psychos with knives. Avoid clowns in the moonlight, sure. Horror reinforces our intuitions that such situations and individuals are to be avoided, horror makes those intuitions ring true with vivid emotional force. But the truths of horror, the genre's truly valuable lessons, tend to be psychological and existential ones. As Stephen King writes in an afterword to a short-story collection, "I have tried my best [in these stories] to record what people might do, and how they might behave, under certain dire circumstances" (2011, 366–367). King, in other words, aims at psychological realism even as he employs supernatural elements. Horror fiction, particularly supernatural horror fiction, can be outrageously outlandish and implausible in terms of the monsters or monstrous events depicted—corpses rising from graves because of space radiation? A haunted car? Really?—but good horror fiction is psychologically realistic, and it engages with substantial issues that are relevant to people. It depicts in plausible and careful detail the responses of characters to monsters and monstrous events. Only thus can horror fiction become "one of the vital

ways in which we try to make sense of our lives, and the often terrible world we see around us," as King puts it in that same afterword (365). Only thus can horror become "a lamp that can guide you through your own eventual nighttime journeys" (Hill 2014).

The appetite for horror, I argue, is an adaptation that functions to give us experience with negative emotion at levels of intensity not safely come by in real life, and to allow us to incorporate danger into our total imaginative universe. As philosophers like to point out, we may never know what it feels like to be a bat, and we might not even care. But if we seek out horror entertainment, we can learn what it feels like to be genuinely afraid, what it feels like to be hunted prey, what it feels like to face and maybe overcome great danger, what it feels like when the world breaks into pieces—and that, surely, is valuable to know. As the psychologist Paul Bloom has pointed out, even unrealistic stories about the zombie apocalypse can serve as "useful practice for bad times, exercising our psyches for when life goes to hell" (2010, 193–194). If we follow *The Walking Dead* (Darabont 2010–) on television, we'll be reassured that perseverance in the face of adversity often pays off, we'll learn to cultivate some caution toward strangers in case of disaster or massive upheaval, we'll be reminded of the value of meaningful, dependable social relations when times are tough. More specifically, we will learn what it *feels like* to be in the midst of such disaster, to combat hostile conspecifics and survive and thrive, to find meaning, in a hostile environment. That kind of vicarious experience, or experiential expansion, is generalizable to real life, even if the zombies aren't. The zombies become catalysts for social and psychological dramas, and they work well as catalysts because they are inherently fascinating and salient. Moreover, the series prompts us to reflect on the meaning of life in an environment that is stripped of many of the structures that sustain meaningful activities in the modern world. Most people find such imaginative, vicarious experience stimulating and rewarding.

When we read a novel, watch a film, or play a video game, we are engaged in "structured experience," in David Bordwell and Kristin Thompson's phrase (2013, 51). We are prompted to imaginatively entertain hypothetical scenarios and are (ideally) emotionally invested in, and cognitively stimulated by, those scenarios. Such involvement and stimulation can be regarded as a form of mental play behavior (Boyd 2009, Steen and Owens 2001, Vorderer, Steen, and Chan 2006), and the biological study of the functions of play can help us pinpoint possible biological functions for the structured experience offered by fiction across media. Play behavior—inherently rewarding but apparently nonfunctional behavior—has been observed in many species, especially among mammals and birds, but also

among reptiles and fish, for example (Burghardt 2014). Play behavior has been somewhat of an evolutionary puzzle. Given the harsh realities of existence for all species, the often vicious struggle to survive and the fierce competition for mates, why would organisms expend time and energy on less-than-crucial activities such as playfighting? The answer is that such activities are, in fact, crucial. Play researchers have suggested that mammalian play functions as "training for the unexpected" (Špinka, Newberry, and Bekoff 2001). When kittens playfight, they gain skills and capacities at low cost and relatively little risk, skills and capacities that may become critically useful later in life when they face a hostile opponent. If one meets a hungry predator for the first time in one's life, it is desirable to have a store of surrogate experience with predator evasion to draw from rather than proceed by trial and error. Francis Steen and Stephanie Owens (2001) argue that human chase play simulates predator-prey interactions; children evolved to find great pleasure in chase play because such play gives them experience with strategies for predator avoidance and lets them build muscle tone and locomotor dexterity. Play behavior lets children explore and push the limits of their abilities—it allows them to practice hunting behavior, evasion strategies, hiding maneuvers, and simple as well as complex social exchanges. There is a functional parallel in the way that the Air Force trains fighter pilots, as Peter Vorderer and his colleagues point out: "An F16 flight simulator . . . allows a novice to acquire experience and practical skills in manipulating a single-seat airplane without risking the loss of life and a multi-million-dollar fighter jet" (2006, 18). In a similar manner, fiction provides a framework for emotionally and cognitively engaging simulation, at little cost and almost no risk.

Horror fiction can help us build coping skills, both by giving us personal experience with negative emotion, and with our reactions to negative emotion, as well as by letting us witness the coping behavior of fictional characters—whether such behavior is efficient or not; theater audiences invariably cry out in frustration when the heroine faces certain death in deciding to check out the weird sound coming from the basement. In narrative media we can observe fictional characters' behavior and the consequences of their behavior; in interactive media such as video games, we can let our avatar try out such behaviors in the game world. All of this works toward the kind of experiential expansion that I mentioned above. When we cognitively model the experience of being in great danger, most of us probably draw on imagery provided to us by horror stories, and on remembered emotions induced in us by horror stories.

The hypothesis that horror stories can function as simulation of and rehearsal for the nastier sides of life is corroborated by research on the

biological function of nightmares. The neuroscientist Antti Revonsuo (2000) has suggested that the biological function of dreaming is to provide offline simulations of adaptively critical scenarios. Nightmares, according to Revonsuo's "Threat Simulation Theory," serve the function of providing opportunities for "rehearsal of the neurocognitive mechanisms that are essential for threat recognition and avoidance behavior while awake" (Valli and Revonsuo 2009, 17). To back this idea, Katja Valli and Revonsuo (2009) provide evidence that mental training or within-mind simulation improves real-world task performance in several domains, and that nightmares are extremely common across cultures. In fact, the "most typical dream theme around the world is that of the dream self being chased or attacked" (Valli and Revonsuo 2009, 31). Valli and Revonsuo conservatively estimate that young adults have dreams featuring "threat simulations" on average 5.1 times per week (2009, 26). The threats of such dreams need not be realistic representations of actual, ecologically valid threats; fantasy-based threats play a substantial role in nightmares because "in the modern world, the input concerning extremely threatening agents comes largely from horror movies and similar fictitious sources." But as Valli and Revonsuo note, "rehearsing how to escape from the jaws of a werewolf or a vampire might be just as efficient as running away from a human character or a wild animal" (2009, 35).

Horror, then, can help us get better at negotiating real dangers in the real world. But most horror probably does not have such functions. I would argue that most commercial horror stories and games function as forgettable and adaptively useless pleasure-via-displeasure technologies—"junk food of the mind"—that leave behind no more than an ephemeral buzz and perhaps a vague sense of dread. However, some works—the best ones—allow for emotional simulation and prompt us to reflect on important themes; they offer insight into the mechanics of social interactions and psychological processes and give us valuable vicarious experience with the terrifying. The second part of the book provides in-depth discussions of such works.

I have focused so far on the positive functions of horror, arguing that horror can serve adaptive functions via its stimulation of evolved psychological danger-management adaptations. But of course such stimulation can come at a cost, and sometimes the genre's effects are more deleterious than benevolent. Horror by definition aims at making us fearful and paranoid. As the horror critic Kim Newman has wryly pointed out, "the central thesis of horror in film and literature is that the world is a more frightening place than is generally assumed" (2011, 5). That is not necessarily a bad lesson, nor a wrong one, but it may come with psychological costs. Who hasn't

spent an uneasy night with the bedside lamp on because of a stupid horror film? Who hasn't double-checked under the bed because of stupid Stephen King? Horror may teach us coping skills and make us better adapted to a dangerous world in the long term, but it can also cripple us with anxiety and traumatize us. The negative psychological effects of horror are much better documented in the research literature than are the positive effects.

The communications scientist Joanne Cantor has spent decades investigating the "lingering effects of frightening media" (2004, 283). In a recent study, she collected and quantified 530 reports from individuals whom she had asked to write about fright reactions to media presentations. Strikingly, 91 percent of respondents described negative reactions to fictional media, rather than to news or documentary presentations. One respondent describes how he watched the horror film *Poltergeist* (Hooper 1982) at a young age and refused to sleep with an open closet door in the room for several months (Cantor 2004, 289). Many other respondents reported suffering from nightmares and other sleep disturbances for months after seeing the film (290). Another respondent, after watching *The Blair Witch Project*, described how she felt compelled to leave all the lights on in her apartment for several days after seeing the film. Several respondents say they refused to go camping or be in the woods after seeing that film, which depicts a group of young people lost and preyed upon in dark and strange woods (293).

In another study, Cantor and her colleague Becky Omdahl (1991) exposed children (kindergarten through sixth grade) to "scary media presentations" to see whether fictional presentations of realistic life-threatening events would influence the children's risk-assessment. They found that children who had been exposed to a "dramatized depiction of a deadly house fire from *Little House on the Prairie* increased their self-reports of worry about similar events in their own lives." Moreover, the children "were also less interested in learning to build a fire in a fireplace" than were children who had not seen the scene, or who had seen a nondramatic scene involving fire (Cantor 2002, 289)—they were more sensitized to this particular source of danger.

Most of the negative psychological consequences identified by Cantor and her colleagues are the result of premature exposure—that is, kids watching or reading stuff they shouldn't be watching or reading. Children find it much harder to disassociate frightening fictional agents from real-world dangers (Cantor and Oliver 1996) and to distinguish fiction from reality; moreover, in terms of neurobiology, they lack the prefrontal maturation necessary for keeping the primitive fear system on a leash. The prefrontal cortex reaches maturation only in a person's early twenties

and is one of the last brain structures to mature (Choudhury, Blakemore, and Charman 2006). That is why we have to remind children that "It's just ketchup" or "It's just acting"—to support prefrontal control of the primitive fear system. All the same, even grown-ups can experience sleep disruptions, hypervigilance, and increased anxiety as a result of exposure to horror fiction. As we get older, we find it more difficult to handle stress. This explains why the typical horror audience is composed of fairly young people (Weaver and Tamborini 1996)—not children, who are overwhelmed by the terrifying presence and apparent actuality of fear-inducing depictions, not the elderly, who are easily distressed, but the fairly young who are eager to test and push their own limits, and eager to achieve and exhibit mastery over their own reactions.

We know, then, that horror fiction can have short-term effects of making us more fearful and vigilant. But we know very little about the long-term psychological consequences of horror consumption. As I argued above, it is likely that sustained horror consumption can give audiences tools with which to handle negative emotions and threat situations. Horror fiction can be much more than escapist entertainment—like all fiction, horror can function as an instrument of psychological calibration, as a means of understanding and making sense of the world. In the next part of the book, I look more closely at selected, canonical works of modern American horror to investigate how those works are structured to fulfill such functions, in particular how the works are structured to target evolved psychological mechanisms. I analyze what the works mean and what they attempt to do; how they are designed to make audiences feel and think in certain ways; and how an evolutionary perspective gives us access to a deeper understanding of why these works are appealing and effective in engaging readers and viewers. First, however, I give a brief historical overview of American horror.

PART 2

*Evolutionary Perspectives
on American Horror*

CHAPTER 5

Monsters Everywhere

A Very Brief Overview of American Horror

The elements of horror can be found in all American cultural domains and across media—not just because of successful marketing or some peculiar resonance with a modern *Zeitgeist*, but because the elements of horror reflect and resonate profoundly with deep-seated evolved dispositions. They captivate people. People tell each other horror stories to delight and terrify, to instruct and to control: There are horror jokes and horror urban legends, sermons with horror content and imaginary monsters in kids' tales. People read horror literature and horror graphic novels, watch horror films and television shows, and play horror video games. They attend horror theater and visit haunted houses, and find pleasure in horror paintings, photography, and sculpture. The American artist Joshua Hoffine, for example, has built a career on producing elaborately staged horror photographs featuring such scenes as semihuman monsters lurking in basements and clawed hands reaching out from under children's beds, as in Figure 5.1. There's even horror music. Death-metal bands with such evocative names as Slayer, Death, and Cannibal Corpse appropriate the themes and iconography of horror. "Viral contagion unleashed upon the earth / Billions of infected dead soon rise / Stalking the living to feast upon the flesh," begins *Cannibal Corpse*'s apocalyptic "Kill Or Become" (2014).

Even advertising agencies occasionally use horror tropes humorously to catch consumers' attention. Audi's 2012 Superbowl ad depicted a group of partying vampires bursting into flame when they were

Figure 5.1: The elements of horror occur across media, from films and novels to music and photography. This photograph, "BED" by Joshua Hoffine, depicts a potent horror scenario. Somebody really ought to have checked under the bed before sending the girl off to sleep. Copyright Joshua Hoffine (2004).

accidentally hit by the glare of the LED headlights of an approaching car. "Daylight, now in the headlight," boasted the ad. Nike's 2000 television ad "Horror" depicted a scantily-clad young woman chased through woods by a masked, chainsaw-wielding maniac. The woman, wearing Nike running shoes, easily outran the killer, who had to stop and catch his breath. "Why sport?" asked the ad, and replied: "You'll live longer." The ad caused some controversy over alleged misogyny and otherwise disturbing content and was pulled from NBC, but the fact remains that nowadays, advertising agencies can safely assume universal familiarity with horror tropes such as vampires and slasher killers. Horror, the many-tentacled beast, reaches into all cultural domains. How did we get here, and when did it all begin? In the following, I provide a brief outline of the history of American horror.

The history of North American horror has to begin with the arrival of humans on that continent. So-called Paleoamericans surely told each other horrifying stories and shared terrifying imaginative scenarios tens of thousands of years ago. Elements of those stories and scenarios became absorbed in Native American tales and folklore, which in turn continue to inspire American horror fiction today. The Wendigo, for example—the beastly, cannibalistic monster of Algonquian legend—occurs in Stephen King's 1983 novel *Pet Sematary*, in a 2005 episode of the television series *Supernatural* (Nutter), and in the 2015 horror video game *Until Dawn* (Bowen, Reznick, and Fessenden). Yet a specifically American literary horror tradition doesn't begin to crystallize until the middle of the nineteenth century, with the emergence of dark American Romanticism—a branch of Romanticism concerned with evil, insanity, and the irrational, dominated by such writers as Edgar Allan Poe, Nathaniel Hawthorne, and Herman Melville (Docherty 1990, Jancovich 1994, Lloyd Smith 2004).

The Gothic novels produced by British writers in the late eighteenth and early nineteenth centuries were hugely popular with American readers, but few American writers embraced the form. Charles Brockden Brown is an exception. He published a string of Gothic novels around the turn of the century, most famously *Wieland* (1798) which depicted a religious fanatic turned axe-murderer, apparently under the sway of malign supernatural forces. Brockden Brown, like many of his British colleagues, invoked supernatural elements only to explain them away in the end. A few decades later, Washington Irving emerged as America's "first supernaturalist," according to the literary historian S. T. Joshi (2007, xi), and published such classics as the lighthearted horror story "The Legend of Sleepy Hollow" (1820). Edgar Allan Poe, however, was identified by H. P. Lovecraft as the first important horror writer in the American tradition, a truly original and widely influential fear artist. Few would dispute that assessment. Lovecraft praised Poe's "vision of the terror that stalks about and within us," as well as the capacity of that artistic vision to penetrate to "every festering horror in the gaily painted mockery called existence, and in the solemn masquerade called human thought and feelings" (1973, 54). Colorful, but not inaccurate. Many of Poe's writings, published in the 1830s and 1840s, adopt a pessimistic worldview and offer disturbing depictions of pathological mental and physical states, thus tapping into an evolved fear of death, disease, and insanity. Hawthorne likewise kept returning in his writings to negative emotions and sick minds, and found in New England's Puritan past a rich repository of guilt and human evil for Gothic stories such as *The House of the Seven Gables* (1982 [1851]), about a family haunted by their ancestors' wrongdoings. Poe's influence in particular continues to shape horror

fiction. Poe was joined, according to Joshi, in the "triumvirate of towering American supernaturalists" by Ambrose Bierce and H. P. Lovecraft. Bierce penned a range of horror short stories such as "The Damned Thing" (1898), about a man killed by an invisible monster. H. P. Lovecraft, active primarily in the 1920s and 1930s, is universally recognized as the most accomplished practitioner and critic of a peculiar brand of literary horror that he called "weird fiction."

The weird, in Lovecraft's conception, is distinct from "the literature of mere physical fear and the mundanely gruesome." The weird

> has something more than secret murder, bloody bones, or a sheeted form clanking chains according to rule. A certain atmosphere of breathless and unexplainable dread of outer, unknown forces must be present; and there must be a hint, expressed with a seriousness and portentousness becoming its subject, of that most terrible conception of the human brain—a malign and particular suspension or defeat of those fixed laws of Nature which are our only safeguard against the assaults of chaos and the daemons of unplumbed space. (1973, 15)

Lovecraft met with little public enthusiasm for his stories but secured a circle of devoted and dedicated readers and fellow writers, including such accomplished horror writers as August Derleth, Robert Bloch, and Fritz Leiber. He found a publication outlet in *Weird Tales*, established in 1923 and the first literary magazine dedicated to horror. He also greatly influenced subsequent horror writers such as Ray Bradbury, Richard Matheson, T. E. D. Klein, Caitlín R. Kiernan, Kelly Link, and Stephen King. Lovecraft's influence is clearly registered in John Carpenter's 1995 horror film *In the Mouth of Madness*, about cosmic forces of evil unraveling the fabric of reality. Likewise, the acclaimed TV show *True Detective* (Pizzolatto 2014–) is inspired by Lovecraft's imaginary universe. Even video game designers have found inspiration in Lovecraft's so-called Cthulhu Mythos, an elaborate, disturbing mythology involving ancient gods and terrible forces. The first-ever 3D survival horror game, *Alone in the Dark* (Raynal and Bonnel 1992), drew inspiration from Lovecraft, as do such critically praised games as *Alan Wake* (Ranki and Kasurinen 2010) and *Bloodborne* (Miyazaki 2015). Lovecraft evidently hit on an imaginatively and emotionally potent recipe with his weird fiction and his evocation of vast cosmic forces that prey on humans and dwarf them to insignificance. Little wonder that his creations continue to resonate with people. From a cosmic perspective, we truly are vulnerable and weird little apes with vastly inflated self-perceptions—perceptions inversely matched by our biased and blinkered understanding of the universe and its forces.

The twentieth century saw the proliferation of horror across media as technological innovations gave rise to new platforms. Broadcasting technology made possible the wireless transmission of radio horror plays (Hand 2006), and decreasing costs of printing gave rise to pulp and paperback novels, magazines, and comic books. The film medium, however, came to be the dominant platform for American horror for much of the century. This medium has advantages over the literary medium in that it capitalizes on the power of sound to evoke emotion (Hayward 2009); it requires a more modest time investment—an hour and a half or so; and it can be a social experience, more so than typical story reading, which is almost always a solitary pleasure. The collective enjoyment of a horror film is a particular pleasure of that medium. Emotions get amplified as their vocal expressions ripple over audiences in a dark theater (Shteynberg et al. 2014), audience screams reverberate inside and outside the skull, and audiences can share meta-emotions such as embarrassed mirth following a collective startle or vocal dread in anticipation of a scare.

Universal Studios' monster films from the 1930s ushered in a golden age of American horror cinema. Such films as *Dracula* (Browning 1931) and *Frankenstein* (Whale 1931) brought to life well-known and beloved literary monsters, yet Universal's brand of Gothic monster-horror—with a fondness for melodrama, romantic settings, and exotic monsters—began to lose steam by the middle of the century, but only temporarily. During the 1950s and 1960s, the old horror films reached a new generation of audiences as the films were picked up by broadcasting companies and shown on the now-ubiquitous television sets in homes across America. The magazine *Famous Monsters of Filmland*, established in 1958, fueled a growing interest in horror by providing readers with publicity stills from horror films and feature articles on horror actors and monsters.

The 1950s are often seen as a particularly fertile decade for American horror. The decade saw horror comics rise to controversial prominence in American popular culture. EC Comics, for example, produced the iconic and often quite gory series *Tales from the Crypt* from 1950 until 1955, when public backlash against allegedly immoral and subversive comics resulted in self-imposed censorship and the death of many comics series (Hajdu 2008). These comics were marketed to and primarily read by adolescents, and some feared that the violent and disturbing content of the comics had a destructive effect on impressionable minds. At the same time, writers such as Richard Matheson, Ray Bradbury, Robert Bloch, and Jack Finney— author of the 1955 sci-fi/horror novel *The Body Snatchers*—reinvigorated literary horror with stories set in the contemporary, recognizable United States and featuring home-bred monsters, such as Finney's doppelgänger

pod-people, to replace the exotic terrors popular in earlier horror (Jancovich 1996, King 1983a). These and other writers engaged intelligently with horror's legacy, developing or subverting well-established genre conventions and tropes in an attempt to make them relevant to a new generation of horror fans, thus paving the way for the groundbreaking horror/ sci-fi television series *The Twilight Zone* (Serling 1959–1964). Matheson, for instance, fused the ancient figure of the vampire with a culture-specific anxiety over apocalyptic war and used those elements as a springboard for a profoundly existentialist story in *I Am Legend* (1954). Shirley Jackson appropriated the old Gothic trope of the haunted house in *The Haunting of Hill House* (2006 [1959]), poking a little fun at Gothic conventions while using them to delve deeply into dark pockets of human psychology in her depiction of a young, insecure woman's descent into suicidal madness, possibly fueled by a malign supernatural force. And Robert Bloch provided the eponymous literary source (1959) for Alfred Hitchcock's watershed *Psycho* (1960), which challenged Hollywood conventions by killing off its heroine in a fairly graphic and disturbing manner only thirty minutes or so into the movie. Moreover, *Psycho* offered audiences a monster—Norman Bates— that emerged from the depths of the human mind, not Transylvania or some crumbling Italian castle (Hutchings 2004, Jancovich 1994).

A few highly successful horror novels—and their artistically accomplished and profitable film adaptations—kicked off a horror boom that lasted into the 1980s, most notably Ira Levin's 1967 novel *Rosemary's Baby*, adapted by Roman Polanski in 1968, and William Peter Blatty's 1971 novel *The Exorcist*, adapted by William Friedkin in 1973. The popularity of these works and a few others, coupled with the eruption of Stephen King onto the American horror scene in 1974, paved the way for a massive output of films and novels (D'Ammassa 2006, Hantke 2016). Horror, as Joshi observes, "suddenly became a blockbuster genre" (2007, xix). In horror film history, the 1970s are best known for the emergence of the so-called "new horror film" (Hutchings 2004, Platts 2014a), a particularly bleak and politically involved subgenre inaugurated by Romero's *Night of the Living Dead* (1968) and epitomized by such shocking pictures as *The Texas Chain Saw Massacre* (Hooper 1974) and *Last House on the Left* (Craven 1972), which depict hapless, flawed protagonists at the homicidal mercy of depraved killers. In the midst of cinematic despair and borderline nihilism, however, the author Anne Rice introduced a romantic spin on a horror archetype with stories of godlike vampires struggling to embrace their predatory nature, most famously in the 1976 novel *Interview with the Vampire*. Rice's novel anticipated the paranormal romances so popular in the 1990s and 2000s— romantic stories featuring (usually) female protagonists falling in love with

well-behaved but titillatingly dangerous monsters, typically vampires. L. J. Smith's *Night World* series (1996–1998) and *Vampire Diaries* series (1991–2011), as well as Stephenie Meyer's startlingly derivative mega-bestseller *Twilight* series (2005–2008), feature female protagonists facing tough choices in the mating domain—prototypically, having to choose between attractive vampire and/or werewolf males (Clasen 2012a). The horror element is muted in paranormal romance, used chiefly as a source of Byronic frisson in the depiction of alluring, fanged, and/or furry gentlemen.

The late-1970s also saw the rise of the slasher film (Nowell 2011a). John Carpenter's *Halloween* (1978), made on a tiny budget and depicting young people stalked and murdered by a masked maniac in a quiet, suburban neighborhood, became a massive hit and was followed by a wave of derivative films such as *Friday the 13th* (Cunningham 1980) (and its ten or so sequels) that also featured a masked killer and youthful victims (Rockoff 2002). These films found a large audience, particularly among teenagers (Nowell 2011a), but the cycle wound down a few years into the 1980s as the market became saturated and audiences habituated to this particular formula. Meanwhile, literary horror was experiencing a golden age of its own (Hantke 2016). American publishing firms churned out horror paperbacks with gleaming black covers and often lurid content. Established horror writers such as Stephen King and Peter Straub were joined by talented newcomers like Robert R. McCammon, Dean Koontz, and F. Paul Wilson, as well as by ephemeral hacks. The release of now-classic horror anthologies such as *Dark Forces* (McCauley 1980) and *Prime Evil* (Winter 1988) indicated that literary horror had reached critical mass and warranted high-profile, high-quality showcase publications. The horror film fan magazine *Fangoria* hit the streets in 1979; nine years later, the literary horror magazine *Cemetery Dance* was established. Both publications emerged in the midst of the American horror boom, and both are still running. As another indication of the financial viability and cultural salience of literary horror in America, a group of horror writers decided in 1985 to found the Horror Writers Association, an organization established to promote the interests of horror writers (Wiater 1996). The association continues to this day to award the prestigious Bram Stoker Awards for superior achievement in horror. In the early 1990s, however, the market for horror became saturated and book publications as well as film releases wound down (D'Ammassa 2006, Winter 1998).

The horror genre waxes and wanes in popularity, but because it is uniquely suited for satisfying evolved desires, it is never on the wane for long. Many of the best American horror writers continued to produce quality work through the 1990s. Several new writers, including an

increasing number of female horror writers (Jancovich 1994, 37–42), managed to break into a literary market now somewhat biased against the genre. Moreover, the 1990s gave rise to a new breed of self-conscious, playful slasher film, most notably with the release of *Scream* (Craven) in 1996 (Wee 2005). This cycle of postmodern slasher films is ongoing, with such films as *Cabin in the Woods* (Goddard 2012) and *It Follows* (Mitchell 2014) finding new ways of playing with genre conventions while horrifying audiences. The postmodern slasher film assumes familiarity with genre conventions on the part of the audience and pokes fun at those conventions while retaining the slasher film's focus on frightening scenarios of conspecific predation. *The Final Girls* (Strauss-Schulson 2015), for example, depicts a group of youths who are sucked into an eighties-style slasher film called *Camp Bloodbath* (see Figure 5.2). In this film-within-the-film, a group of fun-loving summer camp counselors are preyed on by a shady, masked, machete-wielding maniac. Fortunately for the 21st-century-kids, they are able to use their knowledge of slasher film conventions to survive, more or less—don't have sex, stick with the Final Girl, and so on. Meanwhile, filmmakers kept looking for new ways of terrifying media-savvy, seen-it-all audiences. One such way was the found-footage horror film, a type of film that purported to be documentary and was filmed using hand-held cameras and with minimal use of nondiegetic music. *The Blair Witch Project*

Figure 5.2: Horror evolves to keep audiences interested. When the market for slasher films had become saturated, a new breed of genre-savvy, ironic slashers revived the subgenre. In *The Final Girls* (Strauss-Schulson 2015), a group of 21st-century kids are sucked into an eighties-style slasher film—depicted is slasher expert Duncan's attempt to grab a selfie with the slasher villain in the background. Postmodern slashers give a new spin on old formulas, thus ensuring audience engagement.

(Sánchez and Myrick 1999) brought the subgenre to prominence, and sub-sequent films such as *Paranormal Activity* (Peli 2009) refined the formula, cleverly turning budgetary constraints into a forte by capitalizing on a home-video authenticity aesthetic. Horror films had claimed to be "based on real events" for decades—*Psycho* and *The Texas Chain saw Massacre* were both allegedly inspired by the crimes of mass murderer Ed Gein—but now a new wave of horror films *looked* like something a neighbor's kid might have shot on a cheap camcorder. The authentic-looking, unstylized horror scenarios depicted in these films were effective because they mimicked the visual aesthetic of amateur filmmaking and the style of emergency news reporting familiar to—and trusted as mimetic by—contemporary audi-ences (Heller-Nicholas 2014).

The 2000s also saw the controversial eruption of so-called "torture porn" horror films into the mainstream (Jones 2013). Nonsupernatural horror films depicting gore and dismemberment in nauseating detail and vividness were nothing new; exploitation films and splatter films had been around for decades (Arnzen 1994). But well-produced torture porn flicks such as Eli Roth's 2005 film *Hostel*, which depicts a trio of hedonistic American backpackers kidnapped in Eastern Europe and sold to wealthy patrons as recreational prey, shocked some critics and audiences with its unflinching depiction of bodily assault and extreme physical suffering. Nonetheless, the film achieved mainstream distribution. To horror fans who felt they'd seen it all, torture porn delivered new levels of visual spectacle and vis-ceral revulsion. Another major horror trend of the 2000s was zombies. Zombies hit cinema blockbuster payload, made it big on the small screen, and even enjoyed some literary success with bestseller novels such as Max Brooks's *World War Z* (2006). Robert Kirkman and Tony Moore's series of graphic novels *The Walking Dead* (2003–) was made into the hugely popular television series *The Walking Dead* (Darabont 2010–)—the "most watched show in cable television history" (Platts 2014b, 294)—and even inspired an eponymous video game (Vanaman et al. 2012) which allowed the players to become protagonists in a zombie-infected universe. This postapocalyptic zombiecentric franchise became a massively lucrative transmedia phenom-enon, showcasing the continued power of the zombie—an utterly unreal-istic horror monster—to engage psychological defense mechanisms that evolved to protect us from predation and contagion (Clasen 2012d).

Horror video games have become increasingly popular and are encroach-ing on film as the dominant medium for the genre, presumably because games foster immersion more effectively than traditional noninteractive narrative media. Horror video games give players actual agency in worlds teeming with danger, which makes the medium particularly well-suited

for providing horror-happy gamers with high-intensity emotional stimulation (Perron 2009). Horror finds its purest digital expression in the subgenre known as *survival horror*, a type of game that pits a highly vulnerable, unarmed player against dangerous computer-controlled agents in usually labyrinthine virtual worlds. The term was introduced with the Japanese horror game *Resident Evil* in 1996 (Mikami), but the form predates the term, going back at least to the 1982 game *Haunted House* (Andreasen) for the Atari 2600 console (Fahs 2009). In this game, the player has to navigate the dark interior of a haunted house in pursuit of an urn and avoid contact with a spider, a bat, and a ghost—not unlike later games like *Slender: The Eight Pages* (Hadley 2012), which puts the player in a dark wood, equipped with a flashlight, in pursuit of eight pieces of paper, and pursued by a malicious agent which gets closer each time the player finds a piece of paper. These horror games target the evolved fear of predation and the evolved fear of isolation by transporting the player into a hostile and deserted world—deserted but for the monsters (Clasen and Kjeldgaard-Christiansen 2016). Other horror games, such as the 2015 bestseller *Until Dawn*, have richer narratives and much more advanced gameplay, and still others such as *Left 4 Dead* (Booth 2008) combine the thrill of fear with the thrill of shooting up bad guys with automatic weapons (see Figure 5.3),

Figure 5.3: Shooting up zombies in the action horror video game *Left 4 Dead* (Booth 2008). Horror video games allow players to interact with the virtual world, producing high levels of immersion and emotional engagement. Survival horror games usually pit the defenseless player against terrible monsters in dark and unknown surroundings, whereas action horror games allow players to fight back.

but they revolve around the same primal situation: Situating the player as haunted prey in a threatening and unknown game world. As consoles and personal computers have increased in processing power, and game designers have honed their craft, horror video games have become ever-more immersive and effective, accomplished in terms of graphic realism, narrative complexity, and immersive gameplay. Virtual reality headsets for home use—head-mounted displays streaming visual and auditory feeds and responding to head movement with an instantaneous adjustment of in-game perspective—are now readily available and provide an extremely effective illusion of player presence in a virtual world of horror. Such technology allows players to feel that they're actively living the horror, rather than being passive—if emotionally invested—observers. Similarly, the increasingly popular haunted attractions, or *haunts*, revisited in the last part of this book, offer consumers the experience of becoming the protagonist in a horror story unfolding in real time and space, often targeting multiple senses with disturbing sights, sounds, odors, and even bodily contact with actors impersonating zombies or chainsaw killers. The thirst for horror runs deep in human nature, and the diffusion of horror across media platforms and into various cultural domains makes it easier than ever before for people to slake that peculiar thirst.

As this brief and selective overview of the history of American horror suggests, horror changes over time—in response to cultural change, technological change, changes in production conditions (for example in censorship practice and industry structure), and as the result of a novelty-habituation dialectic rooted in human psychology (Grodal 2009). New sub-genres and conventions emerge in response to audience habituation: When a dominant kind of horror loses its ability to disturb audiences, creative and commercial artists will attempt to come up with fresh ways of meeting the genre's affective aim. Horror changes, then, but not arbitrarily and endlessly. As I argued in previous chapters, the genre varies within a possibility space constrained by human biology. Consider the Japanese horror films that became popular with American audiences in the late 1990s and early 2000s, beginning with *Ringu* (Nakata) from 1998 (Balmain 2008). The stories told by these films are easily decipherable for Western audiences because the films follow the formal conventions of classical Hollywood cinema: They are edited for continuity and follow Hollywood conventions of cinematography, sound, and mise-en-scène. Moreover, they feature horror elements familiar to Western audiences such as evil ghosts and curses. All the same, the films had a peculiar exotic and unsettling quality to most American audiences. The mythologies were unfamiliar, the language undecipherable to most, and the pacing slightly different from

homegrown films—these films were easy to decode but hard to predict, all the more effectively terrifying American viewers. Thus, the films sit within the possibility space of effective horror, but slightly adjacent to traditional Hollywood horror films. All effective horror, in whatever medium and from whatever culture, works by targeting universal psychological mechanisms. In the following chapters, I look more closely at a selection of well-known horror works and offer interpretative critiques that consider the ways in which those works managed to resonate with a large number of people.

Vampire Apocalypse

I Am Legend *(1954)*

Richard Matheson's *I Am Legend* (henceforth *IAL*), first published in 1954, is set in Los Angeles in the near future (1975–1979) and depicts Robert Neville's struggles to survive and make sense of a total outbreak of vampirism (Matheson 2006). Except for Neville, everybody seems to have been infected with a strange germ that eventually turns them into predatory vampires. Neville, who lost his daughter and wife to the germ but who is himself immune to it, fills his days with fortifying his house against the nocturnal vampire attacks, getting drunk, and killing comatose infected individuals as well as undead vampires. After several years on his own, Neville comes across a fellow survivor, Ruth. She turns out to be infected with the vampire germ and is a spy sent out by a small society of individuals who are keeping the infection subdued with a drug. Ruth's people are terrified of Neville, who has killed countless of their peers, and eventually capture Neville and sentence him to death for his crimes against the new humanity. Ruth takes pity on Neville and smuggles him suicide pills so he won't have to face public execution. The novel ends with Neville's death upon his realization that in the new society, he is the antagonist, the terrifying legend.

Richard Matheson, born in 1926, produced a staggering amount of fiction—novels, short stories, and screenplays—up until his death in 2013. Although Matheson wrote all kinds of speculative fiction, he is famous mainly for his horror fiction and he inspired generations of horror writers. The horror critic Douglas E. Winter said that Matheson was "perhaps

the most influential writer of horror fiction of his generation" (1990, 37), and that's a writing generation that includes such luminaries as *Psycho*-author Robert Bloch, horror/fantasy/science fiction-writer Ray Bradbury, and *Twilight Zone*-creator Rod Serling. Matheson is widely admired for his ability to create psychologically complex and realistic characters; for blowing the Gothic dust off horror and setting his stories in recognizable, contemporary small-town USA (Jancovich 1996, Murphy 2009); and for his minimalist style—Matheson has been called "the Hemingway of horror" (Publishers Weekly 2002). Of all Matheson's famous stories, *IAL* remains his best known work. In 2012, the Horror Writers Association gave the special Bram Stoker Vampire Novel of the Century Award to *IAL*. The novel has been adapted for the big screen three times: As *The Last Man on Earth* in 1964 (Ragona and Salkow), as *The Omega Man* in 1971 (Sagal), and as *I Am Legend* in 2007 (Lawrence). It has directly and indirectly inspired countless other media products, including George A. Romero's *Night of the Living Dead* (1968), which appropriated Matheson's idea of a monster apocalypse. As of 2011, the novel had been published in at least sixty-four editions and fourteen international translations (Browning 2011), including translations into Chinese, Russian, and Korean.

The novel's continued and cross-cultural success suggests that it taps powerfully into human motives and anxieties that transcend the time and place of its production (Clasen 2010b). *IAL* may be, as Bernice Murphy asserts, "very much a novel of its time" (2009, 29), but the story's lasting power to engage readers comes from the way Matheson taps into basic human anxieties in his depiction of a man's struggles not only to survive and to find fellow survivors after the apocalypse, but to find *meaning* in an antagonistic world. The need for meaning and purpose is a human universal, a byproduct of the evolution of high intelligence which gives us self-awareness and reveals to us the world in all its complexity (Wilson 1998). Why are we here? What is the meaning of events, the world, of existence? Historically, religions and ideologies have given people meaning and purpose, but to many people in the modern world, disenchanted of divine purpose and totalizing ideologies, the lack and hence need of meaning becomes acute. Matheson took an old horror archetype, the vampire, and rationalized it for a modern audience, using the figure not just for thrills and kicks, but to say something true and important about the human condition. The vampire apocalypse robs Neville of those structures that give his life meaning—family, friends, a job—and the novel gets its peculiar power from its evocative depiction of Neville's descent into despair; his conditional acceptance of a semihuman, mechanical existence; and eventually the peace with which he meets his death as he realizes that there

can be no belonging for him, no place in the new vampire society, only as a posthumous legend.

Literary critics have largely ignored the way that *IAL* resonates with evolved dispositions, reading it instead as a parable of racial prejudice (Murphy 2009, Patterson 2005), repressed homosexuality (Khader 2013), misogyny (Murphy 2009), masculinity in crisis (Jancovich 1996), and the Passion of Christ (Ng 2015). Many critics have registered the novel's 1950s ambience and pointed to its engagement with themes that seem specific to mid-century America. Mark Jancovich identifies conformity, and a profound ambivalence toward conformity, as a chief concern in 1950s American horror fiction (1996). Neville certainly is an outsider, literally the last man alive, and eventually completely excluded even from the new vampire society. The themes of conformity and alienation may have had peculiar resonance in the 1950s, but their roots go straight into human nature and the human need to be part of meaningful social networks. Bernice Murphy argues that Matheson's story embodies specifically *suburban* Cold War anxieties (2009, 29). Neville's house—his shelter, fortified against attack from the forces of evil—is a suggestive parallel to the suburban bomb shelters constructed in the fifties in anticipation of Soviet nuclear aggression. Likewise, Andrew Hock Soon Ng says that the "novel's chief concern is the looming fear of nuclear conflict and its aftermath" (2015, 92). It is an overstatement, but the novel does tap into a fear of apocalyptic doom that was particularly salient in the Cold War. The vampire outbreak is apocalyptic in scale, and the novel vaguely links the outbreak of vampirism to bombings and radiation (Matheson 2006, 45).

These critics fail to acknowledge that the figure of the vampire gains its power—its resonance—primarily as an unnatural predator, and only secondarily as a metaphor. Patterson (2005) and Murphy (2009), for example, claim that *IAL* is a story of racial antagonism, that the vampires signify African Americans. Khader thinks the story is about Neville's repressed homosexuality, and that the vampires signify queers (2013). Khader is compelled to wheel out the Freudian *deus ex machina* of symbolic displacement to build his case: Blood is not blood, it's semen; a house is not a house, it's a closet, and so on. The strategy is epistemologically suspect and undermines Khader's argument. Patterson and Murphy base their interpretations largely on the connotative potentials of the adjective "black." But then, blackness or darkness need not *ipso facto* be invested with racial significance; they have been symbolically associated with evil probably since our hominin ancestors' lack of night vision and increased vulnerability at night coincided with the emergence of symbolic thought. Matheson has Neville use the word "black" to describe the vampires to suggest his perception of

them as evil, but he also describes them as "white-faced" (10). The peculiar urge to reduce vampires to subtext and metaphor that have such narrowly topical social referents makes us overlook the vampire's literal, visceral presence as a dangerous, predatory, counterintuitive, and contagious agent. It is a monster well-engineered to capture and hold our attention, given our evolutionary history as a prey species susceptible to lethal infection (Clasen 2012a). Matheson's vampires are themselves victims of disease, but they are still dangerously strong and predatory. In one scene early in the novel, Neville is attacked by a vampire outside his house. Neville "felt the cold, powerful hands clamp on his throat and smelled the fetid breath clouding over his face. The . . . white-fanged mouth went darting down at Robert Neville's throat" (34). The raw power of this scene comes from the vivid description of a predatory attack on our protagonist—it's a dangerous monster attacking Neville, not a metaphor.

The vampires are crucial to *IAL*. Matheson tapped into a rich literary and cinematic heritage when he adapted the vampire as the primary vehicle of horror in *IAL*, but his rationalized vampires are conceptually different from the kind of supernatural fictional vampires that were popular when Matheson was writing. Undead bloodsuckers, of course, had figured prominently in folklore and folk superstition for millennia when they made their transition from folk belief to popular fiction at the end of the eighteenth century (Barber 2010). The most famous vampire novel of all time, *Dracula* (Stoker 1997 [1897]), brought together vampire folklore and ideas from earlier vampire literature and added a healthy dose of imagination in its influential depiction of Count Dracula and his progeny (Clasen 2012a). In contrast to Stoker's supernatural creature of evil, Matheson's vampires are the result of a communicable disease. The root of the vampire epidemic is a "bacillus" which is "a facultative saprophyte . . . Inside the [victim's body] it is anaerobic and sets up a symbiosis with the system. The vampire feeds it fresh blood, the bacteria provides the energy so the vampire can get more fresh blood." This is how Matheson has Neville explain the efficacy of staking the vampire: "When air enters [the body] the situation changes instantaneously. The germ becomes aerobic and, instead of being symbiotic, it becomes virulently parasitic . . . It eats the host" (2006, 134). This is a far cry from Stoker's demonic monster. Matheson's reinterpretation of the vampire as a natural threat, a nonsupernatural monster, serves two distinct purposes. First, it reflects the cumulative success of natural science as a global explanatory paradigm and a large-scale "shift in emphasis" in 1950s American horror away from Gothic conventions to a "preoccupation with the modern world," including a rationalization of monsters (Jancovich 1996, 2). Second, the rationalization of the vampire subserves

Matheson's thematic focus on the search for meaning in a secular world. Neville is an atheist, desperately looking for a reason to carry on when all meaning seems lost; had Matheson's vampires been supernatural, they would have subverted the secular cosmos of the novel.

IAL is structured to foster reader empathy with Neville. The scholar Louise Nuttall has trawled through online reader reviews of the novel and finds that readers consistently report experiencing a good deal of empathy with Neville (2015). The novel is told using a third-person perspective; it is focalized with Neville through whose eyes we see story events. We peer into his mind, we register his emotions and reactions, we follow his reasoning and see things the way he sees them. We never know more than he does; in fact, we know a good deal less. Indeed, crucial story information is strategically withheld by Matheson as a means of building and sustaining suspense. We only gradually learn about Neville's backstory, about his life before the vampire apocalypse, about the first days of the outbreak, and about the traumatic loss of his family. To further sustain reader empathy, Matheson provides vivid and detailed descriptions of Neville's emotional and physiological states. In the following exemplary passage, Neville has been out to visit his wife's grave. As it happens, his watch has stopped, he has lost track of time, he is away from the safety of his house, and vampires are chasing him. One undead has lacerated his cheek and he is trying to escape in his car. "Robert Neville's heart was pounding so heavily now it seemed as if it would drive through his chest walls. Breath shuddered in him and his flesh felt numb and cold. He could feel the trickle of blood on his cheek, but no pain. Hastily he wiped it off with one shaking hand" (33–34). Matheson makes it easy for the reader to mirror Neville's state.

Robert Neville's situation is almost unbearable. He's the last man on earth, utterly alone and under constant assault from the vampires—caught simultaneously in the desert of isolation and the jungle of predation (Clasen 2010b). In the beginning of the story, especially, Matheson lingers on Neville's feeling of deep, devastating loneliness. When Neville visits his wife's grave, he wishes he could believe in an afterlife, die, and join her. But he doesn't believe, and she is dead while he is alive, "heart beating senselessly, veins running without point, bones and muscles and tissue all alive and functioning with no purpose at all" (26). Matheson suggests that there is no point in being alive alone, that life in solitude is a "barren, cheerless trial" (85). By foregrounding the pain of Neville's isolation, Matheson is depicting and evoking a powerful, basic human motive, the motive for meaningful social connection. Humans evolved to be hypersocial, to actively crave sociality. Being isolated makes us sick (Cacioppo and Patrick 2008). As recent research has documented, our brains evolved to be as big

as they are because we need big brains to successfully navigate the kinds of complex social environments that humans naturally create—a good deal of neocortical expansion, in other words, was directly driven by social selection pressures (Gazzaniga 2008). In our evolutionary past, humans grouped together for cooperation in fending off predators and foraging for food. Group life posed new cognitive challenges (keeping track of alliances and social exchanges, for example), which selected for brain expansion and the evolution of cognitive mechanisms necessary for life in complex groups (Dunbar and Shultz 2007). The flip side of our gregarious nature is the pain of social exclusion and the horror of total isolation. Because the horror of total isolation is such a basic human motive, all normally-developed humans can relate to it, just as we intuitively understand the pain of starvation and the urgency of sexual desire. Matheson makes this horror vividly present to the reader; he invites us to take Neville's perspective and share his pain and frustration. We are encouraged to root for Neville when he finally, about halfway through the story, comes across another uninfected, living being—a dog.

When Neville sees the dog, he has not spoken to another human being in ten months. He tries to win the dog's affections. The dog, terrified, runs away; Neville tries to find it. "At last he stumbled home, his face a mask of hopeless dejection. To come across a living being, after all this time to find a companion, and then to lose it. Even if it was only a dog. *Only* a dog? To Robert Neville that dog was the peak of a planet's evolution" (84). The dog sequence is significant because it demonstrates to the reader the depth of Neville's thirst for companionship. It also allows us to follow Neville's further descent into despair when the dog eventually dies of the infection. "The dog looked up at him with its dulled, sick eyes and then its tongue faltered out and licked roughly and moistly across the palm of Neville's hand. Something broke in Neville's throat. He sat there silently while tears ran slowly down his cheeks. In a week the dog was dead" (100). The functions of the dog sequence, which takes up a good chunk of the short novel (more than 10 percent of its pages), are to deepen our sympathy for Neville in his plight and to implicitly suggest a causal factor in Neville's gradual dehumanization.

Neville lives through the vampire apocalypse in constant search of meaning. He finds some meaning by experimentally pursuing the cause of vampirism (conducting experiments on vampires, reading up on physiology, looking at vampire blood in a microscope), but still he repeatedly asks himself why he goes on—always there is "the hope that someday he would find someone like himself" (91). When the dog dies, hope dies with it. "In a world of monotonous horror there could be no salvation in wild

dreaming" (101). Neville immerses himself in his scientific investigation, leading a life "based on day-to-day survival marked by neither heights of joy nor depths of despair" (110). It is a semi-mechanical life, fueled only by Neville's scientific curiosity. After years of living this life, Neville sees Ruth, one of the new vampires disguised to appear uninfected. She runs away from him, frightened. Neville chases her and catches her, asking her what she's afraid of. In one of a few instances where the point-of-view is external to Neville, we are told that he "didn't realize that his voice was devoid of warmth, that it was the harsh, sterile voice of a man who had lost all touch with humanity" (114). Neville's solitary existence has dehumanized him. Matheson is again affirming that true meaning—the key to a full life—lies in sociality, in bonding (romantic or otherwise). As Neville is searching for physiology books in a dusty, abandoned library, he imagines a maiden librarian setting the place in order before the apocalypse. "To die, he thought, never knowing the fierce joy and attendant comfort of a loved one's embrace. To sink into that hideous coma, to sink then into death and, perhaps, return to sterile, awful wanderings. All without knowing what it was to love and be loved. That was a tragedy more terrible than becoming a vampire" (68).

In the end, Neville is captured by the new vampires and scheduled for public execution. To the new vampires, Neville is the villain, the antagonist, and he accepts that. He is the last of his kind, not only utterly alienated but, in the eyes of the new vampires, "anathema and black terror to be destroyed" (161). The world is "theirs and no longer his" (153). But the reader is not invited to suddenly throw all empathy and sympathy for Neville to the wind, as some critics have suggested. Patterson, for instance, portrays Neville as a racist white male whose conservative battle is "doomed to failure" (2005, 26). Yet the new vampire society is represented as brutal and unattractive. When "dark-suited" vampires arrive at Neville's house at night and begin butchering the undead vampires congregated there, Neville is taken aback by their methodical violence. "Is this the new society? . . . Did they have to do it like this, with such a black and brutal slaughtering? . . . They were more like gangsters than men forced into a situation. There were looks of vicious triumph on their faces" (149). In contrast, Neville chooses suicide in the end, rather than public execution: "So long as the end did not come with violence, so long as it did not have to be a butchery before their eyes . . . " (161). He urges Ruth not to let the new society, in which she is a ranking officer, get "too brutal. Too heartless" (159). Neville is flawed, certainly, but he is the protagonist and his humane values are contrasted to the values of the new society. He is no monster. As Matheson himself said in an interview, "Neville was not a monster to me.

He was trying to survive, no more" (Brown and Scoleri 2001). I imagine most readers share Matheson's perspective.

The tragic ending of the novel has a curiously uplifting, awe-inspiring quality. There is a shift in stylistic register in the last chapter, from the tough-minded, no-nonsense style of the preceding chapters to a "somber" (Ng 2015, 106), grandiose tone, one that imbues Neville's death with honorable significance. We have followed Neville's descent from hunted, frustrated prey in search of meaning to a dehumanized, semi-mechanical survivor—but now, in the end, in *death*, he is elevated to larger-than-life stature, an awe-inspiring figure. The end is inevitable because Neville's search for meaning has hit a brick wall. There can be no fitting-in, no purpose for him, except as a posthumous story, a legend. But at least he goes down with his values intact, re-humanized as he is in the very end. The ending is bleak, but also satisfying: Neville lost the struggle for survival, he failed to find anybody with whom to connect—but he fought to the end, and at least his legacy lives on.

Matheson appropriated and adapted the ancient figure of the vampire in *IAL* partly for the inherent fascination of the figure, but more pertinently to use it as a dramatic catalyst in his exploration of one man's psychological development in response to an intensely hostile world robbed of meaning. *IAL* registers several widespread anxieties characteristic of the American 1950s, such as a fear of conformity (symbolized in the brainless vampires crowding together in suburbia, preying on the outsider); and, more abstractly, a fear of the consequences of apocalyptic war (symbolized in the narrative premise as well as in the vague talk of bombings and mutated mosquitoes spreading the vampire germ). But the themes of the novel transcend the context of its production and initial reception—they are universally engaging because they are rooted in universal human dispositions, namely the fear of death, the horror of isolation, and the need for meaning. *IAL*, then, is a compelling meditation on a man's search for meaning in an indifferent, even hostile universe. A sensitive reader absorbed by Matheson's novel comes away with an emotionally rich experience and a deeper understanding of basic human motives and the psychological consequences of their suppression.

Trust No One

Rosemary's Baby *(1967)*

An attractive young couple, Rosemary and Guy Woodhouse, get their dream home in the old Bramford apartment building in Manhattan. Rosemary is eager to have children, but Guy wants to wait. He is a moderately successful actor with big ambitions for himself. Rosemary's friend Hutch, an elderly bachelor, warns them against the Bramford, which has an unsavory history—cannibals and witches have lived there, including Adrian Marcato, who in the 1890s claimed to have summoned Satan himself in the building. The Woodhouses disregard Hutch's warnings and are soon befriended by their new elderly neighbors, the colorful, childless Castevets. Rosemary finds them nosy and meddlesome, but Guy is intrigued by Roman Castevet and his stories of the theater world. Guy soon gets his big acting break when he is offered a big role that was held by a rival actor, who mysteriously and suddenly has gone blind. Guy then promises Rosemary a baby. Rosemary, drunk, falls asleep, dreaming that she is carried into the Castevets' apartment and taken forcefully by a demonic Guy while a coven of witches watch. She becomes pregnant, but her pregnancy is difficult and painful. Rosemary wastes away and becomes secluded from her friends because of the constant pain, but her doctor, Abe Sapirstein— recommended by the Castevets—reassures her. Rosemary becomes suspicious of Sapirstein. Hutch calls, says he has important information and sets up a meeting with Rosemary. Before they can meet, he falls into a coma, mysteriously and suddenly. Hutch manages to send Rosemary a book on witchcraft when he becomes lucid just before his death. Rosemary surmises

that Roman Castevet is the son of Adrian Marcato and that the Castevets are Satanists. They have made a deal with her husband, who gets worldly success in exchange for their baby—the baby is to be used in a sacrificial ritual. Rosemary goes to another doctor with her suspicions, but figuring that she is psychotic, the doctor calls Sapirstein. Rosemary is subdued and drugged, gives birth, and is told that the baby was stillborn. However, she discovers that the baby is held in the Castevets' apartment. When she goes to claim it, she discovers the truth: She was impregnated by Satan himself, and her son, Andy, may be the Antichrist—pure evil, in other words. She wants to kill the demon child, but is then overwhelmed by affection for the infant despite his horns, tail, and strange yellow eyes (Levin 1997a).

Ira Levin (1929–2007) was a successful playwright and novelist, celebrated for his tightly constructed, suspenseful plots, his economy of style, and the verisimilitude with which he managed to invest fantastical stories of conspiracies and occultism. *Rosemary's Baby*—henceforth *RB*—remains his best-known work, rivaled only, perhaps, by his 1972 novel *The Stepford Wives* (Levin 2002), the satirical tale of a patriarchal conspiracy to kill all wives in Stepford and replace them with complacent, obedient robots. Published in 1967, *RB* was an instant bestseller and "became one of the most widely read and talked-about books of the year" (Skal 2001, 292). Its fame was boosted by Roman Polanski's critically and commercially successful 1968 film version, which was highly faithful to the novel. Although the story of Rosemary's ordeal is implausible, it struck a chord with readers and viewers and swiftly entered the pop-cultural myth pool. The basic plot—a woman is tricked into bearing Satan's offspring when her ruthlessly ambitious husband strikes a deal with a coven of black magic-wielding witches—is familiar even to people who have neither read the book nor seen the film. The story provides a compelling evocation of the common fear that modern life gives little defense against mostly subdued but pervasive forces of evil, forces that lurk always beneath the veneer of urban modernity and behind friendly smiles. In *RB*, a lapse in judgment makes the heroine vulnerable to those forces. Evil creeps ever closer to her—it's in the apartment next door, behind her bedroom wall; then next to her, in bed; and finally, monstrously, within her own body. Readers fear for Rosemary and with her as she gradually realizes that her happy life is infested with evil and that her bright world teems with danger. She faces danger in the social realm—she is betrayed and exploited by people she trusts—and in the reproductive realm—her husband turns her deep and frustrated desire to have children against her, uses it as a fulcrum in his exploitative betrayal of her—and, finally, from a supernatural force the reality of which she doubts until the very end. Absolute, metaphysical evil is real, and it works through willing

human agents motivated by selfish, antisocial impulses. Levin thus suggests an affinity between metaphysical evil and antisocial human motives. The devil-worshippers' hunger for power and Guy's selfish ambition and psychopathic disregard for others' suffering become the conduit through which Satan's son—the agent of supreme, transcendent evil—finds deliverance on earth.

Levin managed to capture the imaginations of millions of readers in his depiction of a grotesquely evil, occult conspiracy against a vulnerable heroine in a modern setting. The main characters, Rosemary and Guy, are young and fashionable liberals. They are friendly with the homosexual couple next door and have copies of the Kinsey Reports on their bookshelves. Yet their bright and busy lives, and their seemingly happy marriage, are veined with hypocrisy and deceit. Rosemary tries to trick Guy into impregnating her; Guy tricks Rosemary into carrying the Devil's child in exchange for success in his acting career. Guy's ruthless pursuit of status and success marks him as the antagonist of the story because he immorally obtains that status and success at the expense of others—his acting rival, his wife, her friend Hutch, and ultimately the whole world upon which he helps to unleash pure, embodied evil. Rosemary, the focal point of the reader's sympathies, is the immediate victim to Guy's ruthlessness, but not entirely innocent herself. She is aware of his duplicitous nature yet accepts it as part of what makes him attractive. Her acceptance of this minor evil makes her vulnerable to the massive evil that later befalls her and that she, in turn, perpetuates. Levin skillfully manipulates reader emotions and sympathies in his portrayal of an attractive, if flawed, heroine's gradual realization that her biggest desire has been cruelly turned against her, turned into a grotesque nightmare, by the person closest to her—for no morally acceptable reason and with the aid of black magic. He tapped into a universal fascination with the occult in his invocation of black magic, "malevolent wills" that causally interact with material reality (Levin 1997a, 246). That fascination was particularly salient in the Sixties as traditional religious authority was waning and alternative belief systems were on the rise (Quinlan 2014), but it rests on a universal cognitive disposition for conceptualizing moral categories—good and evil—as transcendent forces that may be harnessed through ritual and made to influence worldly affairs (Grodal 2009, 104). Levin made the occult relevant and imaginatively present by situating its agents—the Satanic coven and Guy—in contemporary Manhattan (Lima 1974, McElhaney 2007), carefully investing his representation with authenticity. He thus not only managed to make his "unbelievabilities believable," as he himself put it (qtd. in King 1983a, 302); he capitalized on the imaginative frisson produced by the introduction of ancient superstition in a modern

environment, the eruption of supernatural forces of evil in enlightened, bustling Manhattan. God may be dead in Rosemary's world, as suggested by the cover of a *Time* magazine in her doctor's office, but Satan is not.

RB opens with a conflict between Rosemary and Guy, a conflict that is rooted in evolved gender differences in reproductive psychology and one that paves the way for the monstrous exploitation of Rosemary. Rosemary desperately wants babies; Guy is not ready, "nor would he ever be ready, she feared, until he was as big as Marlon Brando and Richard Burton put together" (86–87). Rosemary and Guy have divergent, incompatible ideas about happiness. When Rosemary's friend Hutch warns them about the Bramford, which he claims is unnaturally accident ridden, Rosemary and Guy make light of his talk of bad houses: "'Maybe there are good houses too,' [Rosemary] said, 'houses where people keep falling in love and getting married and having babies.' 'And becoming stars,' Guy said" (28). In the depiction of this conflict, *RB* follows an ancient biological pattern. In species that reproduce sexually, females by biological necessity tend to invest much more heavily in offspring than do males. The minimal investment necessary for a human female to produce viable offspring is years of dedicated labor and massive physiological expenditure; for males, the minimal investment is the time it takes to impregnate a woman. This asymmetry in minimal investment has given rise to evolved psychological gender differences in humans, as in other species. Women tend to look for partners that have the resources—cognitive, physical, and material— necessary for protecting and providing for her and their offspring. Status and power are reliable cues that males possess such resources. Thus, men evolved to be more motivated than women to competitively pursue status and power because women tend to find such assets attractive in a partner (Buss 2012, Conroy-Beam et al. 2015). Guy's ambition is attractive to Rosemary, but the conflict between them arises because Guy's pursuit of status and power is so important to him that it excludes reproductive commitment. He pursues status and power for their own sake—not to accumulate resources that he can invest in the reproductive economy of his union with Rosemary.

Guy's ambition has given him some success in acting and a good income; they are "flush" (33) and can afford Rosemary's dream apartment. She is "busy and happy" (35) decorating the apartment according to schemes she has been collecting since high school. However, as Rosemary herself recognizes, Guy is also "vain, self-centered, shallow, and deceitful" (128). Rosemary is willing to accept those character traits as part of the package. "And yes he might lie now and then; wasn't that exactly what had attracted her and still did?—that freedom and nonchalance so different

from her own boxed-in propriety?" (129). Rosemary actively encourages Guy to deceive when doing so will help her reach her goals. When they are offered the apartment in the Bramford, Guy reminds her that they already committed to another apartment. "We signed a *lease*, Ro; we're stuck." She encourages Guy to lie and break the lease: "You'll think of *something*, Guy." When he does come up with an effective lie, Rosemary commends him: "You're a *marvelous* liar" (10). Moreover, Rosemary herself is willing to engage in deception to achieve her goals: "her plan was to get pregnant by 'accident'; the pills gave her headaches she said, and rubber gadgets were repulsive . . . Indulgently he studied the calendar and avoided the 'dangerous days,' and she said, 'No, it's safe today, darling; I'm sure it is'" (87). She is playing a game that is much more dangerous than she realizes. Guy's selfish ambition is so strong that he is willing to sacrifice his own wife and use her deepest desire against her in exchange for professional success. The Satanists need a breeding vehicle; Guy needs their black magic. As he says to Rosemary when she discovers that she has given birth to Satan's offspring: "They promised me you wouldn't be hurt . . . And you haven't been, really. I mean, suppose you'd had a baby and lost it; wouldn't it be the same? And we're getting so much in return, Ro" (301). It's a feeble defense. She has been deeply hurt, and gotten nothing in return. She has been used as a means for Guy to reach his goal.

Rosemary's willingness to overlook Guy's moral flaws, as well as her naiveté, makes her vulnerable to his monstrous betrayal. She is cast into a "world of suffering" because of minor transgressions and lapses in judgment (Langan 2008, 57), including her acceptance of Guy's character. Yet for most of the story, readers are invited to sympathetically identify with her, partly via focalization—the story is told from her perspective—partly via characterization. She is depicted as an attractive and vulnerable character; mild-mannered, eager to please, and somewhat naïve. Her naiveté is set in contrast to Guy's unsentimental, even cruel pragmatism. When the Pope gives a speech on television, Rosemary is "moved." She "was sure it would help ease the Vietnam situation. 'War never again,' he said; wouldn't his words give pause to even the most hard-headed statesman?" (102). She tells Guy about the "wonderful speech." "'War never again,' he told them," says Rosemary, who is preparing mushrooms for dinner. Guy replies, "Rotsa ruck. Hey, *those* look good" (106). Guy inconsiderately dismisses her earnest, blue-eyed admiration for the Pope's platitude. Similarly, when Rosemary asks if Guy has had sex with her as she was unconscious, he "grinned and nodded. 'It was kind of fun . . . in a necrophile sort of way'" (119). Most readers will probably feel that Guy is behaving in a grossly immoral manner, but also that Rosemary is rather too quick to forgive

him: "I guess I feel funny about your doing it that way, with me uncon-
scious . . . It's supposed to be shared, not one awake and one asleep . . . oh,
I guess I'm being silly" (120). Rosemary is being massively victimized, and
the reader's sympathy for her deepens as she begins to realize the mag-
nitude of the conspiracy against her, when she begins to fear for the life
of her offspring. Yet that sympathy becomes complicated, corrupted, and
blended with moral revulsion, in the ending of the novel, when Rosemary
embraces her demonic offspring.

The climax of the story inspires strongly conflicting emotions in read-
ers who sympathetically identify with Rosemary yet register the evilness
of her baby. When Rosemary discovers that she has given birth to Satan's
offspring, her first inclination is to kill the baby, to "save the world from
God-knows-what" (302) by throwing herself and the baby from the win-
dow. The baby's appearance signals its evil, in particular its horns, tail,
and its eyes: "golden-yellow . . . with neither whites nor irises . . . with
vertical black-slit pupils . . . Like an animal's, a tiger's" (295–296, 302).
Motherly affection wins out over moral and visceral repulsion, however.
She "*couldn't* throw him out the window. He was her baby, no matter who
the father was . . . He couldn't be *all* bad . . . Even if he was half Satan,
wasn't he half *her* as well, half decent, ordinary, sensible, human being?
If she worked *against* them, exerted a good influence to counteract their
bad one . . . " (303). Rosemary's reflections are desperate rationaliza-
tions. As Maisie Pearson observes, Rosemary "does not face the reality
of [the baby's] horns and tail" (1968, 500). In keeping with her charac-
ter, Rosemary tolerates evil insofar as it brings her happiness. Levin has
used subjective narration to make us suffer with Rosemary, so we do
root for her and want her to find happiness (Valerius 2005); yet she is
being dangerously, recklessly selfish in her decision to let her demonic
offspring survive and do God-knows-what to the world. One critic writ-
ing about Polanski's film version in 1968 registered the moral revulsion
inspired by the ending in pinpointing "the sickening triumph of evil in
the end" (Carroll 1968). Evil has triumphed in that the Satanists man-
aged to deliver the son of Satan onto the world, but it has also triumphed
in Rosemary's final acquiescence to selfish impulse. The triumph of evil
becomes particularly sickening for readers who sympathetically register
Rosemary's dilemma—to kill or nurse the baby—but wish for another
outcome, wish for her to be morally responsible, unselfish, and save the
world from Satan's offspring.

Levin never tells us what the Satanists hope to accomplish by deliver-
ing the son of Satan onto the world, and he never tells us what evil Satan's

son will go on to accomplish. (Yet in his 1997 sequel to *RB*, the novel *Son of Rosemary*, Levin depicts an adult Andy who is the Antichrist and manages to kill all human life on the planet with an apocalyptic virus.) *RB* ends when Rosemary's baby is born and she has made her decision. The evil that Levin makes imaginatively accessible to the reader is the evil perpetrated by human characters selfishly pursuing their own goals and harming others in the process. Evil in *RB* is investing conventionally male motives with autotelic significance—the love of power, status, and success for their own sake. Those tend to be perceived as legitimate motives when they contribute to a reproductive or otherwise prosocial economy, when they contribute to a collective good. But they are easily conceptualized as antagonistic—evil—when divorced from those economies. Guy is evil for recklessly pursuing his ambitions as legitimate ends in themselves and at great cost to others, most specifically Rosemary, the person closest to him, the one who should be able to trust him unconditionally. Rosemary is vulnerable precisely because she tolerates Guy's character, his lies and ambition, without realizing that his moral faults extend to his relationship with her and their offspring. Rosemary herself is not evil, but she tolerates evil, and that in itself renders her vulnerable to perpetuating evil. The ending of *RB* is shocking, "sickening," because the reader learns that Guy has pursued his own ambition not just in isolation from a prosocial and reproductive economy—he has successfully perverted and poisoned those economies in his pursuit, allowing people to get hurt and killed and his wife to be raped, impregnated, and morally compromised by Satan. Her body is contaminated with evil incarnate, a human-beast hybrid that drains her of energy like a prenatal vampire.

Levin successfully targeted evolved fears of intimate betrayal, contamination of the body, and persecution by metaphysical forces of evil. He gave the world a vivid depiction of a vulnerable and likable woman's victimization at the hands of power- and status-crazed individuals using black magic to serve ultimate, Satanic evil. He set that story in a realistic, modern setting, capitalizing on the imaginative sparks that flew with the eruption of medieval demonology in modern Manhattan. In the world of *RB*, pleasant surfaces just barely cover an abyss of depravity and evil. Absolute evil is real. It's a morally skewed world in which God is dead but Satan very much alive. Absolute evil needs willing human agents to influence worldly affairs but has no trouble finding collaborators among ordinary people—people who actively and selfishly pursue dominance and power as well as people who passively tolerate evil. *RB* inspired scores of horror stories depicting Satanic or demonic possession—to Levin's consternation, since

he himself did not believe in the devil but feared that literalist readers may have been inspired to fundamentalism by stories depicting the devil as "a living reality" (Levin 2012). He did evidently believe in human evil, however, particularly the evil that can result from unchecked male ambition disjointed from prosocial investment, and he deftly made readers care for his protagonist as she faced evil of ever-increasing proportions until, in the end, giving into it.

Fight the Dead, Fear the Living

Night of the Living Dead *(1968)*

In George A. Romero's *Night of the Living Dead* (1968), the unburied, recently dead come back to life, or at least a semblance of life. The reanimated corpses—they're called "ghouls" in the film—are driven by an apparently insatiable appetite for live human flesh. The weird phenomenon seems to be caused by "radiation" from Venus brought back to earth by a space probe. The film depicts the struggles of a small group of people who have barricaded themselves in a farmhouse for the night. The defenders struggle to understand what is happening and to ward off the attacking undead, but a deadly squabble breaks out among them. In the end, just one defender, Ben, survives the night. With daylight a ghoul-killing posse approaches the house. One member of the posse spots Ben moving in the house, mistakes him for a ghoul, and shoots him in the head. End of story. It's bleak, it's devastating, and it's a very powerful film. What's more, *Night of the Living Dead*—henceforth *Night*—gave us the modern horror zombie, the reanimated corpse that feeds on the living, is contagious, travels in hordes, and heralds the apocalypse—a monster type that has all but saturated popular culture. What made Romero's implausible monster resonate so strongly with moviegoers?

Romero's film was inspired indirectly by the zombies of Haitian voodoo religion, individuals who had been robbed of their volition and all higher cognitive functioning and were kept in thrall by a voodoo priest. Those zombies came to the attention of Western audiences via colorful travelogues such as the adventurer W. B. Seabrook's 1929 book *The Magic Island*

(Pulliam 2007) and inspired a number of horror films and comics, which in turn inspired Romero. Haitian zombies, however—unthreatening, mindless automatons—are a far cry from Romero's zombies, the contagious, apocalyptic, devouring horde of the undead. Even so, it was Romero's zombie that came to define the horror zombie, chiefly because it's just such a damned good idea, a monstrous concept well-engineered to capture people's attention, spark their imagination, and embody a whole range of evolved, culturally salient fears. Romero's film inspired hundreds, thousands, of artworks—films, novels, stories, computer games, graphic novels, real-life phenomena such as zombie runs, and so on (Platts 2013, Pulliam 2007). Even the normally austere Centers for Disease Control and Prevention tapped into the fascination with zombies; in 2011 they attempted to increase public disaster preparedness via a campaign that focused on the zombie apocalypse (Khan 2011).

Night was produced on a shoestring budget ($114,000) and was met with wildly divergent reactions. Some critics panned it as immoral, sadistic exploitation—*Variety* famously called the film an "unrelieved orgy of sadism"—while others found aesthetic and cultural value in the film (Phillips 2005, 82). Whether critics and audiences liked what they saw, they continue to respond powerfully to the film, which has now grossed $30 million worldwide (The Numbers 2015). According to the critical consensus, *Night* achieved its power by effectively tapping into extant social anxieties. Kendall Phillips, for instance, identifies a number of "points of resonance between *Night* and the social upheaval occurring in the final years of the 1960s" (2005, 85). The Sixties had seen the rise, consolidation, and disintegration of the counterculture; the decade began with optimism and ended in strife and internal division. Some critics claim that Romero's bleak film reflects this development (Becker 2006): The main characters— a "democratic" blend of ordinary American citizens (Dillard 1987, 19)— seem to have every opportunity to effectively defend themselves against the forces of evil if only they work together, but they fail spectacularly and perhaps inevitably. In Phillips's phrase, the film "acted as a kind of eulogy to the revolutionary spirit" of the counterculture (2005, 93), a spirit that by 1968 seemed to many to be either frustratingly impotent (flower power did not seem to be conquering war, greed, and hate) or disturbingly sinister (with the rise of militaristic counterculture factions, for example). The preyed-upon characters in *Night* fail to cooperate and end up killing each other; authorities prove to be dangerously inefficient (even as they do their best to contain the threat); and the enemy—whether live or undead—is us. As in other horror films of the era (Platts 2014a), the monsters in *Night* are ultimately internal; not exotic monsters from the Carpathian mountains,

lost worlds, or outer space, but the darkest, most destructive impulses in human nature. Conflict and defeat are inevitable. Conflict and defeat are not unique to the 1960s—they are basic terms of existence. They may have been more salient to American citizens in the 1960s than they were in, say, the 1950s, and *Night* did come out of, and reflect, particularly troubled times. But the horror of Romero's film is not that it reflects the defeat of the counterculture; it's that the film reflects the defeat of life.

The visual style of *Night* sustains the film's thematic function as a disturbing reflection of social anxieties. The film is shot in black and white; not because of financial or technological constraints, but as a conscious stylistic choice, one that imparts to the film a *cinéma vérité* tonality (Becker 2006, Phillips 2005, 98). As Joseph Maddrey writes: "Because *Night of the Living Dead* was filmed guerilla-style . . . with the unflinching authority of a wartime newsreel, it seems as much like a documentary on the loss of social stability as an exploitation film" (2004, 51). Moreover, the hand-held camera, the use of natural lighting, and the grainy still images at the end of the film all work to uphold the film's documentary quality (see Figure 8.1). *Night* lacks the artifice of, say, Hitchcock's horror

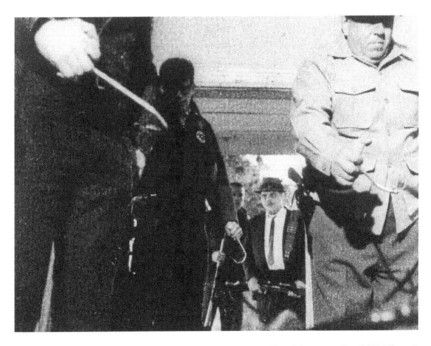

Figure 8.1: George A. Romero's seminal zombie film *Night of the Living Dead* (1968) capitalized on an authenticity aesthetic to more effectively disturb audiences. It looked like a documentary film about the undead walking the earth. The film was shot in black and white, evoking newsreel footage, and ended with grainy still images that suggest news photos.

films (Dillard 1987); its style functions to remove aesthetic distance and give the film a tone of visual authenticity. To contemporary audiences, Romero's zombie film evoked a news broadcast. Is that why the film became a resounding success, an indisputable classic of modern horror cinema which moved and shocked audiences? Partially, yes. The film does function as an accomplished artistic diagnosis of a *Zeitgeist*. But its power goes deeper. It continues to fascinate, engage, even disturb audiences. The film may have lost its capacity to leave audiences "stunned with terror," as the film critic Roger Ebert reported of his experience of watching the film in 1969—he himself "felt real terror in that neighborhood theater last Saturday afternoon"—but the power of the film transcends its cultural context. Romero's zombies are not just apt metaphors for brainless humanity, or capitalism (Wood 1985), or the Vietnam War (Higashi 1990), and the film is not just a dramatization of sociopolitical tendencies peculiar to the apocalyptic tail end of the American Age of Aquarius. The zombies have a horrible, visceral, literal presence, and the central conflicts in the film are universal. Indeed, the film has a resonance that connects with basic dispositions in human nature.

Central to *Night* are, of course, the eponymous monsters, the "ghouls" or zombies. Not that the film's characters realize what they are up against, at least not initially; the film uses restricted narration to withhold background information from characters as well as audience, and it is only forty minutes or so into the film that we are told—via a diegetic newscast—that the ghouls eat their victims. Moreover, we never learn exactly what causes the uprising of the ravenous dead. Some scientists think it has to do with "high-level radiation" from space, but other scientists are shown contesting this hypothesis. *Night*'s zombies would have been disturbingly mysterious to contemporary audiences. They are pale, dumb, animalistic, and aggressively predatory; some have facial disfigurations that appear to be the result of violence, maybe early decay (see Figure 8.2). The zombies of *Night* are less visually disgusting, less decayed, than are most contemporary zombies, such as the rotting, walking cadavers of *The Walking Dead* (Darabont 2010–) (or even the Technicolor zombies of Tom Savini's 1990 remake of *Night*). Like non-human animals, they are afraid of fire. And because the radiation has somehow "activated" their brains, the walking corpses can be killed with a shot or a blow to the head.

An evolutionary perspective helps explain why the modern horror zombie of the type championed by Romero so quickly became such a mainstay of popular culture. Something about zombies makes them peculiarly fascinating to us, even though they do not exist in the real world. The zombie of modern horror is highly dangerous: It is predatory—it has one motivation,

Figure 8.2: A decomposing zombie, or "ghoul," from Romero's *Night of the Living Dead* (1968). A reanimated corpse with a taste for human flesh is a powerful, if implausible, concept because it taps into evolved fears of predation and contagion.

and that is to eat people—and infectious. Once bitten by a zombie, a person becomes one sooner or later. This idea, a loan from vampire fiction, is introduced, but not highly developed, in *Night*. One character, the girl Karen, has sustained a bite on her arm. The characters in the film express some concern over infection, but none of them realizes that she is liable to become a zombie. A present-day zombie-savvy audience, in contrast, immediately realizes the danger; in *The Walking Dead*, if somebody is bitten on a limb by a zombie, that limb is promptly amputated—but this convention of zombie fiction had yet to become widespread when *Night* was released.

Both of the modern horror zombie's defining characteristics, the predation and the contagion, allow it to connect squarely with evolved defense mechanisms in human psychological architecture. We fear agents that have the will and the capacity to eat us, and we have strongly aversive reactions to cues of contagion, such as the odor and sight of decomposing flesh. What's more, the counterintuitive nature of the zombie makes it particularly salient. We intuitively understand that death is the irreversible cessation of self-propelled motion (Barrett and Behne 2005), and zombies, like vampires, violate that understanding (Clasen 2010a). They look like dead people, dead *meat*, but they move around and act in a goal-directed manner. Dead

people are disturbing in their own right. A corpse in an advanced state of decomposition is disgusting and troubling—mainly because it is decomposing, pathogen-riddled meat, but also because a corpse may imply an act of predation (Boyer 2001). The *undead* are even worse. The very concept of an undead agent is fascinating, and the fascination becomes tinged with dread and disgust when the undead agent is predatory and contagious. Yet an undead human is more disturbing than, say, an undead raccoon. The zombie gives us a troubling vision of a human stripped of humanity, of life reduced to meaningless hunger. The zombie, moreover, is a personification of death, a collapse of life and death into one concept, an embodiment of the truism that we are all slowly dying and decaying. The zombie *is* us—not just a symbol of the braindead masses, but a symbol of that most terrifying fact of life, its transience. The power of the zombie is really all in our minds, in the way that human mental machinery is constructed. We fear predators, loathe rotting meat, are captivated by counterintuitive agents, and are terrified of death and the "conqueror worm" that awaits us all, in Poe's phrase. These horrors crowd together in the figure of the modern horror zombie.

Night makes death thematically salient from the outset. In the very first scene, we see a single car traveling a cracked road through a dead landscape. Inside the car are Johnny and Barbra, two youths who are visiting the grave of their father. Johnny teases Barbra about her fear of the cemetery and the dead, even attempting to spook her with a Boris Karloff impression: "They're coming to get you, Barbra," he says as a man is shambling toward them in the distance. The man turns out to be a zombie, and the zombie attacks and kills Johnny. This all happens within a few minutes of screen time. Death, and the dead, saturates the film from the very opening scene, and the audience is drawn into the film partly via the inherent fascination that an evolutionarily relevant theme such as death holds, partly via formal techniques. While the film does not tie the audience to one specific point of view, it does use many reaction shots to show us, and let us mirror, the characters' emotional reactions to the zombie outbreak. For example, in the beginning of the film, Barbra's frantic flight from the zombie that killed her brother is filmed alternating between point-of-view shots from her perspective (to put us in the action) and reaction shots (to let us mirror her emotional state). Moreover, much of the filming is done using a hand-held camera, often held at canted angles or traveling quickly and chaotically, to convey to the audience the urgency of her flight and thus to let us feel an echo of her terror. The use of reaction shots in the film vastly outnumbers shots of the zombies, who only get a few minutes of screen time in all. This is in keeping with the film's thematic focus on

what the zombie apocalypse does to people, rather than on the zombies or the apocalypse themselves.

As the film progresses, the literal fear of the dead gives way to fear of the dangerous living. The very cosmos of the film comes to teem with danger, with the zombies being just one source. The film, like so many subsequent zombie stories, is centrally about the social and psychological consequences of the zombie outbreak. As Romero himself has said, his zombies "don't represent anything in particular. They are a global disaster that people don't know how to deal with," and his zombie films are "about how people respond or fail to respond to this" (McConnell 2008). Romero's interpretation dovetails with Dillard's analytical observation that "the living dead themselves are the active and catalytic agency for the release of all of the film's horrors" (1987, 20). James Twitchell goes further and claims that "to pinpoint the horror [of *Night*] one must ignore the monster and watch the transformations wrought on the victims" (1985, 268), but that is an overstatement. The zombies are not mere window dressing or gratuitous eye-catchers; without the zombies, *Night* would be a very different film. The film may foreground such realistic processes as breakdowns of communication and cooperation, but the quasi-supernatural zombies are crucial to the film's tone and its meaning and, ultimately, its artistic and commercial success.

Conflict plays a major thematic role in *Night*—the conflict between the zombies and the living, who are engaged in a deadly zero-sum game, and the equally deadly conflicts among the living themselves. As Dillard observes, the "film is primarily one of ceaseless and unremitting struggle" (1987, 22). From the outset, the film shows characters quarreling. Barbra and Johnny quarrel over the cemetery visit. Ben and Barbra quarrel over whether to leave the relative safety of the farmhouse and look for Johnny (that quarrel ends with Ben literally knocking Barbra out). Harry and Helen have an unhappy marriage and fight. Their child, Karen, eats part of her father's corpse and kills her mom. Ben and Harry fight, with words and fists (and eventually, a gun). Only Tom and Judy don't quarrel much; they are young and very much in love, but this unconditional love becomes pathological in the film when Judy throws caution to the wind and pursues Tom on his fuel run, which gets her killed. There is in the film a sense that effective cooperation could have saved the defenders of the farmhouse, who all die, but that human nature keeps getting in the way. Conflict is inevitable in this film, as it is in real life. Not only do people have nonoverlapping interests and motives, but everybody struggles with an internal conflict between altruistic and selfish motives. The conflict between prosocial impulses and a desire for dominance is an active theme in most fiction (Carroll 2012b)

and looms large in much zombie fiction, where characters are frequently torn between looking out for number one and helping their peers. This has been a central evolutionary problem for the human lineage for millions of years (Boehm 2012). In *Night*, Ben discovers that the Coopers and Tom and Judy have been hiding in the basement while he was busy boarding up the house and fighting off zombies. Ben asks Harry why he didn't come up to help when he heard Barbra's screams. Harry answers: "I'm not gonna take that kind of a chance when we've got a safe place. We luck into a safe place, and now you're telling us we've gotta risk our lives just because somebody might need help, huh?" Replies Ben: "Yeah, something like that." Here Ben—the closest we come to an actual protagonist in this film—is portrayed as the prototypical good guy, the altruistic fighter, but that does not save him. In *Night*, there is no transcendent good, no ultimate bad. Some characters are better than others (Ben, fighting for survival while trying to protect the weak, is better than whiny, selfish Harry), but in the end, the film shows us flawed people struggling and failing to survive in an indifferent, dangerous world.

Night offers no neat resolution, no happy ending, no reassuring vision to take away from the film—just a lingering sense of profound disturbance and unsettlement. Audiences that register the film's somber tone—the bleak position it takes on the inevitability of social, psychological, even organic breakdown—are left with a feeling that they have witnessed something unpleasantly true. Some audiences, of course, are unable to see past the film's ridiculous premise (radiation from outer space raising the dead). The hostile critic from *Variety* is one such literalist. But the film is more than a ridiculous premise played out to fill an hour and a half of sadistic entertainment. It lets us look into dark pockets of psychology, examine human reactions to disaster, particularly social interaction gone awry in the face of such disaster, and project ourselves into such a world, asking ourselves what we would do and how we would fare. That is why *Night* dwells on the characters' attempts at coping with disaster, for example in the extended sequences depicting Ben and Harry's arguments over whether to stay on the ground floor or in the basement, and Tom and Judy's argument over whether to stay in the relative safety of the house or attempt to run for fuel. The film's truths, then, are psychological and sociological. *Night* engages us by foregrounding themes that are inherently engaging, by pitting human characters against a highly dangerous and salient foe, and by creating suspense and immersion via restricted narration and subjective cinematography. The film makes salient in particular the conflicts endemic to human life. That theme would have had particular relevance for contemporary audiences, who were witnessing ideological as well as armed

conflict all around them, and it continues to fascinate audiences because of its roots deep within human nature. *Night* conveys the profound demoralization borne of the political and cultural conflicts of the 1960s, conflicts that are given vivid embodiment in the trope of the zombie apocalypse. The film offers an opportunity for emotional engagement and for reflection on the human condition under extreme conditions. Audiences are invited to participate vicariously in the struggles depicted, and such vicarious participation can help us reflect on, and maybe modify, our own reactions under similarly extreme conditions. Romero's imaginative universe is a nasty one; the appeal of *Night* is the appeal of temporary, imaginative absorption in such a fascinating, ambivalently compelling, extremely bleak universe.

The immensely successful television series *The Walking Dead*—the "most watched show in cable television history" (Platts 2014b, 294)—appropriated and developed all the central themes and elements of *Night*. The series also uses an outbreak of a zombie virus as a catalyst for a story about human interactions and human psychology, and it also dwells on conflict between and within characters. The popularity of *The Walking Dead* suggests that the themes it shares with *Night* transcend the period of *Night*'s production. Humans are interested in vicarious insight into social and psychological conflicts, and as a prey species, we are captivated by stories that pit human characters against horrible, predatory monsters. Stories that center on the zombie apocalypse may be laughably unrealistic in their narrative premise, but they engage our attention and can tell us something real and true about our constitution.

Never Go Swimming Again

Jaws *(1975)*

A young woman, Chrissie Watkins, is attacked and killed by what appears to be a big shark off the coast of the peaceful New England island of Amity. Local authorities are quick to sweep her death under the rug and pronounce it the result of a boating accident. The recently appointed chief of police, Martin Brody, a city cop terrified of the water, sees the attack for what it is. He wants to shut down the beaches until the shark is caught, but as Amity's mayor Larry Vaughn says, Amity is "a summer town. We need summer dollars." News of a big shark killing beachgoers would scare tourists away from the island. Brody complies, but then a young boy, Alex Kintner, is attacked and killed by the shark in broad daylight and with plenty of eyewitnesses. Brody calls in a shark expert, Matt Hooper, and hires a seasoned local shark hunter, Quint, to find and kill the shark. Brody, Hooper, and Quint set out in Quint's boat. After some hunting they find the great white shark and try to kill it. But the shark is bigger, stronger, and cleverer than the men had expected. It eats Quint and almost gets Hooper, but Brody manages to kill it by shooting a rifle bullet into a tank of compressed air that the shark is swallowing. The shark explodes, the boat sinks, and Brody and Hooper paddle toward safety (Spielberg 1975).

Released in June 1975 and based on Peter Benchley's novel of the same name (1974), *Jaws* quickly became the highest-grossing film up until then—a film that, famously, "filled the theaters and emptied the beaches" (Salisbury and Nathan 1995). *Jaws* didn't just lure people away from beaches and into the darkness of the multiplex, it caused a substantial

drop-off in North American beach tourism (Andrews 1999, 121) and made generations of moviegoers wary of the water and terrified of the monstrous creatures that roam its dark depths. When media psychologists ask people about fright-inducing media presentations, media content that had long-term negative psychological and behavioral effects on viewers, *Jaws* invariably swims into a short list of reliably terrifying, even traumatizing movies (Cantor 2002, 2004, Harrison and Cantor 1999, Hoekstra, Harris, and Helmick 1999). In a recent study (Cantor 2004), 4 percent of a large sample of college students reported "lingering effects" of *Jaws*. Most prominent among those effects were sleep disturbances—mainly nightmares— and "interference with swimming . . . not just in the ocean, but also in lakes and pools." Even years after seeing the film, many viewers still felt uneasy about swimming. As one respondent put it, "to this very day, when floating in a body of deep water, I still occasionally have that feeling that something could come up and grab me" (Cantor 2004, 292). What made *Jaws* so effective that it managed not just to engage and terrify audiences for two hours, but to awaken in hundreds of thousands—if not millions—of viewers an abiding, profound terror of the sea?

 Jaws gets its peculiar power from successfully immersing its audience in a primal scenario of predation by a malevolent animistic agent, the shark, and by aligning audiences with the perspective of an alert and heroically altruistic character, Martin Brody. He is the first major character to take the threat of the shark seriously, and his conscientiousness and determination help him banish the threat to his community. The audience is encouraged to form a sympathetic bond with Brody. Several scenes depict Brody's life with his family, showing him to be a caring father and a loving husband, one unselfishly concerned with the welfare of his kin. He is crippled by his own intense fear of the water as well as by political forces determined to downplay the danger for financial reasons, but he altruistically rises above these constraints and successfully fights back against the shark. *Jaws* provides audiences with a jolting, visceral reminder of a biological truth that most of us ignore or repress most of the time: the fact that we are, to some apex predators, "small, edible animal[s]"—in a word, *meat* (Plumwood 2012, 13, Quammen 2003). The film conveys that idea most powerfully by showing us ourselves from the predatory perspective of the shark, and it embeds the idea in a highly suspenseful story. We never know exactly when the shark will strike, though we are alerted to its presence before the characters via nondiegetic music and camera shots from the shark's point-of-view. The idea of people as meat produces acute anxiety, and the film ultimately resolves that anxiety, in the short term, with the spectacular obliteration of the man-eating shark. Human ingenuity and perseverance

annihilate the monstrous threat. Even small, edible primates can fight back against giant monsters—provided they are willing to face it head-on, like Brody, and unlike the cowardly politicians of Amity. The film both creates and eases short-term anxiety, thus offering immediate emotional relief and satisfaction, and also leaves behind a lasting trace of dread, thus giving viewers a half-conscious feeling that Spielberg's film is not only transient entertainment but also somehow profound, something that enters permanently into the fibers of their nervous systems.

The great white shark is the engine that drives *Jaws*. It structures the story by setting the plot in motion and motivating its characters. The most vividly memorable scenes involve the shark, either directly or as suggested by the on-screen effects of its predatory activities. The shark has also been the focal point of most academic criticism. Most such criticism invests the shark with symbolic significance derived from a theoretical system such as psychoanalysis. Peter Biskind suggests that the shark should be read as "a greatly enlarged, marauding penis" (1975). Jane Caputi also invests the shark with genital symbolism but, in a surprise twist, interprets it as a giant vagina with teeth, a "*vagina dentata*" (1978, 314). According to Caputi, the shark "represents the primordial female in her most dreaded aspects" (307–308). Investing the shark with symbolic psychosexual significance does not get us closer to the causal underpinnings of the film's power to transfix and terrify audiences. *Jaws* made people terrified of the water and sharks, not of genitals, sexual difference, the patriarchy, or the "vengeful mother" (Rubey 1976). Kingsley Amis resisted such interpretations, claiming that *Jaws* is about "being bloody scared of being eaten by a bloody big fish" (qtd. in Quirke 2002, 36). But that's not quite right either. The shark in *Jaws* is more than just a bloody big fish. Over the course of the film it "develops from a mindless eating-machine into a malevolent force—intelligent, vengeful, unnaturally powerful, perhaps thousands of years old" (Rubey 1976). To humans, sharks—whether real or fictional— are rarely just "big fish." They tend to be perceived as monsters or deities, demons or demigods. They "inspire terror out of all proportion to their actual threat" (Crawford 2008, 7)—not because the shark bears a remote resemblance to human reproductive organs, but because of an evolved psychological disposition to regard such a powerful, elusive, and elegant predator with awe-tinged horror. The shark is extremely dangerous yet utterly indifferent toward human affairs. Our reflection in the dead black eye of a great white shark shows us a weak, cowering little ape out of its element.

Sharks make good horror movie monsters. They have existed with little evolutionary change for hundreds of millions of years. They roamed the oceans before the appearance of birds, reptiles, and mammals. Sharks are,

in Hooper's words, a "miracle of evolution"—well-engineered by natural selection to fulfill their purpose of survival and reproduction. The now-extinct megalodon grew up to about fifty feet long. It is an ancestor of today's great whites, and it may have survived into the Holocene and thus coexisted with prehistoric humans. As Crawford writes: "We can imagine how the terror of sighting a two-metre dorsal fin might send shock waves down through our hereditary DNA" (2008, 28). Nobody knows the extent to which sharks have preyed on human and hominin ancestors over evolutionary time, but even if very few individuals—in prehistory as today—have been killed by sharks, the shark amply meets the input specifications of evolved anti-predatory mechanisms in the human mind. The shark is very clearly dangerous and predatory. Its mouth brims with sharp teeth. Its eyes are black, "lifeless . . . like a doll's eyes," in Quint's words—deeply unsettling to us, as is its immobile, expressionless face. The sleek elegance with which the great white moves suggests awesome power. There is an aesthetically pleasing convergence between its form and function; it *looks* like it was designed to kill. Its element, the ocean, is alien and inhospitable to us. We are vulnerable at sea, vulnerable when swimming with our vital organs exposed to threats from below. The original trailer for *Jaws*, narrated by Orson Welles, described the shark as a "mindless eating machine," one that "lives to kill . . . It will attack and devour anything." It is an evocative description, but unfair on several counts. Any carnivore "lives to kill," badgers no less than sharks. Real sharks do not attack and devour "anything," and the shark in *Jaws* is not merely a swimming chainsaw, an indiscriminate machine of destruction. It has agency—malicious, homicidal intent, as its behavior and the optical point-of-view shots from the shark's perspective suggest. It appears to foster mammalian emotions of vengefulness, even primate powers of ingenuity. It is behaviorally unrealistic but dramatically explosive.

The shark in *Jaws* is elevated to the stuff of myth, carefully built up to awesome proportions in the audience's minds throughout the film as it is described and suggested but rarely shown. It is elusive, clearly extremely powerful, and very, very dangerous. The shark's on-screen presence is restricted to a few minutes, all told—partly as a result of a creative decision by the filmmakers, partly because of the recurrent problems caused by the mechanical sharks constructed for the film (Andrews 1999, Gottlieb 2005, Quirke 2002). We don't actually get a glimpse of the shark until more than halfway through the film, but characters tell us about it—it is twenty-five feet long and weighs about three tons—and we see the effects of its violent feeding. The first scene shows us the nighttime swimmer Chrissie Watkins being attacked by *something* in the water, some massively powerful creature

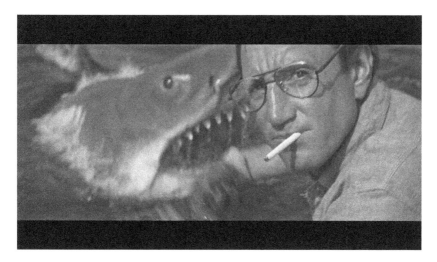

Figure 9.1: The great white shark in Steven Spielberg's *Jaws* (1975) has very little screen time, but when it finally does show up, it looks pretty realistic. It's a terrifying predator with a great many teeth and absolutely no regard for human sensibilities. From the perspective of the shark, Chief Brody is meat—nothing more, nothing less.

that violently tears her to and fro before dragging her under; we witness as her severed arm is discovered on the beach the following morning, being snacked on by crabs. And we witness a pair of hapless islanders try to catch the shark with a roast on a hook tied to a wooden pier, which is torn apart and dragged out to sea by the beast. When we finally do see the shark, it looks very convincing (see Figure 9.1). Even shark experts have trouble telling the mechanical shark from the real ones used in *Jaws* footage shot off the coast of Australia (Gottlieb 2005, 90). By telling us that the shark is around while predominantly withholding it from view, *Jaws* provides a double assault on the audience, amalgamating the evolved fear of predation with the evolved fear of the unknown, of uncertainty. The audience knows that something dangerous is out there, but not where it is, exactly, or when it will strike—but we know before the characters do.

The fear provoked by the shark and provoked by the uncertainty surrounding it is compounded by sympathetic anxiety for vulnerable characters in peril. *Jaws* positions us as vicarious victims as well as helpless observers. Spielberg uses a great number of water-level shots designed to make us feel as though we were treading water along with the potential victims (Bouzereau 1995), but he also uses a "privileged warning system," in Bowles's phrase (1976, 203)—consisting of music and underwater point-of-view shots—to alert us to the shark's presence and approach ahead of characters. Sympathetic anxiety is stronger when we realize that the characters don't know that they are in danger, because their ignorance makes

them more vulnerable. The film's first scene, which took first place in a 2004 list of the "100 Scariest Movie Moments" (Kaufman 2004), employs this strategy of using relatively unrestricted narration to alert the audience ahead of the characters. In this scene, underwater point-of-view shots as well as composer John Williams's famous two-tone musical motif—*duh-dun, duh-dun*—alert us to a menacing underwater presence *before* showing us a young woman jumping into the sea, blissfully unaware of this menace. We know that something nasty is out there, and that she doesn't know. When she is attacked, our fears are confirmed. Williams's motif—by now a cultural shorthand for impending danger, instantaneously recognizable in implication if not reference—uses minor chords to evoke negative emotion (Pallesen et al. 2005) and low pitch to imply aggression and threat (Huron, Kinney, and Precoda 2006). The motif reverberates through the specta-tor's nervous system and stirs up a sense of profound unease. Moreover, its accelerating rhythm functions as a "countdown" (Biancorosso 2010, 320) to suggest the approach of the menace—the menace is there, now, and getting closer. The motif, in short, targets evolved emotional disposi-tions to serve as a signal of impending danger and thus build suspense and sympathetic anxiety.

These various dramatic elements come together in the film's most effec-tive scene, the so-called "beach scene" which starts about fifteen minutes in. Chrissie Watkins has been killed, Brody suspects a shark and wants to close the beaches, but the coroner in collusion with the mayor claims her death the result of a boating accident. We know better because we saw what happened to Chrissie. We're on the beach. People are chattering, swimming, enjoying themselves—but not Brody. He is in a chair, anxiously looking out toward the water, trying to keep track of what is happening. Spielberg aligns our perspective with his, alternating eye-line shots with reaction shots. A corpulent woman is floating in the water. A guy is playing fetch with a wooden stick and his dog. A young couple fools around. A kid is paddling around on an inflatable raft. People keep walking in front of Brody, obscuring his (and the audience's) view of the bathers. Then a black shape breaches the water and approaches the corpulent woman. It's a false alarm—no dorsal fin, just the bathing cap of an elderly swimmer. Brody is rattled, as is the audience. Then a man comes along to complain to Brody about parking violations, again obstructing his view. As the man is talking, the young woman in the water starts screaming. Brody starts to rise. It's another false alarm, she's just having fun with her boyfriend. More child-ren go into the water. Brody is sweating, "uptight" in his wife's phrase. The audience is beginning to relax a little—it's all false alarms and a city cop out of his element, overly anxious—when the man with the dog starts calling

the dog's name. A close-up shows us its stick floating on the water; the dog itself is nowhere to be seen. The next shot is an underwater point-of-view, accompanied by Williams's ostinato—the first nondiegetic sound in this scene. We know this is *it*. The menace whose point-of-view the audience now shares, and which we haven't yet seen, approaches the bathers' legs kicking underwater and zeroes in on the kid on the raft while the music intensifies. Cut, and we are just above water, some distance away from the kid on the raft. It's hard to see exactly what is happening, but a deep bass rumble—suggesting great size and awesome power—accompanies a brief frenzy of circular motion around the kid's raft. He is dragged down amid a fountain of bloody water (Figure 9.2). People start screaming. Spielberg zooms in on Brody while pulling the camera away, producing in the audience the sense of nausea and vertigo that rush through Brody as his worst fears are realized. Panic ensues and people scramble to get out of the water.

The beach scene is a marvel of cinematic construction, extremely effective in building up to an utterly unsettling climax. Alex Kintner's death is simultaneously understated—we see no teeth entering flesh, no overt violence—and wildly graphic, with the geyser of blood. The scene conveys to us the terrible menace of the shark, it lets us share Brody's increasing apprehension and the vindication of his paranoia, and it allows us to feel the terror of the bathers themselves when they realize the danger they are in. Spielberg recounts how, at an early screening of the film, the scene

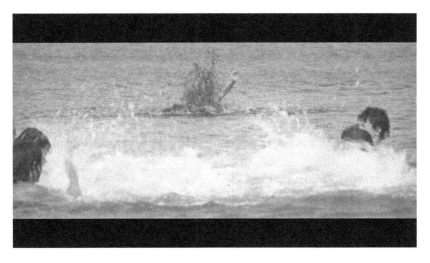

Figure 9.2: The infamous "beach scene" in Spielberg's *Jaws* (1975) is utterly disturbing as it builds up to the climax of a violent shark attack. Here, a small boy is attacked by the great white and dragged underwater in a spray of blood and seawater, evoking a primal nightmare scenario.

caused a man to run into the theater lobby to vomit. "He came back after throwing up and went right back to his seat. That's when I knew we had a hit" (qtd. in Andrews 1999, 114). They had a hit because they so effectively and compellingly evoked the anxiety accompanying uncertainty coupled with danger as well as the terror of the primal encounter between animal predator and human prey.

The great white shark—an ancient monster from the depths of time, the ocean, and the human mind—tears through the busy trivialities of day-to-day life on Amity, much as the screeching sound of Quint's fingernails raking across a blackboard tears through the chaotic babble of the excited citizens gathered in the town hall to discuss the shark attacks. Like that screeching sound which inexplicably, atavistically grates on the nervous system, the shark appears out of prehistoric depths to disrupt yet also provide focus to Brody's world. Brody, who has transferred from crime-ridden New York City to peaceful Amity, has his hands full fending off islanders' complaints about kids from the local karate school "karateing" their picket fences, with petty traffic violations and zoning restrictions. The menace of the shark peels away all concerns but the most basic one: survival. Brody, however, is concerned not just with his own, or even his family's, survival; his strong sense of civic duty—his desire to protect all the people of Amity—marks him as the protagonist of the film. He is animated by a prosocial and unselfish desire to protect his fellow men; he is willing to go against blindly stubborn politicians as well as his own phobia of the water to keep the citizens of Amity safe. That is why the ending is so morally satisfying. Brody, the everyman protagonist, saves the day from a terrifying threat in the face of bleak odds (Bowles 1976). The other two members of the shark-hunting trio fail. Quint is killed, but he is animated by a crazed and selfish desire for revenge over an entire set of species (sharks ate many of his soldier comrades after the sinking of the USS *Indianapolis*, we learn). Hooper is almost killed, but he is motivated more by scientific curiosity than by altruism. Only Brody rises above himself. He is clear-sighted, resilient, and cunning enough to match the ancient threat that endangers the livelihood of his community.

Jaws keeps audiences engaged by carefully distributing information about an evolutionarily salient threat. The narrative prominence of that threat is signaled to the audience in the title of the film, on the official poster art, and in the very first scene. The promotional campaign surrounding the original release of the film focused almost exclusively on the great white, priming audiences to expect a drama pitting human characters against a dangerous shark. Peter Benchley offered an explanation for the wild success of the film, paraphrasing E. O. Wilson (1984) in an interview:

"We do not just fear our predators, we are transfixed by them. We are prone to weave stories and fables and chat endlessly about them. Fascination breeds preparedness, and preparedness survival" (Salisbury and Nathan 1995). His observation dovetails with the evolutionary approach advanced in this book. But the film is more than a depiction of a predator—it's about people's attempt to overcome fear and cope with danger, and about the conscientious, altruistic protagonist's struggle to protect his fellow citizens from an almost otherworldly threat. *Jaws* is a horror story about that most basic and terrifying aspect of human existence—our vulnerability, the fact that we are "food with pretensions" (Plumwood 2012, 18). But it is also an action-adventure about a resourceful individual's battle against, and defeat of, the harbinger of that terrible message. The film tells us that with vigilance, cunning, and perseverance, we can avoid becoming food.

Haunted Houses, Haunted Minds

The Shining *(1977)*

Jack Torrance, a bright and sympathetic man with literary ambitions, a volatile temper, and a drinking problem, has recently lost his job teaching high school because he assaulted a student. His marriage to Wendy has been troubled ever since he in a drunken fury accidentally broke the arm of their now five-year-old son, Danny. A well-connected friend helps him get a job as the winter caretaker of the Overlook Hotel, an upscale resort in the Rocky Mountains. Jack accepts the position, seeing it and its forced sobriety as a last chance at rescuing his marriage and his faltering literary career. Danny, who has clairvoyant abilities—the "shine"—is tormented by horrifying visions. He senses that something bad is going to happen at the Overlook. When the family arrives at the hotel just before it closes down for the winter, the cook, Hallorann, pulls Danny aside. Hallorann also has the shine, sees in Danny a fellow psychic, and warns him that the hotel is haunted—particularly room 217—but says that the ghosts can't harm him. Hallorann is right about the hotel being haunted, wrong about their capacity to hurt Danny. There is an evil, supernatural force at the Overlook, a supernatural accumulation of the atrocities perpetrated by the Overlook's past owners and inhabitants—gangsters, petty criminals, and ruthless businessmen. That evil force is fed by Danny's psychic powers and becomes stronger until Danny is attacked by a zombie woman in room 217. He manages to escape. Danny and Wendy desperately want to leave the hotel, but they are snowed in, with no connection to the outside world because Jack has destroyed their radio and disabled their snowmobile. He refuses to

acknowledge any danger and has no wish to leave the hotel and face unemployment and humiliation. The hotel wants to absorb Danny into its cast of evil ghosts because of his unique psychic powers, but it works on Jack, the family's weakest link, and tempts him with alcohol and the promise of power to get him to murder his son. The evil force gradually unhinges Jack completely and turns him against his family in a murderous rage. Danny and Wendy are rescued at the last minute by Hallorann, whom Danny summoned with a psychic cry for help. Meanwhile, Jack has forgotten to dump the pressure on the hotel's old boiler, which explodes, destroying the hotel and Jack. Danny, Wendy, and Hallorann escape (King 2011).

Stephen King, born in 1947, is the world's most successful horror writer. He has published about seventy books which have sold around 350 million copies, according to one estimate (Hough 2012), and his books have been translated into about fifty languages (Lilja 2015). King has won a staggering number of awards and prizes, most prestigiously the National Book Foundation's Medal for Distinguished Contribution to American Letters in 2003 and, in 2015, the National Medal of Arts from the United States National Endowment for the Arts. Ever since his debut with *Carrie* in 1974 (King 1999), King's work has attracted praise as well as hostility from critics (Magistrale 2013), but evidently his stories resonate with a very large number of people across the world. There are many reasons for King's popularity. He writes in an accessible, colloquial style. His plots are eventful and dramatic, and he engages unashamedly with big and basic themes such as good vs. evil. His characters tend to be ordinary, recognizable people, but they are depicted in psychological complexity and with genuine compassion as they face very dire straits, whether from each other or from supernatural monsters. Moreover, King's brand of supernaturalism—transcendent moral forces that manifest themselves, usually, as traditional horror figures such as malevolent ghosts and evil monsters—has wide appeal because it resonates with people's intuitive beliefs about invisible, morally polarized supernatural agents who exert influence on the material world. And finally, the worldview that emerges from King's fiction contains an unflinching acknowledgment of pain and suffering and evil in the world, yet tempers that acknowledgment with a romantic, sometimes sentimental, celebration of the human potential for good. That combination of hard-nosed realism and moral affirmation is attractive to many readers because, while not descending into nihilism, it seems to capture a difficult but important truth about the harshness of the world.

All of those elements are prominent in *The Shining* (henceforth *TS*), King's third published novel, his first bestseller (Magistrale 2010), and one of his most enduringly popular works. Literary critics have engaged with

TS from a number of perspectives. Several have focused on the autobiographical elements in the novel, most obvious in the depiction of a writer struggling with alcoholism (Buday 2015, Dickerson 1990, Winter 1984). Others have traced its literary historical heritage to the dark American Romantics (Mustazza 1990), literary naturalism (Reesman 1990), and Shakespearean tragedy (Magistrale 1990). Historicists have attempted to situate *TS* in its historical moment. Cohen, for instance, claims that *TS* in its depiction of Jack's descent into homicidal fury offers a "metaphor for the disintegration of American society in the post-Vietnam era" (1990, 48). Ferreira claims that the novel "mirrors the contemporary malaise in American political life" (1990, 27) in its focus on the Overlook's dreadful secrets and sordid history. These critics all deal with important aspects of the novel, but they do not get us much closer to its staying power to engage audiences. Davenport (2000) develops the thesis that *TS* can be read as an index of peculiarly male anxieties arising from contemporary sociocultural organization, anxieties over masculinity and what it means to be a man. In this interpretation, Jack "represents a transitional form of masculinity," torn between the father-image provided to him by his own abusive, patriarchal dad and a more contemporary, soft image of the father as a loving co-parent, a "primary caregiver" (Davenport 2000, 317). This is astute and important, but we still are not much closer to the story's resonance across time and space. Steven Bruhm has tried to get a fix on the deeper psychological significance of *TS* (2012). He applies a Lacanian psychoanalytical framework and offers a queer reading of the novel, claiming that it is really about repressed homoerotic and Oedipal desires. That reading profoundly distorts the meaning of the novel. The story does not engage and terrify readers by confronting them with the monstrosity of repressed incestuous desire—Jack, claims Bruhm, faces "psychic dissolution and collapse" as he is confronted with his own sexual desire for his son (Bruhm 2012, 470, Alegre 2001, 109). The Freudian notion of the Oedipus complex has no correlates in psychological reality (Daly and Wilson 1990), and Lacanian psychoanalysis is scientifically deeply suspect (Buekens and Boudry 2015). In contrast, an evolutionary perspective gets into focus the novel's meaning and its power to engage readers.

The central conflicts of *TS*, Jack's struggle against destructive forces inside and outside himself and Wendy and Danny's struggle to overcome the dangers in the Overlook, go much deeper than King's idiosyncratic concerns and the anxieties peculiar to the American 1970s discussed by most critics. They go straight to the bedrock of human nature. These conflicts reflect evolutionarily recurrent adaptive problems—the problem of balancing conflicting evolved motives, such as motives for selfish status

striving versus motives for affiliative nurturing behavior, and the problem of surviving the hostile forces of nature. Moreover, the supernatural elements—crucial to the novel's imaginative quality and its effect as a horror story—reverberate powerfully with evolved cognitive dispositions for magical thinking and metaphysical dualism (Bloom 2004). They seem to confirm what many people intuit, that there are immaterial, moral forces at work in the world—transcendent forces of evil, animated by antisocial motives, but also supernatural or "spiritual" powers within people, powers like the shine that can detect the powers of evil and thus help people to fend off evil. Those reasons together help explain why the novel continues to engage readers across the world.

King skillfully builds sympathy for his characters via subjective narration and multiple viewpoints (Dymond 2015). He lets us see through their eyes, both inward and outward. We feel with Jack, a sympathetic but flawed man, and only gradually does that sympathy turn to horror as he descends into homicidal insanity (Manchel 1995). We also feel the horror of his wife and child when they become targets for his homicidal rage. The turning point in the reader's sympathy for Jack occurs when Jack goes to examine the hotel's snowmobile, their last medium for escape. King uses free indirect discourse to put us into Jack's mind as he vacillates between wanting to leave the hotel, to protect his family, and wanting to stay, to pursue his own ambition. Jack cannot find a battery for the snowmobile. "It didn't bother him in the slightest. In fact, it made him feel glad. He was relieved" (304). Jack then finds the battery, but decides to lie about it to Wendy and Danny. As he is leaving the shed that holds the snowmobile, he sees Danny playing in the snow. Again we follow his thoughts: "(*What in God's name were you thinking of?*) The answer came back with no pause. (*Me. I was thinking of me.*)" Here Jack has a moment of clarity, a moment in which he realizes that he is yielding to the hotel's evil. "In that instant, kneeling there, everything came clear to him. It was not just Danny the Overlook was working on. It was working on him, too . . . He was the vulnerable one, the one who could be bent and twisted until something snapped" (306). That moment of clarity is followed by a vision of a life in poverty and alcoholism, the fate that Jack envisions for himself if he leaves the Overlook, his last chance at success. He then makes his final decision, yanks out a vital part of the snowmobile's engine and throws it far away into the snow, feeling afterwards "at peace" (310). The reader is here forced away from sympathetic identification with Jack and toward sympathetic identification with his victims.

The destructive forces that fuel Jack's descent are simultaneously psychological and supernatural in character. The psychological forces are the weaknesses of Jack's character, his tendency toward alcoholism, his violent

outbursts, his desire for status, and the memory of his own father, a psy-chopathically abusive parent. That memory haunts Jack, and he is terrified of mirroring it in his own behavior. The supernatural forces are the hotel's evil ghosts awakened by Danny's clairvoyance. The supernatural elements of TS are not, as some critics have claimed, superfluous "icing on the cake" of a social realist story (Herron 1982, 74, Alegre 2001, Notkin 1982). Most readers will recognize that some of the most vividly memorable moments in the novel involve protagonists' meetings with supernatural agents. They are material embodiments of moral forces from the past and the present. For Jack, the evil of the past and the latent evil inside himself gradually con-sume the present, taking over his mind, leaving nothing outside destruc-tive rage. For Danny, the shine is a special power of insight that renders him vulnerable to horror but also ultimately enables him to transcend it. The forces of evil awaken no alluring echo in his own mind, although they do reach out to him—for example by cajoling him into breaking his prom-ise not to enter room 217. Though caught in the cycle of evil transmitted through the generations, Danny does not internalize the evil that threatens to destroy him. Just as the reader is forced to break away from sympathetic identification with Jack, Danny is forced to sever the emotional bond with his father. The father that he knew and loved has already been consumed by the ghosts of the past. In place of his father, Danny has a bond with his mother, whose courage is equal to the challenge of defending her son from a once beloved husband, and he has also a bond with Hallorann, who shares his gift, tries to prepare him for the dangers to which his gift makes him vulnerable, and in the end becomes a surrogate father to Danny. Hallorann invites Danny into the imaginative world opened by the shine—a vital task that his own father, Jack, is unable to accomplish because he does not have the gift, and because he is unwilling to acknowledge to anyone but himself the reality of that imaginative world.

Jack Torrance's dispositions for alcoholism and violent aggression are set in tension with his affiliative dispositions for parental care and nur-turing. Depicted as a likeable and ambitious man in a bad situation, Jack is torn between pursuing his ambitions and taking care of his family, two motives that prove increasingly incompatible over the course of the novel as the hotel's evil forces lure him with alcohol and promises of power and status, bringing out his violent tendencies and turning him against his family. Jack becomes obsessed with the hotel's violent and sordid past, its previous owners' ties to organized crime, the suicides and brutal assassina-tions that have taken place there. The hotel promises him a "position of responsibility"; it promises him the prestige, power, and respect that he feels he doesn't get elsewhere; it promises him a place in "the Overlook's

organizational structure. Perhaps . . . in time . . . [at] the very top," as one ghost says to Jack (390). Jack, harboring dreams of writing a history of the Overlook, even sees a chance to salvage his literary career. As he is examining the snowmobile, he thinks:

> The Overlook didn't want them to go and he didn't want them to go either . . . Maybe he was part of it, now. Perhaps the Overlook, large and rambling Samuel Johnson that it was, had picked him to be its Boswell. You say the new caretaker writes? Very good, sign him on. Time we told our side. Let's get rid of the woman and his snotnosed kid first, however. We don't want him to be distracted. (309–310)

Jack's concern with status and social power dynamics is signaled from the beginning of the novel, from the very first sentence: "Jack Torrance thought: *Officious little prick*" (3). The situation is Jack's job interview with the manager of the Overlook. The manager, the officious little prick, Ullman, is highly condescending toward Jack, indelicately bringing up Jack's past mistakes, the loss of his previous job and his alcoholism. Jack in turn is highly aware of, and resentful toward, the asymmetric power dynamics: "Ullman behind the desk and Jack in front of it, interviewer and interviewee, supplicant and reluctant patron . . . his original dislike [for Ullman] washed over him again in a wave" (5, 7). Jack is here forced into a position of submission, and he hates it. His desire for status, exemplified in his fantasy-image of himself as "acclaimed playwright and winner of the New York Critics Circle Award . . . man of letters, esteemed thinker, winner of the Pulitzer Prize at seventy" (420), is a representation of a basic, universal motive. People, and men more strongly than women, evolved to desire status (Buss 2012, 361). As the psychologist David Buss notes, people can obtain status by two routes—dominance and prestige. Dominance is obtained by force or threat of force, and tends to be perceived as illegitimate, whereas prestige is "freely conferred deference" (365)—that is, legitimate status. As Jack's attempts to acquire status by prestige fail—he "had failed as a teacher, a writer, a husband, and a father" (365)—he turns to aggressive dominance, spurred by the evil forces of the hotel, themselves represented as metaphysical disembodiments of the violent dominance and illegitimate status wielded by the hotel's previous owners, the gangsters and amoral businessmen.

As the hotel's bad influence becomes increasingly evident—Jack becomes short-tempered and preoccupied, Danny has violent seizures that accompany his disturbing premonitions—Wendy becomes increasingly anxious to leave the hotel, even though it would cost Jack his job

and throw the family into economic despair. "She didn't like what the Overlook seemed to be doing to Jack and Danny" (209). Her primary concern is for her family's well-being. Jack, however, refuses to leave. He refuses to even acknowledge that there is a problem, a real danger to their son. After Danny has been attacked by the zombie woman in room 217, Jack goes to investigate. He senses that there *is* something in room 217, something nasty, and flees the room to report back to Danny and Wendy. That scene is followed by the novel's shortest chapter, a chapter called "The Verdict" and only about a quarter of a page long. " 'Nothing there,' he said, astounded by the heartiness of his voice. 'Not a thing'" (281). The chapter is called "The Verdict" because it signals Jack's decision to prioritize his ambition, his desire for status, over concern for his son's well-being. Jack's reasons for not wanting to quit his job and leave the Overlook are given in free indirect discourse, after Wendy has expressed her desire to flee the hotel on a snowmobile and go to Sidewinder, the nearest town:

> She hadn't said a word about what was going to happen to them *after* they got down, when the party was over . . . It was Danny this and Danny that and Jack I'm so scared. Oh yes, she was scared of a lot of closet boogeymen and jumping shadows, plenty scared. But there was no lack of real ones, either. When they got down to Sidewinder they would arrive with sixty dollars and the clothes they stood up in . . . There would be no job, not even part-time or seasonal, except maybe shoveling out driveways for three dollars a shot. The picture of John Torrance, thirty years old, who had once published in *Esquire* and who had harbored dreams—not at all unreasonable dreams, he felt—of becoming a major American writer during the next decade, with a shovel from the Sidewinder Western Auto on his shoulder, ringing doorbells . . . (294)

That "picture" scares Jack more badly than any supernatural agent in the hotel (294). The real boogeyman, for Jack, is this vision of himself in a degrading, low-status job, emasculated and pitiable. His fear of that boogeyman is strong enough that it overrides his concern for his family. Jack's train of thought is followed by an impulse to kill Wendy, an elaborate, murderous fantasy. Then Jack notices that Danny is having a nightmare. "The bitter shock of his emotions was broken. He got out of bed, and went across to the boy feeling sick and ashamed of himself. It was Danny he had to think of, not Wendy, not himself . . . And no matter what shape he wrestled the facts into, he knew in his heart that Danny must be taken out [of the Overlook]" (296). At this point in the novel, Jack is still torn between conflicting motives, but it becomes increasingly unpleasant for

the reader to be in his head as he gradually suppresses his affiliative dispositions in favor of selfish dominance behavior and murderous aggression.

Jack's disturbing psychological development is powerfully signaled by the use of a shift in his perspective as he twice recollects a childhood episode of his father's brutal, drunken beating of his mother. King represents Jack's first recollection of the "irrational" (248) beating in grisly detail, describing the seven *"whumps"* (247) that issue when Jack's father smashes his cane into Jack's mother's head, whumps that split her scalp, send her glasses flying into the gravy on her plate, and put her in the hospital for three days. Jack remembers the incident with horror and revulsion, but when he revisits the episode much later in the novel, as his descent into homicidal insanity is much further along, he can "see how necessary that [beating] had been, how his father had only been feigning drunkenness, how his wits had been sharp and alive all along, watching for the slightest sign of disrespect . . . now, twenty years later, he could finally appreciate Daddy's wisdom" (422). Jack's change in perspective suggests that the scales have tipped, that he is now more evil than he is good, that the forces of darkness are winning. He is now embracing violent domination as a legitimate route to status and fulfillment.

In King's conception, the forces of darkness, or evil, may be characterized as supernatural forces, but they are ultimately rooted in human nature, as selfish motives that conflict with motives for parental care and interpersonal love. King never tells us exactly what the supernatural forces of the Overlook want or how they came to be, but he does characterize the hotel's ghosts as abusive, power-hungry, status-seeking, aggressively dominant forces that supply Jack with alcohol to bring out those same forces in him. There is a suggestion that the hotel is evil simply because bad people have done bad things there: "drugs, vice, robbery, murder" (179). The woman in room 217, Mrs. Massey, went to the Overlook to pursue an extramarital affair with a paid lover who abandoned her, resulting in her ignoble suicide in the bathtub. Previous to that, mobsters staying in the hotel had liquidated another gangster and his two bodyguards with "heavy-gauge shotguns at close range," removing his testicles before they fled the scene (180). In a key scene Jack is surrounded by ghosts in the hotel bar, including the hotel's previous owner, Horace Derwent, a millionaire playboy deeply involved in organized crime, including bootlegging, gambling, prostitution, and the weapons trade. Derwent finds great pleasure in taunting and degrading a friend and erstwhile lover, Roger, making him act like a dog for the entertainment of the other ghosts. "Derwent was now holding a tiny triangular sandwich over Roger's head and urging him, to the general merriment of the onlookers, to do a somersault . . . Roger suddenly leaped,

tucking his head under, and tried to roll in mid-air. His leap was too low and too exhausted; he landed awkwardly on his back, rapping his head smartly on the tiles. A hollow groan drifted out of the dogmask. Derwent led the applause. 'Try again, doggy! Try again!'" (385–386). The public degradation of a friend may seem like a trivial pastime for a supernatural force of evil, but the scene does suggest that evil is at base human, that it is a product of human behavior, more specifically the behavior fostered by the ethos of organized crime, an ethos built around pure dominance and power hierarchies. Social dominance is universally integral to the notion of evil because dominance by definition is in tension with the prosocial motives necessary for collaborative action and social cohesion (Kjeldgaard-Christiansen 2016). Humans, like other primates, have evolved dispositions for dominance, but unlike other primates, they tend to demonize those dispositions and privilege prosociality and egalitarianism (Carroll et al. 2012). Jack can get power and respect by collaborating with the hotel's forces, but those forces are antithetical to family sentiment, to compassion and mutual love—those forces are, in King's perspective, evil. Thus, King taps into evolved folk morality by setting up a zero-sum game between dominance-seeking forces and affiliative, prosocial dispositions.

By the end of the novel, when he attempts to murder his son with a mallet, Jack has wholly submitted to evil. The three dark forces that haunt Jack—his own destructive dispositions, the legacy of his father, and the evil of the Overlook—have come together in this mallet-wielding monster. Jack is, viewed from Danny's perspective, "the controlling force of the Overlook, in the shape of his father" (468). Supernatural and psychological evil have the same antisocial motives, and those motives are violent domination and aggression. Hence the hotel's forces are able to lure Jack (and not Wendy, or Danny) with their promise of a position of power, prestige, and responsibility in the Overlook's cast of ghostly characters—here, then, is his "last and best chance: to become a member of the Overlook's staff, and possibly to rise . . . all the way to the position of manager, in time" (422). By now, all that stands between Jack and his final achievement of status and power are his wife and son.

Five-year-old Danny finds himself threatened by the supernatural forces of the Overlook. A child preyed upon by hostile forces is horrible enough, but King compounds the horror of that scenario by pitting the child protagonist's own father against him, and he makes the horror viscerally present by providing access to Danny's emotions and reactions. King lets us know very early in the novel that Danny is in danger. His precognitive visions warn him against the Overlook. He has visions—basic horror scenarios— of being alone, in dark and unknown surroundings, preyed upon by a

dangerous agent. In the novel's perhaps most memorable and terrifying scene (Herron 1982, 66), Danny goes to investigate room 217 despite Hallorann's warnings that the room is particularly haunted. He is driven by curiosity and, King suggests, spurred on by the hotel. As Danny enters room 217, we are in his mind, empathizing with him, sharing his perspective and his trepidation. This shared perspective with a sympathetic, vulnerable character gives the scene its evocative, mesmerizing power. King filters the description of the abomination in room 217 through Danny's mind, tinging the depiction with Danny's terror. He evokes a primal confrontation that pits a live, hyperactive consciousness—Danny's—against the horror of blank nothingness in human form, the undead woman in the bathtub.

The undead woman is described to evoke a strong fear-and-disgust response in the reader. Danny has entered the bathroom and pulls aside the shower curtain to see what it is hiding: "The woman in the tub had been dead for a long time. She was bloated and purple . . . Her eyes were fixed on Danny's, glassy and huge, like marbles. She was grinning, her lips pulled back in a grimace . . . Her hands were frozen on the knurled porcelain sides of the tub like crab claws" (239). That situation is nasty in its own right. A pathogen-riddled corpse evokes a powerful disgust response in humans (Curtis, Aunger, and Rabie 2004), and even holding this image in one's mind is unpleasant. It gets worse when the corpse begins to move. "Still grinning, her huge marble eyes fixed on him, she was sitting up. Her dead palms made squittering noises on the porcelain . . . She was not breathing. She was a corpse, and dead long years" (239). A decomposing corpse with *agency*, with malicious intent and the capacity to move, is a horrifying concept to a prey species vulnerable to infection. It violates a basic human intuition about dead organisms—they're not supposed to have intent and locomotion—and is highly dangerous. The reader's horror and revulsion are compounded by King's description of Danny's reaction to this monster. "Danny shrieked. But the sound never escaped his lips; turning inward and inward, it fell down in his darkness like a stone in a well. He took a single blundering step backward . . . and at the same moment his urine broke, spilling effortlessly out of him . . . Danny turned and ran" (239).

TS is efficient as a horror story because it puts the reader into the minds of realistically depicted characters who are faced with highly hazardous situations. But more than eliciting strong emotional responses in the reader, the novel offers the psychological and social insight that readers have come to expect from King's novels. In its depiction of Jack's struggle and eventual failure to suppress his own weaknesses and destructive impulses, the novel offers a moral vision of evil as essentially antisocial and an aspect of human

nature—an aspect of human nature which may be natural, but which is not inevitable. Only Jack, after all, succumbs to the siren call of evil. Hallorann, Danny's surrogate father, resists it, as do Wendy and Danny. *TS* remains one of the most popular horror novels of all time because it so effectively evokes and explores biologically salient conflicts and fears, and because it offers a compellingly hard-nosed but ultimately optimistic perspective on those conflicts and fears. In the novel's epilogue, King has Hallorann offer Danny the following advice: "The world's a hard place, Danny. It don't care. It don't hate you and me, but it don't love us, either . . . The world don't love you, but your momma does and so do I . . . see that you get on. That's your job in this hard world, to keep your love alive and see that you get on, no matter what" (497). Like other accomplished tragedies, *TS* "engage[s] painful emotions but leave[s] us feeling that we have a deeper and more adequate understanding of the forces that drive human experience" (Carroll 2012a, 59). Specifically, *TS* leaves us feeling that we have a better understanding of the *dark* forces in this world—most pertinently, the aggressive, destructive, dominance-seeking impulses in human nature, impulses powerful enough to override affiliative, prosocial impulses in particular circumstances. That is the psychological truth forcibly conveyed in *TS*.

CHAPTER 11

Hack n' Slash

Halloween *(1978)*

On Halloween night, six-year-old Michael Myers inexplicably murders his teenage sister with a kitchen knife. He is committed to a mental institution. Fifteen years later, Myers escapes the institution and returns on Halloween night to his home town—quiet, suburban Haddonfield, Illinois. Myers, wearing a creepy mask and a mechanic's uniform, begins stalking three local teenagers—Laurie, Annie, and Lynda. Laurie spots him lurking in the distance on several occasions and expresses her concern, but her carefree friends laugh at her anxiety. Meanwhile, Myers's psychiatrist, Dr. Loomis, has followed Myers to Haddonfield and tries unsuccessfully to warn local law enforcement about the danger posed by Myers's "pure evil." Myers, in the meantime, kills Annie, then Lynda's boyfriend, and finally Lynda. He attacks Laurie, who fights back while protecting the two children that she's babysitting. Loomis arrives in the nick of time and empties a revolver into Myers, who falls from a second-story balcony. When Laurie and Loomis look for Myers on the ground, he has disappeared (Carpenter 1978).

Halloween was a surprise box office hit. It was cheaply made, featuring predominantly unknown actors and an uncomplicated plot. The film was independently produced and shot in only twenty-one days by the young filmmaker John Carpenter, who directed, cowrote, and scored the film (Rockoff). While *Halloween* was clearly influenced by earlier films such as *Psycho* (Hitchcock 1960), *Black Christmas* (Clark 1974), and *The Texas Chain Saw Massacre* (Hooper 1974), which also depicted young protagonists killed by psychopaths, Carpenter's film kicked off the slasher film craze, spawning

a staggering number of derivative films—sequels, knock-offs, and eventually remakes. *Halloween* became a signal example of the slasher film, a film type "characterized by a distinct story-structure that concerned a shadowy blade-wielding maniac stalking and killing a group of fun-loving young people in an everyday non-urban setting" (Nowell 2011a, 54). This film type would prove extremely attractive to film producers looking to turn a buck, and went on to become the "most high-profile [cinematic] production trend" of the 1980s (Nowell 2011b, 137). Slasher films could be made quickly and cheaply, and they were eagerly consumed by a huge teenage cinema audience. The so-called first wave of teen slasher films, which began with *Halloween* and continued into the early 1980s, saw the release of more than a dozen similar films within a couple of years.

Why were teenagers attracted to slasher films? What was the appeal of looking at "fun-loving" teens being slashed to death by some "blade-wielding" creep? Critics have looked to the *Zeitgeist* in their search for answers. Kendall Phillips argues that teenaged audiences in the late 1970s and early 1980s were feeling subconscious guilt over their own fun-loving, hedonistic lifestyles and turned to slasher films in an attempt to assuage that guilt by witnessing fictional counterparts getting their just deserts at the hands of a monstrous enforcer of conservative morality (2005, 140). Others have argued that audience members—consisting, supposedly, predominantly of males—were perniciously identifying with the slasher killer, finding misogynist pleasure in his mutilations of female characters. The prominent film critics Roger Ebert and Gene Siskel engaged in a public campaign against what they called "women in danger films" (Kendrick 2014), which included slashers and rape-revenge films, claiming that many such films encouraged the audience to identify with a misogynist killer. They exempted *Halloween* from their crusade, however, because they felt that it displayed real "artistry" (Ebert 1981, 56) and, more importantly, did not invite viewers to sympathize with the killer. So most critics agree that early slasher films encode a conservative backlash against the liberal values and sexual liberation advocated by the counterculture (Dika 1987, Hutchings 2004, Phillips 2005). Robin Wood called slasher films "depressingly conservative" (Wood 1987, 82). Mark Jancovich cites several critics to the effect that slashers "act to contain [female sexuality] by presenting the sexually active women who are killed as merely 'getting what they deserve'" (Jancovich 1994, 29). Yet these interpretations don't get at the heart of slasher films like *Halloween*. There is no evidence to support that American teenagers felt guilt over their hedonistic lifestyle, or that slasher films assuaged such guilt if it did exist. Slasher film audiences were not, in fact, predominantly male—they consisted of at least

50 percent females, according to Vera Dika (1987, 87), and many such films, *Halloween* included, were marketed explicitly to female teenagers (Nowell 2011a, b). Most slasher films did not wallow in depictions of mutilations of female characters—research has documented that the victims in slasher films are, in fact, fairly evenly distributed across the sexes (Dika 1987, 89–90, Nowell 2011a, 251–252, Weaver et al. 2015). Early slasher films did tap into culturally salient anxieties, including anxieties over large-scale shifts in the American sociopolitical landscape such as a partial shift from family- and community-oriented values toward a more egocentric ethos, as well as a perceived decay of suburban middle-class life (Gill 2002). *Halloween* thus depicts teens left to fend for themselves, with no help from adult authorities, in a suddenly dangerous world—but that scenario resonates beyond its cultural moment.

Halloween's emotional and imaginative power has its wellspring in human nature. The central premise of the film—the threat of being killed by another human—reflects an evolutionarily ancient hazard, one that has left traces deep in our constitution. Conspecific predation has been a constant danger of social life for millions of years (Buss 2005, Duntley 2005), and *Halloween* effectively evokes that danger in a contemporary setting (Clasen and Platts *in press*). The film gets its power from depicting, and aligning audiences with, likeable and peaceful characters in quiet, well-ordered, and safe suburbia, which is suddenly infested with a homicidal agent who is simultaneously subhuman and superhuman. Those characters that are too busy pursuing hedonistic pleasure and carefree social interaction to notice the infiltration of danger are killed. The one vigilant character, Laurie Strode, registers the threat and saves not just herself, but also the children in her care. Some critics have suggested that Laurie Strode, the genre-typical "Final Girl" (Clover 1992), is spared because she alone, among the female characters, does not violate a sexually conservative and patriarchal ideology (Phillips 2005, 139). Carpenter himself has repeatedly contested this interpretation (Boulenger 2001, 99). The proximal narrative motivation for her survival is that Laurie Strode is the only character who detects and responds adequately to the danger. In one scene, Laurie is walking with her friend Annie and sees Myers standing on a pavement, observing her, and then slipping behind a bush. Annie fails to see Myers but goes to investigate and finds nothing. She dismisses Laurie's anxiety, saying "you're wacko, now you're seeing men behind bushes." In another scene, Laurie is in a classroom, taking notes and looking slightly bored as the teacher is droning away in the background. She looks out the window and spots Myers standing immobile across the street. The teacher then distracts her by asking her a question, to which Laurie promptly

Figure 11.1: A character from John Carpenter's seminal slasher *Halloween* (1978) chatting on the phone, blissfully unaware of homicidal Michael Myers lurking in the background. The audience realizes that she is in danger, and that she doesn't realize it, which produces empathetic anxiety and engagement.

delivers an intelligent answer. Not only is she vigilant, she is bright and conscientious—the focal point for our sympathy. Other characters are less keenly observant, and *Halloween*'s most suspenseful scenes involve protagonists acting or interacting with no clue that Myers is lurking nearby. A scene shows Annie talking on the phone with her back to a glass door. We notice the sudden, ghostly appearance of Myers behind the door (Figure 11.1), but Annie doesn't register him. She keeps chatting frivolously into the phone. We know that she's in acute danger, and we know that she doesn't know. This asymmetric narration—alerting the audience to danger ahead of the characters—is crucial in fostering audience engagement. As Dika notes (1990), slasher film audiences frequently attempt to interact with the screen—yelling warnings to characters, berating them for ill-advised behaviors ("don't go in there!"), and so on. Awareness of danger, then, is a chief thematic concern in this film. Pennington observes that "[u]sually in slasher movies, ignorance of lurking danger diminishes a character's chances for survival" (2009, 59), and he is right to point to this pattern as a genre convention, but the convention is rooted in real-world patterns of predator-prey relations. Ignorance of lurking danger reliably diminishes actual organisms' chances for survival, and *Halloween* is structured around this basic biological fact. Laurie alone among her peers is sufficiently vigilant to survive, and sufficiently altruistic to deserve our full sympathy. Late in the film, when Myers enters her house on his killing spree, she gets the children in her care to safety before worrying about

herself. The moral economy of the film allows her to survive because she responds prudently to danger and because she cares for and about others, in contrast to her self-involved peers who happily hand over their babysitting duties to Laurie to pursue sex with their boyfriends.

Halloween encourages the audience to root for Laurie Strode and to be afraid of Michael Myers. Nonetheless, some critics have interpreted the use of point-of-view cinematography in the first scene of the film—a scene shot from young Myers's perspective—as an invitation to identify with him. As Roger Ebert wrote, "when the camera takes a point of view, the audience is being directed to adopt the same point of view" (1981, 55). And in Phillips's words: "*Halloween* forces its audience members to implicate themselves in the acts of killing and being killed" (2005, 141). But visual alignment does not entail moral alignment or even sympathetic identification (Smith 1995). Slasher films routinely use point-of-view cinematography to suggest the presence of an agent undetected by the protagonists and to withhold the identity of that agent from the audience (Dika 1987, Hutchings 2004). It is a suspense technique, and in *Halloween*, it is only used in the opening scene. Here, we see through *somebody's* eyes as that person lurks around a house, spies on a couple of teenagers inside the house, sneaks into the house, waits a few moments until the boy leaves (presumably after a remarkably rapid sexual encounter with the girl), and then enters the girl's bedroom. The girl, naked and brushing her hair, recognizes the intruder and exclaims: "Michael!" Along the way, our point-of-view character has picked up a kitchen knife and put on a mask. The ominous music suggests that the character has malicious intent. Indeed, he stabs the naked girl to death and leaves the house with the bloody knife in his hand. Outside, he is met by a middle-aged couple—presumably just back from a night on the town— who ask: "Michael?" and remove the mask. The camera angle shifts, and we see that the knife killer is a small boy in a Halloween costume. We deduce that the couple are Michael's parents and the victim his sister. The scene is structured to powerfully bring home the depth of this child's depravity, not to seduce us into identifying or empathizing with him. As Carpenter himself put it, "the whole movie is about surviving horror, it's not about identifying with horror. No. It's 'Watch out!'" (personal communication).

Carpenter constructed a cinematic world that in its all-American setting and its mimetic depiction of teenage protagonists was intimately familiar to the target audience. The kids in the audience knew this kind of town, perhaps they lived in towns that looked like Haddonfield; they knew the types of teenage kids that they saw on the screen, they knew their mannerisms and clothing styles and their topics of conversation. The director wanted to get away from the conspicuously creepy locations often used in

older horror films—he wanted to "take a horror movie and put it into a suburban atmosphere, with a nice little row of houses and beautiful manicured lawns and some place that you can assume is very safe. Because if horror can get you there, it can get you anywhere" (qtd. in Jones 1997, 64). He asked his young co-writer, Debra Hill, to pen the dialogue of the female cast to make it realistic. The premise of *Halloween* is extremely implausible—pure evil doesn't really exist, only as a cognitive label used to dehumanize antagonistic others and as an illusory metaphysical concept (Clasen 2014, Kjeldgaard-Christiansen 2016), and even garden-variety serial killers are exceedingly rare (Buss 2005)—but this use of realism in setting and character depiction made the premise imaginatively accessible and urgent.

Michael Myers is a homicidal force driven by alien, private motivations and in possession of quasi-supernatural powers. He moves around swiftly and silently, almost impossibly so, and his mind is utterly inaccessible to the viewer. David Buss, in his study of the evolutionary psychology of homicide, explains that when people kill other people, they are rarely driven by psychopathology. Rather, they have intelligible and often rational reasons for killing:

> Murder gives us an X-ray of the inner core of human nature. It lays bare the things that matter most to humans everywhere—the necessities of survival, the attainment of status, the defense of honor, the acquisition of desirable partners, the loyalty of our lovers, the bonding of our allies, the vanquishing of our enemies, the protection of our children, and the successes of the carriers of our genetic cargo. These are the things that we humans and our astonishingly victorious ancestors have always been willing to kill and die for. (2005, 244)

If Michael Myers's murders are X-rays, they bounce off his pale, expressionless mask. There is nothing to lay bare behind it. He is not motivated by any discernible emotion or motive; no search for status, no honor to defend, no sexual desire—nothing to protect. Moreover, Myers's mask literally blocks our attempts at inferring his state of mind through his facial expression. Humans evolved an ability to infer the content of others' minds through their behavior, including their facial expressions; by obscuring a villain's face with paint or a mask, a filmmaker can make that villain even more disturbing (Clasen 2012b). There is no predicting the villain's behavior, no negotiating with him; there are no visible human emotions to appeal to. A key scene elegantly shows Myers's inhumanity. Bob, Lynda's boyfriend, is rummaging through a dark kitchen, looking for a beer and glasses. We faintly hear Myers's heavy breathing on the soundtrack, which tells us that he is nearby. A door creaks open. Bob goes to investigate,

thinking his friends are pulling a prank on him. "Okay, Lynda. Come on out," he says, opening another door. Shockingly, Myers bursts from the door, brutally slamming Bob up against a wall. With inhuman strength, Myers lifts him one-handedly from the floor and with the other hand pins him to the wall with a knife through the abdominal region. Myers stands back and looks at his victim as life leaves the body and it ceases to move. Myers, standing still, tilts his head first to the right, then to the left, and then to the right again. The effect is deeply disturbing. Here is a man who has just violently assaulted and killed an innocent stranger. What does he do? He stands back and admires, in a slightly puzzled way, his handiwork (see Figure 11.2). The scene suggests that Myers is homicidal, yes, but also that he is devoid of empathy, of humanity. To him, other people are fleshbags that either move or they don't. When stabbed, they stop moving. When strangled, they stop moving. Dr. Loomis, Myers's psychiatrist, says that when he met six-year-old Myers "there was nothing left. No reason, no conscience, no understanding; even the most rudimentary sense of life or death, good or evil, right or wrong . . . I spent eight years trying to reach him, and then another seven trying to keep him locked up because I realized what was living behind that boy's eyes was purely and simply . . . evil." The film corroborates the psychiatrist's assessment. We don't know why Myers does what he does, and some of his behavior is disturbingly illogical. By the end of the film, Laurie nervously enters the house in which she suspects that Lynda may be in trouble. As she enters a bedroom, she finds

Figure 11.2: Michael Myers of Carpenter's *Halloween* (1978) has just stabbed an innocent guy to death. He stands back and gazes quizzically at the result, not unlike a bewildered patron in a gallery of modern art. The scene suggests Myers's inhumanity, his lack of empathy; he is a monstrous semihuman agent of death.

the corpse of Annie splayed on a bed. Above her head sits Myers's sister's gravestone, which Myers has stolen from the cemetery. The corpse of Bob swings out of a closet, suspended from the legs. Another closet door swings open, revealing the body of Lynda. Why has Myers arranged this tableau of terror? How did he do it so swiftly? The film doesn't tell us. It uses the scene to reinforce our sense that Myers is beyond rational reach, that he is dangerously erratic and unnaturally quick and strong (Kendrick 2014).

The filmmakers' decision to deny the audience access to Myers's motivation has prompted some critics to invent it. Robin Wood, for example, says that "the basis for the first murder [is] sexual repression—the girl is killed because she arouses in the voyeur-murderer feelings he has simultaneously to deny and enact in the form of violent assault" (Wood 1979, 26). The film gives us no cues to suggest such an interpretation—the cues are in Wood's head, spawned by dubious Freudian ideas about perverse infant sexuality. Likewise, Peter Hutchings says of Myers's murder of his sister that it is "redolent of social taboos such as incest and child sexuality, with a young child stabbing his naked, postcoital sister to death with a large and decidedly phallic carving knife" (2004, 74). A more plausible interpretation, one in line with the film's actual content cues, is that six-year-old Myers is a raging sociopath, possibly prompted to attack his sister because she pursues selfish pleasure rather than looking after him while their parents are away, possibly—and more likely—driven by no intelligible motive at all—that he is "purely and simply evil," in Loomis's phrase. When his parents remove his mask after the murder, young Myers has a blank, almost sleepy facial expression. There's no lust, no rage, no strong emotion in his face. Moreover, there is really no interpretative need to invest the knife with psychosexual significance. The choice of a knife as murder weapon is narratively motivated—it's one of the few lethal implements accessible to a six-year-old in normal circumstances—and contributes to the revolting quality of Myers's killings. As Kendrick points out: "Unlike being shot from a distance, as is typical in most action-adventure films and thrillers, being stabbed is a deeply personal, physically close violent action that leaves a lingering sense of discomfort in the viewer" (2014, 319).

Adult Myers is a reflection of a persistent ancestral threat, the homicidal male, yet dehumanized and apparently impossible to kill. He bears some resemblance to the great white shark of *Jaws* (Nowell 2011a, 92), with the crucial difference that unlike the shark, which is confined to its element, Myers roams freely and can emerge anywhere. During the course of the film, he is stabbed with a sewing needle, a steel coat hanger, and a kitchen knife, and he is shot six times at close range, falling wounded from a second-story balcony, yet still he keeps going. The film ends with a montage, showing

static images of places that have been haunted by Michael Myers and over-laid with the sound of Myers's breathing, suggesting that not only is he still alive, he could be anywhere. Myers became a horror icon not because he is a symbolic embodiment of sexual guilt or a castrating, phallus-wielding agent of conservatism, but because he is a supercharged representation of an ancient danger—a murderous conspecific outside rational reach, an individual perfectly capable of, and willing to, take lives using what-ever implement is at hand. As David Buss notes, people's fascination with murders and murderers "results from our evolved homicide-prevention psychology" (2005, 21). Throughout human evolutionary history, other people have consistently been "one of the most pervasive hostile forces of nature" (Duntley 2005, 224). This fierce selection pressure has resulted in evolved cognitive biases that "lead people to overinfer homicidal intent in others" so that they "systematically overestimate the likelihood that they will be killed" (241), particularly in situations of great uncertainty, as a defensive measure—a false alarm is infinitely better than a miss. We evolved to swiftly detect anger in others and to pay close attention to hos-tility in conspecifics (Öhman, Lundqvist, and Esteves 2001), to be vigilant toward potential killers, and the fascination that murders and murderers command extends to fictional representations of slasher villains. Indeed, Myers is even more dangerous than the homicidal individuals that have threatened our ancestors for millions of years, with his quasi-supernatural powers and complete lack of humanity. Once we understand the evolved psychological dispositions targeted by this figure, it's no wonder that he became a cinematic icon, an enduring symbol of human evil.

Halloween hit a nerve in contemporary audiences and significantly influ-enced subsequent horror films. Shortly after the first wave of slasher films petered out in the early 1980s, a second wave took off with *A Nightmare on Elm Street* (Craven) in 1984. In the 1990s, a third wave of genre-savvy slasher films—kicked off by *Scream* (Craven) in 1996—delighted fans of the films in the first waves as well as a new generation of horror fans. The films in the third wave explicitly toyed with genre conventions and presumed knowledge of those conventions in their audience. In *Scream*, the protago-nist, Sidney Prescott, receives a threatening phone call from the killer. He asks: "Do you like scary movies?" Sidney replies: "What's the point? They're all the same. Some stupid killer stalking some big-breasted girl who can't act, who is always running up the stairs when she should be running out the front door. It's insulting." All slasher fans will recognize with delight the kind of hackneyed film to which she is referring. The 1999 film *Cherry Falls* (Wright) turned the perceived plot convention of sex-equals-death on its head and introduced a slasher killer who targeted only virgins, sending

the teenage population of an entire town into a sexual frenzy. Yet no matter their postmodern self-awareness or clever convention-juggling, films in all three waves work when they effectively target evolved dispositions, chiefly the disposition for detecting and reacting adequately to homicidal conspecifics. *Halloween*'s original target audience—American suburban teenagers—were particularly receptive to the scenario of the film. They were at the life stage where one is learning to fend for oneself, and they may have felt that the world was less safe and less stable than they had previously assumed. Family structures were loosening, social and sexual norms were slowly shifting, the world was changing around them. *Halloween* resonated with audiences because it tapped into a diffuse sense of unease. It transformed that unease into a full-blown terror scenario with the infestation of an almost otherworldly agent of evil into peaceful suburbia, an agent who would suddenly appear in between the nice little houses and on the beautifully manicured lawns and disappear just as suddenly, lurking just out of sight.

Carpenter gave his audiences a thrill; he allowed them to immerse themselves into an evolutionarily potent scenario of predation, but he also wanted to suggest that evil can be conquered. As he expressed it: "If there's any point to be made in the film, it's that you *can* survive the night . . . being aware of the possibility of evil is an important thing in life . . . the world can be bad and dark and dangerous, but with a little luck and awareness you can survive" (Carpenter 2003). That interpretation of the film aligns well with the evolutionary hypothesis that horror stories function as threat-simulation devices. They sensitize us to danger and have real emotional, cognitive, and behavioral effects—but they can also help us think about evil and to cope with danger and calibrate our responses to it.

CHAPTER 12

Lost and Hunted in Bad Woods

The Blair Witch Project *(1999)*

The Blair Witch Project opens with a brief message written in white letters on a black background: "In October of 1994, three student filmmakers disappeared in the woods near Burkittsville, Maryland while shooting a documentary. A year later their footage was found." The message is followed by the students' footage, edited into a coherent narrative about three young amateur filmmakers chasing the legend of the Blair Witch. According to this legend, a ghostly witch—Elly Kedwards—has haunted the woods outside of Burkittsville (formerly Blair) since she was killed in the late eighteenth century over suspicions of witchcraft and child abductions. Ever since, children from the area have irregularly and mysteriously disappeared. In the 1940s, Rustin Parr, a local hermit, abducted and killed seven children, claiming to have acted under the influence of the witch ghost. Now director Heather Donahue and her two helpers—camera operator Josh Leonard and sound recorder Mike Williams—interview Burkittsville locals about the legend and travel into the Black Hills in search of the witch. They soon lose their way in the vast woods, and come across eerie signs: what appears to be a primitive cemetery with seven stone cairns, one of which is accidentally knocked over by Josh, as well as a number of humanoid stick-figures suspended from trees. Forced to camp out in the woods, they are awoken in the middle of the night by disturbing, unidentifiable noises. Trust among the three deteriorates as they lose their map and become irrevocably lost. Josh then disappears, a bundle of cloth containing bloody teeth appears

outside their tent, and Heather and Mike follow screams to a decrepit house. Following the screams into the basement, Mike and Heather apparently meet their deaths at the hands of an unseen agent. The last shot of the film is taken by Heather's camera which lies, dropped and still recording, on the floor of the basement.

The Blair Witch Project (Sánchez and Myrick 1999, henceforth BWP) is probably more famous for its low-budget production and marketing history than for its aesthetic qualities. Most academic research has focused overwhelmingly on the Blair Witch phenomenon's transmedia intertextuality, its innovative cross-platform marketing campaign, and the unconventional methods used in shooting the film (Higley and Weinstock 2004, Roscoe 2000, Turner 2015, Velikovsky 2014). Months before BWP premiered in New York in July 1999, audience interest was piqued by auxiliary media products. Two days before its cinema release, a 45-minute documentary, Curse of the Blair Witch (Myrick and Sánchez 1999), about the Blair Witch legend and the missing filmmakers was broadcast on the Sci-Fi (SyFy) Channel (Roscoe 2000, Turner 2015). That documentary featured shots of forensic evidence, clips from news broadcasts, and interviews with law enforcement personnel, historians, and relatives of the three filmmakers. It was all fabricated, of course, but made to look authentic. Prior to that, missing persons posters with images of Heather, Josh, and Mike were distributed on university campuses (Keller 2004). And in June 1998, the website www.blairwitch.com was launched. It was the 45th most visited website on the entire web (Katz 1999), garnering 75 million hits in one week, according to one source (Roscoe 2000). Like Curse of the Blair Witch, the website featured forensic photos, background information on the witch legend, and information on the missing film students. Dozens of fan websites were constructed, with passionate discussions about the ontology of the Blair Witch and whether it was all a hoax. Many people just didn't know. For some time after BWP's premiere, the Internet Movie Database listed Donahue, Leonard, and Williams as "Missing, presumed dead" (Newman 2011, 439). The book The Blair Witch Project: A Dossier (Stern), released in September 1999, included more fake police reports, entries from Heather's diary, and other bits of pseudodocumentary material that presented BWP's premise as fact. This was all part of directors Eduardo Sánchez and Daniel Myrick's plan. They did not set out to construct an elaborate hoax, but they did equivocate and they did encourage doubt (Klein 1999, Roscoe 2000). The incredible commercial success of the whole project—the film was produced for $60,000 plus advertising costs and has grossed close to a quarter of a billion dollars—landed Sánchez and Myrick on the cover of Time magazine in August 1999.

While most critics engaging with BWP have focused on its extraordinary production and marketing history, a few have engaged with the symbolic content and subtext of the film. None has gotten into clear focus the psychological underpinnings of the film's commercial success. Alexandra Heller-Nicholas (2014), approaching BWP from a feminist perspective, sees it as a misogynistic film. She suggests that Heather is being punished for assuming control over the filmmaking process—for attempting to take control of the male gaze embodied in the camera—and for thus attempting to "demasculinize" Josh and Mike (Heller-Nicholas 2014, 109). Heller-Nicholas claims that the late scene depicting Josh's verbal assault on Heather for "still making movies" despite their desperate situation meaningfully mirrors an early shot of a bag of marshmallows in a shopping cart. Zooming is involved in both shots. The first shot zooms in on the marshmallows, the second one on Heather. This formal parallelism, suggests Heller-Nicholas, signifies "the instinct of the masculine gaze to reduce female flesh—and a woman's suffering—to a soft, accessible commodity" (109). It's a stretch, one that distorts the meaning and narrative function of these scenes. The early scene with the marshmallows shows us carefree film students preparing for what they assume will be a camping trip with bonfires and marshmallow roasting. The function of that scene is to provide a stark contrast with the later shots of film students who are exhausted and terrified, and for whom the state of their marshmallow stash is the least of all worries. In the latter scene, Josh is scolding Heather for failing to recognize the danger they are in, for prioritizing the film project over the group's safety. That scene contributes to the film's theme of danger overlooked, and it implicitly justifies and motivates Heather's continued filming (without which there would be no film)—"It's all I have fucking left," she sobs in response to Josh's assault. Moreover, Heller-Nicholas attempts to bolster her ideological reading by claiming that the film itself suggests that there is no witch, but that viewers irrationally maintain their belief in the witch "against the film's own internal logic" because they feel comfortable by "blaming women" (107). What really happens, she says, is that Josh goes crazy and kills his comrades, yet viewers are reluctant to blame a guy. The claim is unconvincing because the film's internal logic strongly suggests supernatural agency. The film gets most of its power from the suggestion of supernatural agency, and it offers many cues to suggest such agency—most prominently, the nightly disturbances documented from within the tent, with Josh present—and no cues to suggest that Josh is homicidally insane. Like poststructuralist readings that see the Blair Witch phenomenon as a collection of signifiers bopping around in a textual funhouse (Keller 2004), Heller-Nicholas's ideological interpretation does little

to explain the imaginative and emotional power of the film. An adequate explanation of that power gets into focus the psychological dispositions targeted by the marketing campaign and by the film itself.

The success of *BWP* is not exclusively a function of an efficient transmedia marketing effort, nor of postmodern intertextual mind-games or misogynist spectacle, but crucially depends on the film's (and the auxiliary media products') ability to target evolved psychological mechanisms. The very premise of the film—individuals becoming lost in an unknown, hostile environment, hunted by some malignant, apparently supernatural agent—is highly salient because it engages powerful defense mechanisms in human nature. *BWP*'s premise resembles the central scenario in hunter-gatherer stories about the dangers of wandering into the wilderness and the risk of getting lost, of starving to death, of being attacked by terrible antagonists. Such stories have been told through the ages to children in forager communities to discourage them from wandering off by emphasizing and exaggerating the attendant dangers (Scalise Sugiyama and Scalise Sugiyama 2011). The scenario of wandering off, getting lost, and perishing in the wild has been a real prospect for our ancestors for millions of years, and it is compellingly evoked in *BWP*. This film offered a depiction of three hip, ordinary-looking, vulnerable characters' eminently plausible reactions to a primal danger scenario. They were savvy youths who knew how to navigate socially—an early scene shows them relaxing and bantering in a motel room in Burkittsville (see Figure 12.1)—and handle high-tech audiovisual equipment, but who found themselves utterly powerless against the hostile forces of nature, including the supernatural agent who appeared to be stalking them; forces that they grievously underestimated. They ventured insufficiently prepared into a dangerous place, messed with a vast and evil force, and paid a terrible price for these transgressions. Moreover, the film's lure of authenticity, its implicit promise to show us authentic recordings of what actually happened, made the narrative premise even more salient. To most audiences, *BWP* promised more than make-believe. It promised access to real horror—to something that had actually happened, or might have happened, or at least looked the way it would have looked if it had actually happened (Heller-Nicholas 2014, 7).

The hype and expectation generated by the prelaunch campaign fed into an evolved disposition for morbid curiosity. Like so many other animals, we are captivated by the spectacle of violent death. Black-headed gulls, for instance, flee when a conspecific is attacked but hover in the distance to observe, to "learn what kind of adversary they are facing" (Kruuk 2002, 169). The adaptive rationale behind morbid curiosity is that paying attention to attacks on conspecifics and to the causes of violent death helps us

Figure 12.1: Sánchez and Myrick's *The Blair Witch Project* (1999) depicts fun-loving, hip American youths venturing into deep and dark woods on an ill-fated expedition to document the Blair Witch legend. They are good at handling high-tech audiovisual equipment and at having fun, but they grievously underestimate the hostile forces that lurk in the Black Hills.

avoid a similar fate (von Gersdorff 2016). The *BWP* marketing campaign lured audiences with intimations of strange and violent deaths at the hands of a malevolent, possibly supernatural agent. The website and the fake documentary provided pieces of the morbid puzzle; pieces of information, lore, and evidence that, if put together correctly, would lead audiences closer to the truth about the mysterious disappearance of the filmmakers. The film itself was the biggest puzzle piece, the main attraction, and the only part of the Blair Witch media complex that still draws a substantial audience. The ontological ambiguity that attached to the legend probably compelled many moviegoers to read up on the legend and buy movie tickets to get closer to the truth. The claims of authenticity and the multimedia campaign prompted audiences to take the film seriously and by doing so absolve in themselves the kind of error that led to the death of the protagonists. The film's "supplementary materials," with their information on the witch legend and pieces of forensic "evidence," were "enthusiastically embraced" not because they allowed audiences to retain their misogynistic understanding of the film as a supernatural story about an evil witch (Heller-Nicholas 2014, 111), but because they were felt to satisfy audiences' morbid curiosity and efficiently tapped into an evolved vigilance mechanism.

BWP is produced to look authentic in order to heighten audience response. Real horror is more terrifying than artificial horror, and people

who look genuinely frightened are more moving than people who are clearly just acting scared. The footage we see in the film is the footage recorded by the three actors. It is amateurish and shaky, frequently blurry—the raw footage of what actually happened, in other words. The audience is thus encouraged to view the film as a "neutral recording of real horror" (Roscoe 2000). The footage is shot on a consumer-grade video camera (a Hi8 camcorder) and a black-and-white 16mm film camera. The video camera is primarily handled by Donahue and used for behind-the-scenes footage, for documenting the documentary shoot, and the film camera is operated by Josh and used for shooting the footage that is to go into their documentary film. The actors themselves were cast on their ability to improvise convincingly (Turner 2015, 21–22), and they were directed to behave and react plausibly. Sánchez and Myrick gave the actors very little information about the movie. They received a crash course in the handling of audiovisual equipment and were sent to Burkittsville to interview locals. Some of the interviewees were actors themselves, others were real locals. Donahue, Leonard, and Williams were then given GPS units and sent into the woods, on their own, where they spent seven days, each day following GPS directions and finding fresh batteries for their cameras and sound recording gear as well as ever-smaller food rations and brief instructions on the day's route (Turner 2015, 22–29). The actors became increasingly hungry, cold, sleep-deprived, and genuinely anxious. They were harassed in the middle of the night by unseen crewmembers ruffling their tent and playing audio recordings of eerie sounds, including children's laughter. The many reaction shots of terrified, exhausted, panicking individuals (see Figure 12.2)—individuals who are genuinely frightened and under pressure—elicit empathetic mirroring in the audience and, together with the atmosphere of dread produced by the suggestion of malevolent supernatural agency, explain how *BWP* became "an extraordinarily effective horror film," in Roger Ebert's words (1999).

BWP infuses its depiction of youths lost in bleak and desolate woods with an insidious intimation of supernatural agency, but that agency is kept off-screen and unexplained. We never see any monster or any real violence. The closest we get to gore is a shot of bloody teeth. *BWP* effectively establishes and maintains an atmosphere of dread (Freeland 2004). Dread, in Cynthia Freeland's definition, is "an ongoing fear of imminent threat from something deeply unnerving and evil, yet not well-defined or well-understood" (2004, 191). That evil, poorly understood force is the witch (or whatever is haunting the characters) who is never directly witnessed—we only see the effects of her (or its) actions. Shortly after the filmmakers realize they are lost in the woods, they are woken up in the middle of the night by booming

Figure 12.2: *The Blair Witch Project* (Sánchez and Myrick 1999) features many reaction shots of genuinely fearful characters. The actors were put under tremendous pressure and kept in the dark for much of the filming in a successful attempt to elicit genuine responses from them, thus more powerfully cueing viewers to feel strongly about the events depicted in the film.

and crashing noises. These auditory cues are ambiguous, but they suggest agency. Their cause is withheld, but it is clear that someone or something is outside the trio's tent. They fail to capture the source of the noise on video. The next night something similar happens. The following morning they find three little piles of stones outside their tent, supposedly makeshift grave markers signifying their impending death and intended as a warning from the agent terrorizing them. The markers are especially unsettling because they suggest that whatever agency is about the woods, it's not a passive force. It targets *them* specifically. Soon thereafter, they come across a number of human-like stick figures suspended from trees (Figure 12.3). As Josh says, "That's fucking creepy." It's fucking creepy because the figures are clear signs of some obscure agency and because they connote death by hanging or crucifixion. The following night they are woken up as something rustles their tent and they hear children's laughter. Heather runs into the night with her camera. There are no children to be seen. The attached light source provides a circle of illumination chaotically jumping around as she is running with the camera. "Oh God, what the fuck *is* that," she screams, out of breath. We don't see what she sees. Josh then disappears. Heather

Figure 12.3: Sánchez and Myrick's *The Blair Witch Project* (1999) elicits dread through its insidious suggestion of a supernatural, malicious agent hiding in the woods. That agent targets the three protagonists and leaves behind ominous objects such as the stick figures dangling from the trees. The meaning of these figures is obscure, but they seem to suggest death by crucifixion or hanging.

and Mike hear screams of pain in the distance and eventually find bloody teeth wrapped in fabric from Josh's shirt outside their tent. We now know that they are not alone, and that whatever is hunting them has malicious intent and the capacity to inflict real damage. But because that agent is hidden from view, it is ambiguous and unknown, hence unpredictable. An unpredictable enemy is much more dangerous and thus terrifying than a well-known one, and this principle is exploited by *BWP* in its strategy of keeping the dread-evoking agent offscreen.

The three protagonists of *BWP* are depicted as lively, good-natured individuals. While there is in the film no sense that they deserve what they get, they do ignore warnings and foolhardily venture into a natural environment that they severely underestimate. The first scene shows Heather packing a book called *How to Stay Alive in the Woods*, but that does not help her much. They laugh at the old Burkittsville lady who tells them about the ghostly and dangerous Blair Witch, calling her crazy. They meet a pair of elderly fishermen in the woods who attempt to warn them. "Damn fool kids never learn," says one fisherman. As Ebert observes, the filmmakers view the legends and horror stories about the Blair Witch "as good footage,

not a warning" (1999). Early in the film, they come across seven little cairns, one of which is accidentally upset by Josh. Heather draws breath sharply. "You didn't just knock that over, tell me you didn't just knock that over." The film implies a causal relationship between this act of carelessness and Josh's fate. We have heard about Rustin Parr's murder of seven children and assume these cairns to be grave markers. Josh's carelessness is an inadvertent act of moral transgression, and the film subtly suggests that he is punished gruesomely for it. The greater transgression is the youths' lack of respect not just for the witch, but for the woods themselves. As Heather says when they realize the map has gone missing: "it's very hard to get lost in America these days, and it's even harder to stay lost." She is massively, fatally wrong.

The Black Hills woods are depicted as a bad place, colorless and dying, "a hiding place for dread secrets" (Higley 2004, 88, Ebert 1999)—a place invested with a suggestion of physical and moral corruption. The moral corruption of the area emerges from its unsavory history: Parr's murders, the witch's murders, and the crimes perpetrated against the witch herself. The psychological tendency to invest a place with moral value grows out of an adaptive tendency to associate fitness-relevant (and thus emotionally significant) events with their physical setting. The tendency is adaptive because attributing negative value to a place where something bad has happened would make people avoid dangerous places. If something bad has happened once, there is a certain likelihood of it happening again in the same place—especially in ancestral environments where natural dangers could reliably be associated with place, such as a particular area haunted by predators, treacherous features of topography, or a particular food or water source being contaminated. The same psychological phenomenon is at work when people shun houses in which murders or other particularly violent or grisly forms of crime have taken place. The immorality—the *wrongness*—of the crime is felt to have contaminated the setting (as with the Overlook Hotel). When the young filmmakers laugh off the Blair Witch legends, they disregard the real danger of the woods and pay the price.

BWP is not the kind of film one watches many times—it is not beautifully filmed, it has no elaborate production design, no aesthetically pleasing staging. The cinematography is nauseatingly amateurish, the production design scanty, and the staging often glaringly accidental. But those lacks are not deficiencies; they contribute directly to the power of the film. *BWP* was remarkably effective in using simple cinematic techniques and a suggestive multiplatform advertising campaign to engage audiences' attention and produce very strong emotional responses in them. The basic predation scenario connected with deeply conserved evolved dispositions, and

the lure of authenticity ramped up the perception of relevance. *BWP* was not the first found-footage horror film and certainly not the last, but it did launch the subgenre into the mainstream (Heller-Nicholas 2014, 95). Critics have argued that the film tapped into a context-specific fascination with conspiracies and the paranormal (Roscoe 2000) and millennial anxieties over uncertainty (Weinstock 2004, 242). Uncertainty, however, is endemic to the human experience because of limitations in our perception and understanding. We can never know anything for certain because our senses and cognitive powers are limited, and because the world is unpredictable in its complexity. Intentional agents are particularly unpredictable, which is why the depiction of youths lost in dark woods and hunted by some unseen agent is especially terrifying. *BWP* rose to cultural notoriety and commercial success not by immersing audiences in an elusive web of postmodern signifiers or by allowing them to wallow in misogyny and putative millennial anxieties. It rose to prominence by targeting evolved survival mechanisms through the multiplatform dissemination of a compelling pseudoauthentic story about malicious supernatural agency and vulnerable youths dying terribly at the hands of this agency.

Future Evolutions in Horror Entertainment and Horror Research

CHAPTER 13

The Future of Horror

I have argued that horror is culturally pervasive because the genre is uniquely suited for satisfying fundamental human needs, most centrally the evolved need for simulated experience with threat scenarios. As I have shown in my readings of modern canonical American works of literary and cinematic horror, such works can target a range of evolved emotions, offer wildly different imaginative experiences, and be informed by strikingly different worldviews. Some horror works are uplifting, others deeply depressing. Some depict scenarios of existential threat and philosophical despair, and some feature protagonists in collision with vicious predators or metaphysical evil. Some works aim at producing ephemeral sensations of shock, surprise, and disgust, others leave vivid and lasting impressions of the fragility of the mind and the evanescence of life. The best works of horror have the capacity to change us for life—to sensitize us to danger, to let us develop crucial coping skills, to enhance our capacity for empathy, to qualify our understanding of evil, to enrich our emotional repertoire, to calibrate our moral sense, and to expand our imaginations into realms of the dark and disturbing.

Horror works by engaging psychological mechanisms that evolved gradually and adaptively over millions of years, and the genre itself changes in response to cultural variation, including technological developments. Predicting the future of horror is difficult, but one thing is certain: Horror is not going away. As long as we are fearful, imaginative creatures, there will be a central place for horror in our culture, and there is no reason to believe that we will evolve into fearless, unimaginative creatures anytime soon. Evolution by natural selection works slowly, and the human fear

system as well as the imagination are such integral parts of our nature that a massive, sustained selection pressure would be required for evolution to whittle away at them. We need fear to stay alert and alive in an occasionally dangerous and unpredictable world, and we need imagination to make sense of this world and our place in it, and to guide our behavior—even in the 21st century and, presumably, beyond.

Our great-grandchildren's horror will resemble our horror in most respects. The media will change—the content, less so. Like ours, the horror of our great-grandchildren will depict humans clashing with dangerous, unnatural forces. It will capitalize on our evolved fears and anxieties and feature predatory, supernatural, disgusting agents preying on humans. They will have access to a wider range of horror experiences, some of which are more immersive and much more emotionally powerful than anything we have today. Technological innovations will provide new outlets for the desire to get experience with negative emotion and threat scenarios in safe settings. We are already seeing such innovations emerge and take hold. Horror video games are entering a phase of maturity, and immersive virtual reality technology is now both affordable and convincing. Other forms of real-time interactive horror experiences, such as so-called haunted attractions, are embracing new technologies in their designs and are becoming more popular than ever before. Augmented reality, which blends actual and digital objects on a screen, as well as mixed or hybrid reality, which allows digital and real-world objects to co-exist and interact in a mediated world, are hospitable to horror scenarios. For example, the curious can download an app that uses the phone's camera to depict the user's environment while adding creepy elements such as suddenly emerging and screaming ghosts, visible and audible only through the phone. The prospect is deeply unsettling—you're seeing your own home on the screen, but it's suddenly infested with uncanny sights and sounds. That's augmented reality, a fairly simple way of immersing the user in a horror story that unfolds in real-time. The technology is new, but the scare tactics are predictably designed to exploit evolved defense mechanisms: Pale, disembodied agents invade your home, behaving in a manner consistent with malicious intent; sudden noises startle you; the darkness is oppressing and sets your precautionary instincts on red alert. Such technologies are in their infancy and have little narrative and figurative content—they provide little more than serial jump scares. In contrast, some horror video games manage to take full advantage of the medium's affordances and provide users with uniquely immersive horror experiences. Some even offer rich narratives and aesthetically pleasing representations.

Horror video games share characteristics with horror films but crucially add interaction (Clasen and Kjeldgaard-Christiansen 2016, Krzywinska 2002). In such games, players control the behavior of a digital agent—an avatar—in the game. The player's behavior determines the outcome of the game. We can *do* things in the game world, and the game world responds to our actions (Fox, Arena, and Bailenson 2009, Landay 2014). Such interactivity fosters immersion, defined as the "experience of losing oneself in the digital environment and shutting out cues from the physical world" (Fox, Arena, and Bailenson 2009, 96, Therrien 2014). Players feel present and invested in the game world; they feel that they are agents in a deadly zero-sum game, that they are directly responsible for the unfolding of the narrative. If their avatar dies, they will have to replay the level or the whole game. Perhaps they lose valuable in-game currency such as fuel or ammunition. Immersion through virtual embodiment is evident in the curious fact that gamers typically use the first-person pronoun when they recount gameplay experiences to others. They'll say, "I shot up a horde of zombies with my Minigun," or "I evaded the face-gobbling behemoths by jumping clean across the pit of snakes." Conversely, nobody in their right mind would say "I managed to survive Michael Myers's killing spree," no matter how intensely they empathize with Laurie Strode as they're watching *Halloween* (Carpenter 1978).

The purest instance of the horror video game is the subgenre known as *survival horror*. Games in this subgenre typically use a first-person perspective. They situate players in a game world that teems with danger, and they set players at a distinct disadvantage by giving them no or few means of defense. Those elements come together effectively in the independent 2010 production *Amnesia: The Dark Descent* (Grip and Nilsson), celebrated as "one of the scariest games in recent memory" (Onyett 2010). The player controls an amnesic character, Daniel, who finds himself in a 19th-century castle, hunted by terrible monsters, alone, and in the dark—with no map, no weapons, and very little knowledge about what is going on. The player must solve a number of puzzles to complete the game, and is intermittently rewarded with cut scenes—short noninteractive film sequences—that deliver backstory. The game uses a first-person optical perspective to generate the illusion that the player is in the game, as depicted in Figure 13.1. It looks as though we are seeing through Daniel's eyes. As the game designers put it, "one of the main goals was for the player to become the protagonist" (Grip 2010). The illusion is enhanced with event-sensitive audiovisual feedback. When Daniel sees something particularly disturbing, such as gore-spattered walls or an approaching monster, the visual field ripples and distorts (Figure 13.1), and the game emits sounds of quickened

Figure 13.1: Survival horror games such as *Amnesia: The Dark Descent* (Grip and Nilsson 2010) are structured to facilitate immersion. The game uses a first-person perspective and audiovisual feedback mimicking fear-induced perception changes to sustain the illusion that the player is in the threatening game world, and the toothy monsters evoke ancestral predators.

breathing, accelerated heartbeat, and whimpering. This audiovisual feedback mimics fear-induced perceptual and physiological changes (Clasen and Kjeldgaard-Christiansen 2016). The game uses predictable stimuli to evoke negative affect in the player. The monsters preying on Daniel are humanoid creatures with predatory morphological characteristics such as claws and a huge gaping mouth with rows of sharp teeth (Figure 13.1). They are supernormal predators, motivated apparently only by the desire to attack the protagonist. Conversely, the protagonist can do nothing to protect himself—except hide, for example in a closet. The player has to pay very close attention to the virtual environment to survive and proceed in the game. Only by staying alert will the player spot the monsters in time to hide from them and find caches of fuel for the lantern, and only by being persistent in their attempt to evade the monsters and solve progress-enabling puzzles will they reap the reward of compiling the full backstory and completing the game.

Amnesia: The Dark Descent is notoriously effective in evoking negative affect in players—strangely so, perhaps, given that the situation depicted in the game is so far removed from most people's lives that we might expect it to be perceived as utterly irrelevant. How many of us have ever found ourselves—or anticipate finding ourselves—hunted by supernormal predators in an old German castle? Yet the basic premise resonates powerfully with ancient structures in our constitution. For eons we *were*

hunted by dangerous agents with claws and sharp teeth. We *did* have to navigate unknown, dark environments in a quest for resources, we *did* have to overcome obstacles through cunning, and we *did* have to stay alert to stay alive. *Amnesia* taps into conserved dispositions to satisfy an evolved desire for imaginative experience with scenarios of predation (Clasen and Kjeldgaard-Christiansen 2016). The monsters roaming the castle may be implausible, but they look fairly real—real enough, that is, to be cognitively and emotionally processed as dangerous agents rather than dynamic pixel patterns on a two-dimensional screen. A recent empirical study polled college students on their experiences with horror video games and found that graphic realism (that the game world looks real) caused fear in players more frequently than did manifest realism (that the events depicted in the game are likely to occur in the real world) (Lynch and Martins 2015). The stimuli used by *Amnesia* to engage our attention and elicit negative emotion are fairly common to survival horror games—according to the study, the most frequently mentioned fear-evoking stimuli are darkness, disfigured humans, zombies, and the unknown (Lynch and Martins 2015). Sound effects, such as sudden loud noises to accompany fright-inducing visuals, also play a major role in producing fear responses (Toprac and Abdel-Meguid 2011). These are all predictable stimuli from an evolutionary perspective, stimuli that reliably produce negative affect in humans. We see similar stimuli in horror literature and horror films, but the experience of playing *Amnesia* is qualitatively and quantitatively different from the experience of reading stories and watching films. *Amnesia* is significantly more terrifying than any novel I've ever read or any film I've ever seen—but it's also imaginatively and intellectually less satisfying than the best horror stories and films. Survival horror video games more effectively provoke negative emotion and immersion than does horror in other media, but they still lack the richness of narrative, depth of characterization, and complexity of symbolic structure that horror in literature and cinema have achieved.

The more recent and more technically accomplished horror video game *Until Dawn* (Bowen, Reznick, and Fessenden 2015) explicitly attempts to combine the qualities of horror film with the affordances of video games. In this game, a youthful group of friends travel to a remote cabin to spend a few days. Not surprisingly, they are hunted by a malicious agent—several malicious agents, in fact. There's a maniac in a creepy mask and dangerous Wendigoes out there. The virtual environment is carefully rendered; many of the scenes approach photorealism. In this game, the player controls each of the eight characters in turn, but from a third-person perspective. This perspective diminishes the sense that the player and the avatar merge into

Figure 13.2: The horror video game *Until Dawn* (Bowen, Reznick, and Fessenden 2015) combines the pleasures of the video game with the pleasures of the horror film, situating players in an interactive slasher film. Here, the player controls the character Ashley who is investigating a creepy basement.

one—we are given control over the characters' behavior and encouraged to invest in their fate, but we don't quite feel that their fate is our fate. If one youth dies, no big loss; there are seven others to control, and besides, some of the characters are programmed to be fairly annoying. *Until Dawn* uses reaction shots similar to the ones used in horror films, to make up for the decreased sense of perspective-taking. When the game employs jump-scares, however, the perspective on several occasions changes from third- to first-person. At one point, the player controls a character, Ashley, who believes she has seen a ghost. She is nervously investigating a creepy old basement with another character, Chris, who is at this point in the game computer-controlled (Figure 13.2). Suddenly, a ghostly face appears out of nowhere—just as the perspective changes to a first-person point-of-view, to enhance the perception of personal threat and thus the startle in the player (Figure 13.3). The use of a variable point-of-view is efficient in giving players both the pleasure of total immersion and the more detached pleasure of controlling the behavior and fate of characters.

Until Dawn balances tightly scripted sequences with ones that grant the player a great deal of control. This is typical for horror video games that need players to follow a certain trajectory in order to shape and guide their experience while giving them the agency characteristic of the medium (Krzywinska 2002). In some sequences, we have little or no control over the characters; in others, we have to search the environment for crucial resources or make choices that may lead to life or death. In *Until Dawn*,

Figure 13.3: When the character Ashley comes across a creepy ghost in *Until Dawn* (Bowen, Reznick, and Fessenden 2015), the perspective changes from a detached third-person to an immersive first-person perspective, which ramps up the startle effect. The threat of the ghost feels much more personal and immediate.

several such decision nodes emerge at critical junctures during sequences of predation, for example when a character pursued by a maniac enters a room that has opportunities for hiding as well as opportunities for escape. About midway through the game, we control an attractive young woman, Sam, whose clothes mysteriously and, ahem, inconveniently disappear as she is enjoying a warm bath. She's now walking around in the cabin wearing only a bath towel. Soon enough she is attacked by the masked maniac. She flees, and at predetermined intervals during her flight the player has to make crucial choices under intense time pressure—does she hide under the bed or jump over it? Does she run or hide, as in Figure 13.4? Quick, make a decision! The premise of the game is painfully familiar—we've seen countless slasher films featuring youths in remote locations and pitted against homicidal maniacs or supernatural monsters—but *Until Dawn* lets players shape the narrative. Early in the game, players have to pick from lists of common phobia objects such as gore and bugs. The chosen objects then appear later in the game. In this game, we don't have to yell at the heroine for deciding to investigate the weird noise from the basement; we can choose to ignore the noise and go elsewhere. If the heroine's decision to hide under the bed rather than keep running gets her killed, that is our fault because we made the decision. When completion of the game (and the fate of the characters) rides on the player's vigilance, there's really no zoning out, no looking away from the screen. It is an engaging experience, and one that can be genuinely terrifying. Technology is expanding the range

Figure 13.4: In *Until Dawn* (Bowen, Reznick, and Fessenden 2015) the player has to make crucial decisions under intense time pressure. Here, the player controls Sam, who is pursued by a homicidal maniac in a mask. Does she run or hide? The player makes the choice by pushing the thumb stick on the PlayStation controller either to the left or to the right.

of options for the horror aficionado—especially the aficionado eager to become participant in, rather than merely observer of, the horrors.

Horror video games promise immersion and engagement through interaction. Unlike augmented reality, which adds digital elements to the empirical environment, video games take us into another, digitally rendered world. But immersion is still somewhat limited in so-called flat-screen media where one looks at a two-dimensional screen that takes up maybe a third or half of one's visual field to play a horror video game, controlling the behavior of digital agents through an interface. A player of *Amnesia* presses the W on the keyboard to make the avatar move forward. The *Until Dawn* player pushes a stick on a wireless controller. That's a far cry from walking in the real world (Gregersen 2014). So-called immersive virtual reality (VR) technology, in contrast, is bridging the gap between real-world first-person phenomenology and behavior in digital virtual environments. VR typically uses a head-mounted display fitted with two small screens, one for each eye, with slightly different outputs to produce an ecologically realistic stereoscopic view of a high-resolution computer-generated environment (Figure 13.5). The headset also blocks sensory information from the actual environment—all you see is the digital world in three-dimensional splendor. Moreover, the headset is equipped with motion sensors that track head movement. When the user moves his or her head, the scene changes—that is, the digital environment is updated to match the change in viewpoint. This visual technology is supported by technologies that provide sensory

Figure 13.5: Immersive virtual reality produces extremely faithful simulations of horror scenarios. Here, the consumer-grade virtual reality headset Oculus Rift sends stereoscopic images to the author while blocking out the empirical environment. There are no distractions, and the sense of immersion is so strong that the technology becomes invisible. Not for the faint of heart. Photo: Lars Kruse, Aarhus University.

feedback in other modalities—auditory and haptic, for example, producing sensations of sound and touch—as well as body-mounted motion sensors that reproduce movement in the virtual world. In effect, the user's body, and not a clunky controller or a keyboard, becomes the interface. It's a lot of technology to be wearing, but paradoxically, when VR really works the technology becomes invisible (Fox, Arena, and Bailenson 2009). It really feels like the user is in the computer-generated world; immersion is near-perfect. Because the VR experience can be so realistic, the technology is used to investigate fear responses (Meehan et al. 2005, Slater et al. 2006), to train medical and military personnel, even to treat phobic individuals through gradual virtual exposure (Fox, Arena, and Bailenson 2009). Indeed, the VR-generated illusion can be so strong, and the emotions so intense, that some researchers have expressed concerns that the technology can be used as an especially effective instrument of torture that would leave no physical traces but do great psychological damage (Madary and Metzinger 2016).

Unsurprisingly, VR is also used to scare the living daylights out of gamers (Figure 13.5). The sense of presence generated through VR is so strong that even non-interactive simulations can be highly immersive. For example, a simple simulation for the consumer-grade VR headset Oculus Rift

called "Death Simulator" (Germouty 2015) displays a night-time scene with a bonfire, some trees, and a masked figure in the distance. The user cannot interact with the virtual world, or even move around in it, but when he or she moves their head, the computer-generated viewpoint changes. They can look down and see a virtual torso tied to a chair. To users who are in reality sitting down in front of a computer while running this simulation, the sense of virtual embodiment is surprisingly strong because the expected sensory input matches the actual sensory input. You can look around by moving your head, but you can't move your body. You can only observe. Delight turns to horror when the masked figure starts throwing knives at you. The first knife flies through the air, toward you, and bores into the surface to your immediate right with a *whack*. Several knives follow. Finally, the masked agent throws a knife straight at you. This knife hits you in the belly, releasing a torrent of blood. It is very difficult to disassociate oneself entirely from the avatar, to not flinch and squirm and feel a phantom echo of abdominal pain. Other simulations are more interactive, using the elements developed in survival horror games but increasing the level of immersion. It is almost unbearable even to jaded horror fans. Nonetheless, future developments will presumably improve the technology to the extent where digital environments are indistinguishable from real ones, where the courses of action are infinite, and where all senses, even the senses of taste and smell, are engaged—imagine coming across a horde of decomposing zombies in a VR zombie game with olfactory feedback. Imagine feeling a jab of pain in your shoulder—produced through a force-feedback mechanism built into your VR suit—as a zombie sinks its teeth into you. I predict that such ultra-faithful horror simulations will have very limited appeal. It becomes too real, too much like torture, and ceases to satisfy an adaptive appetite for vicarious experience. This kind of experience will be perceptually indistinguishable from real-world encounters with horror. It will probably be less painful—nobody would want to feel the full force of a zombie bite in a simulation—but still too frightening, too real, for most people. As I suggested in the beginning of the book, people generally don't seek out fear-inducing experiences unless there is psychological or aesthetic distance between themselves and the fear-inducing stimuli.

Parallel to the rapid developments in digital horror video games and VR technology, an immersive horror phenomenon known as haunted attractions, or haunts, has become increasingly popular (Kerr 2015, Ndalianis 2012). Not to be confused with dwellings reputedly haunted by spirits, a haunt is a horror-themed venue that visitors walk through. The venue is designed to be creepy, often around a theme such as a zombie outbreak or an insane asylum, and populated with actors in spooky make-up and

costume. Most haunts are open only around Halloween. The phenome-
non has roots in dark rides such as ghost trains, spooky carnival attrac-
tions, and so-called "trails of terror," which emerged in the United States
in the 1930s as parents became "anxious to divert the attention of prank-
ing boys" around Halloween (Morton 2012, 100). Trails of terror were
mazes with creepy and disgusting elements created in people's homes or
yards. The decisive event in the history of haunts, however, was the 1969
opening of Disneyland's Haunted Mansion, a dark ride with horror scen-
ery and effects, including spectral visual illusions and animatronic ghosts
(McKendry 2013, Ndalianis 2012). It was an instantaneous success. "In a
single day shortly after its debut, more than 82,000 people passed through
the Haunted Mansion" (Heller 2015). This horror attraction inspired count-
less others, including charity haunts, which blossomed in the 1970s, as well
as the commercial haunted attractions industry. This industry really took
off in the 1990s and continues to grow. According to one estimate, there
were in 2015 about 2,700 active haunts in the United States (Heller 2015).
Like horror video games and VR, haunts allow the consumer to become the
protagonist in a horror story that unfolds in real-time. In haunts, however,
the consumer is actually *there*, in the flesh, as are the spooky agents. The
actual, empirical environment is threatening.

Dystopia Haunted House, established in 2014, is the biggest haunt in
Denmark. As scientific advisor to the project, I am intimately familiar with
its design and will use it to illustrate the phenomenon of haunts. Dystopia
is open only on weekends in the month leading up to Halloween, but it
attracts up to 5,000 customers per season—and each season, hundreds of
paying customers have to abort their visit partway through because they're
overwhelmed by the experience. Customers have fainted in abject ter-
ror, they have wet themselves in distress, they have accidentally attacked
actors in panic, and they have had to be carried out—not dead, but lifeless.
Dystopia is built on the American model and uses effects identical to those
employed in the American industry. Its creators regularly visit TransWorld,
the premier American trade convention for professional haunters, and all
actors speak English. Customers walk through in groups of four or five—
but it is possible to pay extra and walk through alone or in pairs of two for
an even more intense experience. We conduct consumer research to max-
imally target visitors' fears, for example through surveys on their expe-
riences in the haunt and on their personal fears. Dystopia has a detailed
backstory which is narrated to visitors by an actor as they're waiting in
line and disseminated via social media. We're in the near future. Society
is collapsing. An infectious fungal disease, "The SPORE," is raging, turn-
ing the populace into flesh-eating monsters. The repressive, totalitarian

regime—"The GOVERNMENT"—blames an underground movement, "The RESISTANCE," for the outbreak. Another faction, "The CULT," is convinced that cannibalism cures the disease. Visitors meet representatives of all three groups (as well as zombies and other monsters) in Dystopia, and they are encouraged to participate imaginatively in this elaborate universe. Visitors are told that their mission is to procure "The ESSENCE"—spinal fluid from patient zero of the outbreak. They meet several obstacles on the way, but by the end of the haunt, they extract a fluorescent fluid from a plastic tube attached to a very sick-looking young woman.

When visitors enter the haunt, which is located in an abandoned factory, actors dressed in brown robes—Cultists—approach and sniff visitors. They behave erratically, as if they're barely managing to repress violent psychosis. Visitors are unsettled. They know it's make-believe, but these actors get too close for comfort. They seem slightly unhinged. During their walk-through, visitors will be separated from their group, experience sensory deprivation in pitch-black rooms, encounter spiders and bugs, and be aggressively accosted by a muscular man in a butcher outfit with a very big machete (Le Chef, depicted in Figure 13.6). They will witness gruesome scenes of torture and open-body surgery, come across diseased-looking

Figure 13.6: Haunted attractions let visitors become protagonists in horror stories that unfold around them in real-time. Scare actors can disturb visitors in ways that fictional monsters can't. Here, Le Chef of Dystopia Haunted House gets too close to two paying visitors, staring threateningly at them. The visitors look distressed, but they are getting their money's worth—thrill-seekers flock to haunted attractions for immersive horror experiences. Photo: Andrés Baldursson, Baldursson Photography.

and apparently deranged children, and be chased by decomposing zombies. They will be forced into moral dilemmas, such as choosing whether to release a sick-looking girl from a cage. If they release her, she will give crucial information about an upcoming obstacle, but she will also end her days in a flaming oven. The big screamer is when a very big guy with a pig's head—a latex mask—and an actual, roaring chainsaw comes running towards visitors. The crew fondly refers to this individual as Mr. Piggy.

These various elements are carefully calibrated to target common fears. There are sudden noises, confined spaces, heights, darkness, creepy-crawlies, deranged and hostile individuals, broken bodies, omnipresent cues of contagion and infection, and violations of personal space. At one point in the haunt, visitors are forced to crawl through a dark, narrow tunnel to get from one room to the next. Suddenly, a light comes on underneath the visitor and an animated, decomposing corpse slides into sight (behind a strong glass plate) and emits a jarring scream. This particular effect had visitors pass out from fear. One visitor froze in place, utterly terrified, and had to be carried out by several helpers. Another hurt her arm as she tumbled out of the tunnel in terror. These kinds of unfortunate incidents naturally encourage thrill-seekers to flock to Dystopia. Our surveys have shown that the vast majority of visitors are strongly affected during their walk-through—and that the vast majority of visitors are expecting to visit Dystopia again in the future. The negative affect engendered by the setting, the actors, and the effects are precisely what visitors are after. They pay good money to be scared witless for a good half hour, and according to customer satisfaction surveys, they love it.

Haunted attractions are real in a way that horror video games and VR simulations aren't. There is no technological interface between the consumer and the scary environment, no problems with pixelated scenes, no limitations in sensory input. Of course, visitors know that it is make-believe, and they are instructed about the "safe word"—hands on your head—that will immediately summon helpers to escort them out, but the actors in haunts can get at people in ways that digitally rendered agents cannot. As a visitor, you can never be entirely sure that the big guy with the creepy makeup and the shiny knife isn't on the brink of psychosis; he certainly acts that way. As the actor portraying Le Chef told me, "I just stare at them with dark eyes, saying nothing, just staring and breathing slowly and hoarsely. That gets them. Every single time." Le Chef is physically formidable and exhibits visual and behavioral cues—the blood-spatter on his head and clothes, the eagerness with which he handles the machete—that suggest a violent disposition. The rude staring suggests a lack of restraint, a disregard for social norms. The heavy breathing suggests an unhealthy, perhaps sexual interest

in the visitor; nobody likes to be stared at by a stranger for more than a few seconds. This character truly is well-suited for making visitors deeply uneasy—as depicted in Figure 13.6.

Haunted attractions offer an experience that is akin, though not identical, to the experience offered in other horror media. In a haunt, the feeling of personal threat is stronger than when the horror is digitally rendered. According to one of Dystopia's creators, Jonas Bøgh Pedersen (referred to by crew members as "The Architect of Fear"): "People know they're paying to be scared in a safe setting, but our job is to make them forget that they are safe—if even just for a moment" (personal communication). In recent years, new variations on haunts have become widespread—horror camp-outs, for example, where visitors spend the night in a forest, chased by axe-murderers, and horror runs, where customers run through dark woods chased by zombies as in Figure 13.7. These outdoors horror experiences resemble extreme sports, or even regular sports with a twist, but they tend to have some narrative content, some backstory, and they invite participants to become protagonists in unfolding live-action horror narratives where it is surprisingly easy to forget that it is all just make-believe.

Interactive horror experiences—games, VR, haunts, and so on—offer immersive experiences for horror aficionados. We are likely to see more

Figure 13.7: In recent years, live-action horror experiences such as horror camp-outs and horror runs have become increasingly popular. Here, a participant in Dystopia Horror Run 2016 tries to get away from a messed-up zombie. The run takes place at night in a forest outside of Vejle, Denmark. Photo: Klaus Dreyer/Headturn Images.

(and more effective) versions of such immersive and interactive horror experiences, but they will never replace traditional narrative horror in literature and cinema. Their pleasures overlap, but not perfectly; according to survey results, many visitors to Dystopia—but not all—are also horror fans. Interactive horror experiences are more effective at engendering strong emotional responses, but they don't offer the psychological, social, and existential insight offered by the best horror in narrative media (Ndalianis 2012, 22). There is rarely any interpretative effort involved in such experiences, rarely much of a prompt for critical reflection, although some haunts do invite participants to respond to morally charged scenarios, such as the political vision embedded in the backstory and structure of Dystopia Haunted House. In the future, we will probably see more convergence between media, with various horror media merging and exchanging techniques to enhance the experience—stronger narratives in video games and haunts, interactive dimensions in cinema, and so on. And as horror evolves, horror research will have to follow suit.

Horror research has come a long way—but not nearly long enough to give us an adequate understanding of the genre in all its facets and with all its peculiar appeals. Researchers have made real progress, for example, in delineating the history of horror and its subgenres, and in charting horror's formal characteristics, ideological subtexts, and cultural influences. But as I argued in Chapter 1, much humanistic horror research is marred by a reliance on obsolete psychological models or a blinkered focus on cultural factors, and there are many burning questions still unanswered. Researchers in media psychology have broached some empirical questions about personality dimensions (such as thrill-seeking) and genre preference, and they have investigated gender and developmental stage as factors in responses to horror (Weaver and Tamborini 1996, Cantor 2002, Hoffner and Levine 2005). But we still don't know much about the behavioral effects of horror, nor do we know enough about the psychological ones. We don't have a clear picture of the personality profile and motivations of horror fans. We don't know much about the genre's neurobiological underpinnings, and we don't know much about what happens in the minds of horror artists when they produce horror scenarios, nor about what kind of people they are. To begin to answer these questions, horror scholars need the aid of science.

In this book, I have proposed an evolutionary approach to horror—an approach built on findings about human nature from the evolutionary social and natural sciences. That's one crucial way of integrating horror study with science: to use relevant scientific findings to construct models and, in the process, weed out obsolete theories and hypotheses. I think we need much more of this kind of research—more theory-building and

more close-readings of horror works. We need more science-based investigations of subgenres, auteurs, and horror in various media. We need to use scientific findings to address correlations between life-history phases and horror content—such as systematic differences between horror for kids, horror for young adults, and horror for grown-ups. As social scientists and evolutionarily-minded scholars in the humanities come up with more refined models of human nature, evolutionary horror study will have to follow suit. That's not all, though. Horror scholars need to engage with scientific methodology too. Traditionally, scholars in most humanities subjects have relied on qualitative, subjective methods; methods which are indispensable because they can yield important insight, but which are also inadequate for answering a set of crucial questions. Does horror make us more fearful or less fearful? You can't answer that question without controlled psychological experiments. You can make educated guesses, guided and constrained by relevant evidence, as I have done in this book—but those guesses need to be subjected to scientific scrutiny. Do horror fans tend to have a specific personality profile? Are they, for example, mildly neurotic—that is, mildly sensitive to negative stimuli—rather than highly emotionally reactive or the opposite? You can't tell without a psychometric study. Scholars in the humanities have been reluctant to incorporate experimental and quantitative methods in their studies, but there is no good reason for them not to add such methods to their toolkit (Carroll et al. 2012, Gottschall 2010 [2008]).

Future research on horror should use a variety of empirical methods for throwing light on important questions. We need case studies, naturalistic observation studies, correlational survey studies, and experimental lab studies to get deeper into the mysteries of horror. We need quantitative methods from the digital humanities, such as text-mining of large corpora, to unearth large-scale content trends, for example across historical periods and across cultures. We need experimental psychology to help us figure out whether, and to what extent, and by which mechanisms, exposure to horror calibrates our fear system. Maybe watching a horror film or reading a scary short story makes us faster at detecting partly hidden threats in the environment. Neuroimaging studies would help us figure out what happens in the brains of horror consumers and horror artists as they delve into dark imaginative worlds. Biofeedback studies could investigate individual differences in strength of response to particular horror experiences. Structured interviews would get us closer to horror fans' motivations. Observational studies could look into whether social horror experiences bring people together or drive them apart—do individuals leaving a movie theater after having seen a horror film talk more, do they stay closer together (for

protection), than do people leaving a historical drama? Conversely, do zombie film audiences increase interpersonal distance because they have been sensitized to pathogen disgust? Does horror exposure make us more pro-social toward in-group individuals? And what about out-group individuals? We just don't know. But these are all empirical questions, eminently worth investigating. The field of experimental and quantitative horror research is wide open, and only the imagination—and institutional barriers, such as a lack of training and funding opportunities (Carroll 2010)—put a limit to growth in this domain.

Why does horror seduce? Why are we irresistibly drawn to the dark side of entertainment, to artworks and interactive experiences designed to produce pleasure through negative affect? Based on our best current knowledge about human nature, the answer is that we have an adaptive need to face the darkness in a safe context. Horror seduces because it so effectively satisfies our appetite for looking into the abyss, for imaginatively facing the very worst that we can conceive. The things we don't know about the functions and effects of horror outnumber the things we do know, but the quest for understanding the darkest of genres is well underway.

REFERENCES

Alegre, Sara Martín. 2001. "Nightmares of Childhood: The Child and the Monster in Four Novels by Stephen King." *Atlantis* 23 (1):105–114.

Andreasen, James, creator. 1982. *Haunted House*. Videogame. New York: Atari.

Andrews, Nigel. 1999. *Nigel Andrews on* Jaws. London: Bloomsbury.

Atran, Scott, and Ara Norenzayan. 2004. "Religion's Evolutionary Landscape: Counterintuition, Commitment, Compassion, Communion." *Behavioral and Brain Sciences* 27 (6):713–730; discussion 730–770. doi: 10.1017/S0140525X04000172.

Arnzen, Michael A. 1994. "Who's Laughing Now? The Postmodern Splatter Film." *Journal of Popular Film and Television* 21 (4):176–184. doi: 10.1080/01956051.1994.9943985.

Asma, Stephen T. 2015. "Monsters on the Brain: An Evolutionary Epistemology of Horror." *Social Research: An International Quarterly* 81 (4):941–968.

Bahna, Vladimír. 2015. "Explaining Vampirism: Two Divergent Attractors of Dead Human Concepts." *Journal of Cognition and Culture* 15 (3–4):285–298. doi: 10.1163/15685373-12342151.

Baldick, Chris, and Robert Mighall. 2012. "Gothic Criticism." In *A New Companion to the Gothic*, edited by David Punter, 267–287. Somerset, NJ: John Wiley & Sons.

Balmain, Colette. 2008. *Introduction to Japanese Horror Film*. Edinburgh: Edinburgh University Press.

Barber, Paul. 2010 [1988]. *Vampires, Burial, and Death: Folklore and Reality*. Rev. ed. New Haven, CT: Yale University Press.

Barrett, Deirdre. 2010. *Supernormal Stimuli: How Primal Urges Overran their Evolutionary Purpose*. New York: W. W. Norton.

Barrett, H. Clark. 2005. "Adaptations to Predators and Prey." In *The Handbook of Evolutionary Psychology*, Vol. 1, edited by David M. Buss, 200–223. Hoboken, NJ: John Wiley & Sons.

Barrett, Justin L. 2004. *Why Would Anyone Believe in God?* Walnut Creek, CA: AltaMira.

Barrett, H. Clark, and Tanya Behne. 2005. "Children's Understanding of Death as the Cessation of Agency: A Test Using Sleep Versus Death." *Cognition* 96 (2):93–108. doi: 10.1016/j.cognition.2004.05.004.

Becker, Matt. 2006. "A Point of Little Hope: Hippie Horror Films and the Politics of Ambivalence." *The Velvet Light Trap* 57 (1):42–59. doi: 10.1353/vlt.2006.0011.

Benchley, Peter. 1974. *Jaws*. Garden City, NY: Doubleday.

Biancorosso, Giorgio. 2010. "The Shark in the Music." *Music Analysis* 29 (1-3): 306–333. doi: 10.1111/j.1468-2249.2011.00331.x.

Bierce, Ambrose. 2007 [1898]. "The Damned Thing." In *In the Midst of Life*. Project Gutenberg. http://www.gutenberg.org/ebooks/23172.

Biskind, Peter. 1975. "*Jaws*: Between the Teeth." *Jump Cut: A Review of Contemporary Media* 9:1–26.

Blatty, William Peter. 1971. *The Exorcist*. New York: Harper & Row.

Bloch, Robert. 1959. *Psycho*. New York: Simon and Schuster.

Bloom, Clive. 2010. *Gothic Histories: The Taste for Terror: 1764 to the Present*. London: Continuum.

Bloom, Clive. 2012. "Horror Fiction: In Search of a Definition." In *A New Companion to the Gothic*, edited by David Punter, 211–223. Somerset, NJ: John Wiley & Sons.

Bloom, Paul. 2004. *Descartes' Baby: How the Science of Child Development Explains What Makes Us Human*. New York: Basic Books.

Bloom, Paul. 2010. *How Pleasure Works: The New Science of Why We Like What We Like*. New York: W. W. Norton.

Boehm, Christopher. 2012. *Moral Origins: The Evolution of Virtue, Altruism, and Shame*. New York: Basic Books.

Booth, Michael, creator. 2008. Videogame. *Left 4 Dead*. Bellevue, WA: Valve Corporation.

Bordwell, David, and Kristin Thompson. 2013. *Film Art: An Introduction*. 10th ed. New York: McGraw-Hill.

Botting, Fred. 1996. *Gothic*. London: Routledge.

Boulenger, Gilles. 2001. *John Carpenter: The Prince of Darkness: An Exclusive Interview with the Director of* Halloween *and* The Thing. Los Angeles, CA: Silman-James Press.

Bouzereau, Laurent. 1995. *The Making of Steven Spielberg's* Jaws. DVD. Universal City, CA: Universal Home Video.

Bowen, Nik, Graham Reznick, and Larry Fessenden, designer and producers. 2015. *Until Dawn*. Videogame. Supermassive Games. San Mateo, CA: Sony Computer Entertainment.

Bowles, Stephen E. 1976. "*The Exorcist* and *Jaws*." *Literature/Film Quarterly* 4 (3):196–214.

Boyd, Brian. 2005. "Literature and Evolution: A Bio-Cultural Approach." *Philosophy and Literature* 29 (1):1–23. doi:10.1353/phl.2005.0002.

Boyd, Brian. 2009. *On the Origin of Stories: Evolution, Cognition, and Fiction*. Cambridge, MA: Belknap Press of Harvard University Press.

Boyd, Brian, Joseph Carroll, and Jonathan Gottschall. 2010. "Introduction." In *Evolution, Literature, and Film: A Reader*, edited by Brian Boyd, Joseph Carroll and Jonathan Gottschall, 1–17. New York: Columbia University Press.

Boyer, Pascal. 2001. *Religion Explained: The Evolutionary Origins of Religious Thought*. New York: Basic Books.

Boyer, Pascal. 2007. "Specialised Inference Engines as Precursors of Creative Imagination?" In *Imaginative Minds*, edited by Ilona Roth, 239–258. London: British Academy.

Boyer, Pascal, and Brian Bergstrom. 2011. "Threat-Detection in Child Development: An Evolutionary Perspective." *Neuroscience & Biobehavioral Reviews* 35 (4):1034–1041. doi: 10.1016/j.neubiorev.2010.08.010.

Brewster, Scott. 2014. "Gothic and the Question of Theory: 1900–Present." In *The Gothic World*, edited by Glennis Byron and Dale Townshend, 308–320. Abingdon, UK: Routledge.

Brooks, Max. 2006. *World War Z: An Oral History of the Zombie War*. New York: Crown.

Brown, Charles Brockden. 2010 [1798]. *Wieland, or, The Transformation: An American Tale*. Mineola, NY: Dover.

Brown, Donald E. 1991. *Human Universals*. New York: McGraw-Hill.

Brown, David, and John David Scoleri. 2001. "Richard Matheson Interview." *The I Am Legend Archive*. Accessed 18 May 2015. http://iamlegendarchive.blogspot.co.uk/p/richard-matheson-interview.html.

Browning, John Edgar. 2011. "Survival Horrors, Survival Spaces: Tracing the Modern Zombie (Cine)Myth." *Horror Studies* 2 (1):41–59. doi: 10.1386/host.2.1.41_1.

Browning, Tod, dir. 1931. *Dracula*. DVD/Video. Universal City, CA: Universal Pictures Corporation.

Bruhm, Steven. 2012. "Picture This: Stephen King's Queer Gothic." In *A New Companion to the Gothic*, edited by David Punter, 469–480. Oxford: Blackwell.

Buday, Maroš. 2015. "From One Master of Horror to Another: Tracing Poe's Influence in Stephen King's *The Shining*." *Prague Journal of English Studies* 4 (1):47–59. doi: 10.1515/pjes-2015-0003.

Buekens, Filip, and Maarten Boudry. 2015. "The Dark Side of the Loon: Explaining the Temptations of Obscurantism." *Theoria* 81 (2):126–142. doi: 10.1111/theo.12047.

Burghardt, Gordon M. 2014. "A Brief Glimpse at the Long Evolutionary History of Play." *Animal Behavior and Cognition* 1 (2):90–98. doi: 10.12966/abc.05.01.2014.

Buss, David M. 2005. *The Murderer Next Door: Why the Mind is Designed to Kill*. London: Penguin.

Buss, David M. 2012. *Evolutionary Psychology: The New Science of the Mind*. 4th ed. Boston: Pearson Allyn & Bacon.

Cacioppo, John T., and William Patrick. 2008. *Loneliness: Human Nature and the Need for Social Connection*. New York: W.W. Norton.

Cannibal Corpse. 2014. "Kill Or Become." In *A Skeletal Domain*. Sanford, FL: Metal Blade Records.

Cantor, Joanne. 2002. "Fright Reactions to Mass Media." In *Media Effects: Advances in Theory and Research*, edited by Jennings Bryant and Dolf Zillman, 287–306. Mahwah, NJ: Lawrence Erlbaum.

Cantor, Joanne. 2004. "'I'll Never Have a Clown in My House'—Why Movie Horror Lives On." *Poetics Today* 25 (2):283–304. doi: 10.1215/03335372-25-2-283.

Cantor, Joanne, and Mary Beth Oliver. 1996. "Developmental Differences in Responses to Horror." In *Horror Films: Research on Audience Preference and Reactions*, edited by J. B. Weaver and R. Tamborini, 63–80. Mahwah, NJ: Lawrence Erlbaum.

Cantor, Joanne, and Becky L. Omdahl. 1991. "Effects of Fictional Media Depictions of Realistic Threats on Children's Emotional Responses, Expectations, Worries, and Liking for Related Activities." *Communications Monographs* 58 (4):384–401.

Caputi, Jane E. 1978. "*Jaws* as Patriarchal Myth." *Journal of Popular Film* 6 (4):305–326. doi: 10.1080/00472719.1978.9943447.

Carleton, R. Nicholas. 2016. "Fear of the Unknown: One Fear to Rule Them All?" *Journal of Anxiety Disorders* 41:5–21. doi: 10.1016/j.janxdis.2016.03.011.

Carpenter, John, dir. 1978. *Halloween*. DVD. Falcon International Productions, Compass International Pictures/Trancas Pictures. Universal City, CA: Compass/Trancas Pictures.

Carpenter, John, dir. 1994. *In the Mouth of Madness*. DVD. Los Angeles, CA: New Line Productions.

Carpenter, John. 2003. *Halloween Audio Commentary with Writer/Director John Carpenter. Halloween* 25th Anniversary Edition. Anchor Bay Entertainment. DVD.

Carroll, Joseph. 1995. *Evolution and Literary Theory*: Columbia: University of Missouri Press.

Carroll, Joseph. 2004. *Literary Darwinism: Evolution, Human Nature, and Literature*. New York: Routledge.

Carroll, Joseph. 2006. "The Human Revolution and the Adaptive Function of Literature." *Philosophy and Literature* 30 (1):33–49. doi: 10.1353/phl.2006.0005.

Carroll, Joseph. 2008. "Rejoinder to the Responses." *Style* 42 (2–3):308–370.

Carroll, Joseph. 2010. "Three Scenarios for Literary Darwinism." *New Literary History* 41 (1):53–67.

Carroll, Joseph. 2011. *Reading Human Nature: Literary Darwinism in Theory and Practice*. Albany: SUNY Press.

Carroll, Joseph. 2012a. "The Adaptive Function of the Arts: Alternative Evolutionary Hypotheses." In *Telling Stories: Literature and Evolution*, edited by Carsten Gansel and Dirk Vanderbeke, 50–63. Berlin: De Gruyter.

Carroll, Joseph. 2012b. "The Truth about Fiction: Biological Reality and Imaginary Lives." *Style* 46 (2):129–160.

Carroll, Joseph. 2013. "A Rationale for Evolutionary Studies of Literature." *Scientific Study of Literature* 3 (1):8–15. doi: 10.1075/ssol.3.1.03car.

Carroll, Joseph, Jonathan Gottschall, John A. Johnson, and Daniel J. Kruger. 2012. *Graphing Jane Austen: The Evolutionary Basis of Literary Meaning*. Basingstoke, UK: Palgrave Macmillan.

Carroll, Kathleen. 1968. "*Rosemary's Baby* Is Horribly Frightening." *New York Daily News*. Last modified 11 June 2015. http://www.nydailynews.com/entertainment/movies/rosemary-baby-shockingly-captivating-1968-review-article-1.2251841.

Carroll, Noël. 1990. *The Philosophy of Horror, or, Paradoxes of the Heart*. New York: Routledge.

Cherry, Brigid. 2009. *Horror*. New York: Routledge.

ChildFund Alliance. 2012. *Small Voices, Big Dreams 2012: A Global Survey of Children's Hopes, Aspirations, and Fears*. Edited by Heather Wiseman. Richmond, VA. Accessed 23 February, 2017. http://www.indiaenvironmentportal.org.in/files/file/Small-Voices-Big-Dreams-2012.pdf.

Choudhury, Suparna, Sarah-Jayne Blakemore, and Tony Charman. 2006. "Social Cognitive Development during Adolescence." *Social Cognitive and Affective Neuroscience* 1 (3):165–174. doi: 10.1093/scan/nsl024.

Clark, Bob. 1974, dir. *Black Christmas*. DVD. Canada: Film Funding International; Vision IV; Canadian Film Development Corporation; Famous Players.

Clasen, Mathias. 2004. *Homo Timidus: Om Gys og Gru—Med Fokus på Danske Horrorforfattere*. Ruds-Vedby, Denmark: Tellerup.

Clasen, Mathias. 2007. "Darwin and Dracula: Evolutionary Literary Study and Supernatural Horror Fiction." MA diss., Department of English, Aarhus University.

Clasen, Mathias. 2009. "A Conversation with Peter Straub." *Cemetery Dance* (61):40–48.

Clasen, Mathias. 2010a. "The Anatomy of the Zombie: A Bio-Psychological Look at the Undead Other." *Otherness: Essays and Studies* 1 (1):1–23.

Clasen, Mathias. 2010b. "Vampire Apocalypse: A Biocultural Critique of Richard Matheson's *I Am Legend*." *Philosophy and Literature* 34 (2):313–328. doi: 10.1353/phl.2010.0005.

Clasen, Mathias. 2012a. "Attention, Predation, Counterintuition: Why Dracula Won't Die." *Style* 46 (3):378–398.

Clasen, Mathias. 2012b. "'Can't Sleep, Clowns Will Eat Me': Telling Scary Stories." In *Telling Stories: Literature and Evolution*, edited by Carsten Gansel and Dirk Vanderbeke, 338–360. Berlin: Walter de Gruyter.

Clasen, Mathias. 2012c. "Monsters and Horror Stories: A Biocultural Approach." PhD diss., Department of Aesthetics and Communication, Faculty of Arts, Aarhus University.

Clasen, Mathias. 2012d. "Monsters Evolve: A Biocultural Approach to Horror Stories." *Review of General Psychology* 16 (2):222–229. doi: 10.1037/a0027918.

Clasen, Mathias. 2012e. *Monstre*. Aarhus, Denmark: Aarhus University Press.

Clasen, Mathias. 2014. "Evil Monsters in Horror Fiction: An Evolutionary Perspective on Form and Function." In *A History of Evil in Popular Culture: What Hannibal Lecter, Stephen King, and Vampires Reveal about America*, edited by Sharon Packer and Jody Pennington, 39–47. Santa Barbara, CA: Praeger.

Clasen, Mathias. 2016. "Terrifying Monsters, Malevolent Ghosts, and Evolved Danger-Management Architecture: A Consilient Approach to Horror Fiction." In *Darwin's Bridge: Uniting the Humanities and Sciences*, edited by Joseph Carroll, Dan P. McAdams and E. O. Wilson, 183–193. New York: Oxford University Press.

Clasen, Mathias. 2017. "The Evolution of Horror: A Neo-Lovecraftian Poetics." In *The Call of Cosmic Panic: New Essays on Supernatural Horror in Literature*, edited by Sean Moreland. Forthcoming.

Clasen, Mathias, and Jens Kjeldgaard-Christiansen. 2016. "A Consilient Approach to Horror Video Games: Challenges and Opportunities." *Academic Quarter* 13: 127–142.

Clasen, Mathias, and Todd K. Platts. In press. "Evolution and Slasher Films." In *Don't We All Like It? Popular Literature and Culture under an Evolutionary Lens*, edited by Dirk Vanderbeke and Brett Cooke.

Clover, Carol J. 1992. *Men, Women, and Chainsaws: Gender in the Modern Horror Film*. Princeton, NJ: Princeton University Press.

Cochran, Gregory, and Henry Harpending. 2009. *The 10,000 Year Explosion: How Civilization Accelerated Human Evolution*. New York: Basic Books.

Cohen, Allan. 1990. "The Collapse of Family and Language in Stephen King's *The Shining*." In *The Shining Reader*, edited by Tony Magistrale, 47–60. Mercer Island, WA: Starmont House.

Conroy-Beam, Daniel, David M. Buss, Michael N. Pham, and Todd K. Shackelford. 2015. "How Sexually Dimorphic Are Human Mate Preferences?" *Personality and Social Psychology Bulletin* 41 (8):1082–1093. doi: 10.1177/0146167215590987.

Cooke, Brett. 1999. "On the Evolution of Interest: Cases in Serpent Art." In *Evolution of the Psyche*, edited by David H. Rosen and Michael C. Luebbert, 150–168. Westport, CT: Praeger.

Coplan, Amy. 2006. "Catching Characters' Emotions: Emotional Contagion Responses to Narrative Fiction Film." *Film Studies* 8 (1):26–38. doi: 10.7227/FS.8.5.

Cosmides, Leda, and John Tooby. 1997. "Evolutionary Psychology: A Primer." Last modified January 13, 1997. http://www.cep.ucsb.edu/primer.html.

Craven, Wes, dir. 1972. *The Last House on the Left*. DVD. Sean S. Cunningham Films. Universal City, CA: Universal Studios Home Entertainment.

Craven, Wes, dir. 1984. *A Nightmare on Elm Street*. DVD. The Elm Street Venture, Media Home Entertainment, Smart Egg Pictures. Los Angeles, CA: New Line Cinema.

Craven, Wes, dir. 1996. *Scream*. DVD. Woods Entertainment. New York: Dimension Films, The Weinstein Company.

Crawford, Dean. 2008. *Shark*. London: Reaktion.

Creed, Barbara. 1996. "Horror and the Monstrous-Feminine." In *The Dread of Difference: Gender and the Horror Film*, edited by Barry K. Grant, 35–65. Austin: University of Texas Press.

Crichton, Michael. 1990. *Jurassic Park: A Novel*. New York: Knopf.

Cunningham, Sean S, dir. 1980. *Friday the 13th*. DVD. Georgetown Productions. Hollywood, CA: Paramount Pictures.

Curtis, Valerie, and Adam Biran. 2001. "Dirt, Disgust, and Disease. Is Hygiene in Our Genes?" *Perspectives in Biological Medicine* 44 (1):17–31. doi: 10.1353/pbm.2001.0001.

Curtis, Val, Robert Aunger, and Tamer Rabie. 2004. "Evidence that Disgust Evolved to Protect from Risk of Disease." *Proceedings of the Royal Society of London B: Biological Sciences* 271 (Suppl 4):S131-S133. doi: 10.1098/rsbl.2003.0144.

Daly, Martin, and Margo Wilson. 1990. "Is Parent-Offspring Conflict Sex-Linked? Freudian and Darwinian Models." *Journal of Personality* 58 (1):163–189. doi: 10.1111/j.1467-6494.1990.tb00912.x.

D'Ammassa, Don. 2006. "Introduction." In *Encyclopedia of Fantasy and Science Fiction*, edited by Don D'Ammassa, v–viii. New York: Facts on File, Inc.

Darabont, Frank, dir. 2010–. *The Walking Dead*. AMC. New York: AMC Studios.

Darwin, Charles. 1998 [1872]. *The Expression of the Emotions in Man and Animals*. 3rd ed. New York: Oxford University Press.

Darwin, Charles. 2003 [1859]. *On the Origin of Species by Means of Natural Selection*. Peterborough, Ont.: Broadview Press.

Davenport, Stephen. 2000. "From Big Sticks to Talking Sticks: Family, Work, and Masculinity in Stephen King's *The Shining*." *Men and Masculinities* 2 (3):308–329. doi: 10.1177/1097184x00002003004.

De Backer, Charlotte J. S. 2012. "Blinded by the Starlight: An Evolutionary Framework for Studying Celebrity Culture and Fandom." *Review of General Psychology* 16 (2):144–151. doi: 10.1037/a0027909.

De Gelder, Beatrice, Josh Snyder, Doug Greve, George Gerard, and Nouchine Hadjikhani. 2004. "Fear Fosters Flight: A Mechanism for Fear Contagion when Perceiving Emotion Expressed by a Whole Body." *Proceedings of the National Academy of Sciences of the United States of America* 101 (47):16701–16706. doi: 10.1073/pnas.0407042101.

Demme, Jonathan, dir. 1990. *The Silence of the Lambs*. DVD. Strong Heart/Demme. Los Angeles, CA: Orion Pictures.

De Palma, Brian, dir. 1976. *Carrie*. DVD. Red Bank Films. Culver City, CA: United Artists and MGM Home Entertainment.

Dibble, Jayson L., and Sarah F. Rosaen. 2011. "Parasocial Interaction as More than Friendship: Evidence for Parasocial Interactions with Disliked Media Figures." *Journal of Media Psychology: Theories, Methods, and Applications* 23 (3):122–132. doi: 10.1027/1864-1105/a000044.

Dickens, Charles. 2003 [1854]. *Hard Times for These Times*. Edited by Kate Flint. London: Penguin.

Dickerson, Mary Jane. 1990. "The 'Masked Author Strikes Again': Writing and Dying in Stephen King's *The Shining*." In *The Shining Reader*, edited by Tony Magistrale, 33–46. Mercer Island, WA: Starmont House.

Dika, Vera. 1987. "The Stalker Film, 1978–1981." In *American Horrors: Essays on the Modern American Horror Film*, edited by Gregory A. Waller, 86–101. Chicago: University of Illinois Press.

Dika, Vera. 1990. *Games of Terror:* Halloween, Friday the 13th, *and the Films of the Stalker Cycle*. Rutherford, NJ: Fairleigh Dickinson University Press.

Dillard, R. H. W. 1987 [1973]. "*Night of the Living Dead*: It's Not Like Just a Wind That's Passing Through." In *American Horrors: Essays on the Modern American Horror Film*, edited by Gregory A. Waller, 14–29. Urbana: University of Illinois Press.

Docherty, Brian, ed. 1990. *American Horror Fiction: From Brockden Brown to Stephen King*. New York: St. Martin's.

Dozier, Rush W. 1998. *Fear Itself: The Origin and Nature of the Powerful Emotion that Shapes Our Lives and Our World*. New York: St. Martin's Press.

Dumas, Chris. 2014. "Horror and Psychoanalysis: A Primer." In *A Companion to the Horror Film*, edited by Harry M. Benshoff, 22–37. Malden, MA: John Wiley & Sons.

Dunbar, Robin I., and Susanne Shultz. 2007. "Evolution in the Social Brain." *Science* 317 (5843):1344–1347. doi: 10.1126/science.1145463.

Duntley, Joshua D. 2005. "Adaptations to Dangers from Other Humans." In *The Handbook of Evolutionary Psychology, Vol. 1: Foundations,* edited by David M. Buss, 224–249. New York: Wiley.

Dutton, Denis. 2009. *The Art Instinct: Beauty, Pleasure, and Human Evolution*. New York: Bloomsbury.

Dymond, Erica Joan. 2015. "Objectivity and the Overlook: Examining the Use of Multiple Narratives in Stephen King's *The Shining*." *The Explicator* 73 (2):124–128. doi: 10.1080/00144940.2015.1030585.

Ebert, Roger. 1969. "*Night of the Living Dead*." 5 January 1969. Accessed 27 April 2015. http://www.rogerebert.com/reviews/the-night-of-the-living-dead-1968.

Ebert, Roger. 1981. "Why Movie Audiences Aren't Safe Any More." *American Film* 6 (5):54–56.

Ebert, Roger. 1999. "The Blair Witch Project." Accessed 16 May 2016. http://www.rogerebert.com/reviews/the-blair-witch-project-1999.

Ekman, Paul. 2005. "Basic Emotions." In *Handbook of Cognition and Emotion*, edited by Tim Dalgleish and Mick J. Power, 45–60. John Wiley & Sons.

Erwin, Edward. 1996. *A Final Accounting: Philosophical and Empirical Issues in Freudian Psychology*. Cambridge, MA: MIT Press.

Fahs, Travis. 2009. "IGN Presents the History of Survival Horror." IGN.com. http://www.ign.com/articles/2009/10/30/ign-presents-the-history-of-survival-horror.

Feinstein, Justin S., Ralph Adolphs, Antonio Damasio, and Daniel Tranel. 2011. "The Human Amygdala and the Induction and Experience of Fear." *Current Biology* 21 (1):34–38. doi: 10.1016/j.cub.2010.11.042.

Ferreira, Patricia. 1990. "Jack's Nightmare at the Overlook: The American Dream Inverted." In *The Shining Reader*, edited by Tony Magistrale, 23–32. Mercer Island, WA: Starmont House.

Finney, Jack. 1999 [1955]. *Invasion of the Body Snatchers*. London: Prion.

Fox, Jess, Dylan Arena, and Jeremy N. Bailenson. 2009. "Virtual Reality: A Survival Guide for the Social Scientist." *Journal of Media Psychology* 21 (3):95–113. doi: 10.1027/1864-1105.21.3.95.

Freeland, Cynthia A. 2004. "Horror and Art-Dread." In *The Horror Film*, edited by Stephen Prince, 189–205. New Brunswick, NJ: Rutgers University Press.

Freud, Sigmund. 2003 [1919]. *The Uncanny*. Translated by David McLintock. New York: Penguin.

Friedkin, William, dir. 1973. *The Exorcist*. DVD. Hoya Productions. Burbank, CA: Warner Bros

Gazzaniga, Michael S. 2008. *Human: The Science behind What Makes Us Unique*. New York: Ecco.

Germouty, Nicolas, creator. 2015. *Death Simulator: Halloween*. VR Oculus Rift. *Wearvr*. https://www.wearvr.com/apps/death-simulator-halloween

Gill, Pat. 2002. "The Monstrous Years: Teens, Slasher Films, and the Family." *Journal of Film and Video* 54 (4):16–30.

Gilmore, David D. 2003. *Monsters: Evil Beings, Mythical Beasts, and All Manner of Imaginary Terrors*. Philadelphia: University of Pennsylvania Press.

Goddard, Drew. 2012. *The Cabin in the Woods*. DVD. Mutant Enemy. Culver City, CA: United Artists, Metro-Goldwyn-Mayer.

Gottlieb, Carl. 2005. *The Jaws Log*. 30th anniversary ed. New York: Newmarket.

Gottschall, Jonathan. 2010 [2008]. "Literature, Science, and a New Humanities." In *Evolution, Literature, and Film: A Reader*, edited by Brian Boyd, Joseph Carroll, and Jonathan Gottschall, 457–468. New York: Columbia University Press.

Gottschall, Jonathan. 2012. *The Storytelling Animal: How Stories Make Us Human*. Boston: Houghton Mifflin Harcourt.

Gottschall, Jonathan, and David Sloan Wilson, eds. 2005. *The Literary Animal: Evolution and the Nature of Narrative*. Evanston, IL: Northwestern University Press.

Grant, Barry Keith, ed. 1996. *The Dread of Difference: Gender and the Horror Film*. Austin: University of Texas Press.

Gregersen, Andreas. 2014. "Cognitive Theory and Video Games." In *Cognitive Media Theory*, edited by Paul Taberham and Ted Nanicelli, 253–267. New York: Routledge.

Grillon, Christian, and Michael Davis. 1997. "Fear-Potentiated Startle Conditioning in Humans: Explicit and Contextual Cue Conditioning following Paired versus Unpaired Training." *Psychophysiology* 34 (4):451–458. doi: 10.1111/j.1469-8986.1997.tb02389.x

Grip, Thomas. 2010. "How the Player Becomes the Protagonist." *In the Games of Madness*, 22 November 2010. Accessed 10 September 2016. http://frictionalgames.blogspot.com/2010/11/how-player-becomes-protagonist.html.

Grip, Thomas, and Jens Nilsson, creators. 2010. *Amnesia: The Dark Descent*. Videogame. Frictional Games. Helsinborg, Sweden.

Grodal, Torben Kragh. 2009. *Embodied Visions: Evolution, Emotion, Culture, and Film*. New York: Oxford University Press.

Gross, James J., and Robert W. Levenson. 1995. "Emotion Elicitation Using Films." *Cognition and Emotion* 9 (1):87–108. doi: 10.1080/02699939508408966.

Gurven, Michael. 2012. "Human Survival and Life History in Evolutionary Perspective." In *The Evolution of Primate Societies*, edited by John C. Mitani, Josep Call, Peter M. Kappeler, Ryne A. Palombit, and Joan B. Silk, 293–314. Chicago: The University of Chicago Press.

Hadley, Mark J. 2012. *Slender: The Eight Pages*. Videogame. USA: Parsec Productions.

Hajdu, David. 2008. *The Ten-Cent Plague: The Great Comic-Book Scare and How It Changed America*. New York: Farrar, Straus and Giroux.

Hand, Richard J. 2006. *Terror on the Air! Horror Radio in America, 1931–1952*. Jefferson, NC: McFarland.

Hantke, Steffen. 2016. "The Rise of Popular Horror, 1971–2000." In *Horror: A Literary History*, edited by Xavier Aldana Reyes, 159–187. London: The British Library.

Harris, Thomas. 1988. *The Silence of the Lambs*. New York: St. Martin's Press.

Harrison, Kristen, and Joanne Cantor. 1999. "Tales from the Screen: Enduring Fright Reactions to Scary Media." *Media Psychology* 1 (2):97–116. doi: 10.1207/s1532785xmep0102_1.

Hart, Donna, and Robert W. Sussman. 2009. *Man the Hunted: Primates, Predators, and Human Evolution*. Expanded ed. Boulder, CO: Westview.

Hartz, Glenn A. 1999. "How We Can Be Moved by Anna Karenina, Green Slime, and a Red Pony." *Philosophy* 74 (4):557–578.

Hawthorne, Nathaniel. 1982 [1851]. *The House of the Seven Gables*. Edited by Milton Stern. New York: Penguin.

Hayward, Philip, ed. 2009. *Terror Tracks: Music, Sound and Horror Cinema*. London: Equinox.

Heller, Chris. 2015. "A Brief History of the Haunted House." *Smithsonian.com*. Accessed 10 September 2016. http://www.smithsonianmag.com/history/history-haunted-house-180957008/?no-ist.

Heller-Nicholas, Alexandra. 2014. *Found Footage Horror Films: Fear and the Appearance of Reality*. Jefferson, NC: McFarland.

Herron, Don. 1982. "Horror Springs in the Fiction of Stephen King." In *Fear Itself: The Horror Fiction of Stephen King (1976–1982)*, edited by Tim Underwood and Chuck Miller, 57–82. London: Pan.

Higashi, Sumiko. 1990. "*Night of the Living Dead*: A Horror Film about the Horrors of the Vietnam Era." In *From Hanoi to Hollywood: The Vietnam War in American Film*, edited by Linda Dittmar and Gene Michaud, 175–188. New Brunswick, NJ: Rutgers University Press.

Higley, Sarah L. 2004. "'People Just Want to *See* Something': Art, Death, and Document in *Blair Witch*, *The Last Broadcast*, and *Paradise Lost*." In *Nothing That Is: Millennial Cinema and the Blair Witch Controversies*, edited by Sarah L. Higley and Jeffrey Andrew Weinstock, 87–110. Chicago: Wayne State University Press

Higley, Sarah L., and Jeffrey Andrew Weinstock, eds. 2004. *Nothing That Is: Millennial Cinema and the Blair Witch Controversies*. Chicago: Wayne State University Press.

Hill, Joe. 2014. "Peering into the Darkness." *New York Times*. October 30. Accessed 10 March 2015. http://opinionator.blogs.nytimes.com/2014/10/30/peering-into-the-darkness/.

Hitchcock, Alfred, dir. 1960. *Psycho*. DVD. Shamley Productions. Hollywood, CA: Paramount Pictures.

Hoekstra, Steven J., Richard Jackson Harris, and Angela L. Helmick. 1999. "Autobiographical Memories About the Experience of Seeing Frightening Movies in Childhood." *Media Psychology* 1 (2):117–140. doi: 10.1207/s1532785xmep0102_2.

Hoffner, Cynthia A., and Kenneth J. Levine. 2005. "Enjoyment of Mediated Fright and Violence: A Meta-Analysis." *Media Psychology* 7 (2):207–237. doi: 10.1207/S1532785XMEP0702_5.

Hogle, Jerrold E. 2006. "Theorizing the Gothic." In *Teaching the Gothic*, edited by Anna Powell and Andrew Smith, 29–47. Basingstoke, UK: Palgrave McMillan.

Hogle, Jerrold E., and Andrew Smith. 2009. "Revisiting the Gothic and Theory: An Introduction." *Gothic Studies* 11 (1):1–8. doi: 10.7227/GS.11.1.2.

Hooper, Tobe, dir. 1974. *The Texas Chain saw Massacre*. DVD. USA: Vortex.

Hooper, Tobe, dir. 1982. *Poltergeist*. DVD. SLM Entertainment. Culver City, CA: Metro-Goldwyn-Mayer.

Hopkins, Stephen, dir. 1996. *The Ghost and the Darkness*. DVD. Constellation Films, Douglas-Reuther Productions. Hollywood, CA: Paramount Pictures.

Hoppenstand, Gary, and Ray B. Browne. 1987. *The Gothic World of Stephen King: Landscape of Nightmares*. Bowling Green, OH: Bowling Green State University Popular Press.

Hough, Andrew. 2012. "Stephen King Announces Sequel to The Shining after 36 Years of Suspense." *The Telegraph*. Accessed 5 June 2015. http://www.telegraph. co.uk/culture/books/booknews/9554162/Stephen-King-announces-sequel-to-The-Shining-after-36-years-of-suspense.html.

Hughes, William. 2006. "Gothic Criticism: A Survey, 1764–2004." In *Teaching the Gothic*, edited by Anna Powell and Andrew Smith, 10–28. Basingstoke, UK: Palgrave McMillan.

Humphrey, David. 2014. "Gender and Sexuality Haunts the Horror Film." In *A Companion to the Horror Film*, edited by Harry M. Benshoff, 38–55. Malden, MA: John Wiley & Sons, Inc.

Huron, David, Daryl Kinney, and Kristin Precoda. 2006. "Influence of Pitch Height on the Perception of Submissiveness and Threat in Musical Passages." *Empirical Musicology Review* 1 (3):170–177.

Hutchings, Peter. 2004. *The Horror Film*. Harlow, UK: Pearson Longman.

Irving, Washington. 1996 [1820]. "The Legend of Sleepy Hollow." In *The Sketch-Book of Geoffrey Crayon, Gent.*, edited by Susan Manning, 291–318. Oxford: Oxford University Press.

Jabbi, Mbemba, Jojanneke Bastiaansen, and Christian Keysers. 2008. "A Common Anterior Insula Representation of Disgust Observation, Experience and Imagination Shows Divergent Functional Connectivity Pathways." *PLoS ONE* 3 (8):e2939. doi: 10.1371/journal.pone.0002939.

Jackson, Rosemary. 1981. *Fantasy, the Literature of Subversion*. London: Methuen.

Jackson, Shirley. 2006 [1959]. *The Haunting of Hill House*. New York: Penguin.

James, Henry. 1969 [1898]. *The Turn of the Screw, and Other Stories*. Harmondsworth, UK: Penguin.

Jancovich, Mark. 1994. *American Horror from 1951 to the Present*. BAAS pamphlet/British Association for American Studies. Staffordshire, UK: Keele University Press.

Jancovich, Mark. 1996. *Rational Fears: American Horror in the 1950s*. Manchester: Manchester University Press.

Jensen, Arnt, creator. 2010. *LIMBO*. Videogame. Playdead. Copenhagen, Denmark.

Johansen, Kristine E. R. 2013. "Horror and Personality: A Bio-Cultural Approach to Horror Fiction and an Empirical Investigation of the Personality Profile of Horror Fans." MA diss., Department of English, Aarhus University.

Jones, Stephen. 1997. *Clive Barker's A-Z of Horror*. London: BBC Books.

Jones, Steve. 2013. *Torture Porn: Popular Horror after "Saw."* Basingstoke, UK: Palgrave Macmillan.

Joshi, S. T., ed. 2007. *American Supernatural Tales*. New York: Penguin.

Katz, Richard. 1999. "'Blair' Fare a Big Hit on the Web." *Variety*. Accessed 10 September 2016. http://variety.com/1999/digital/news/blair-fare-a-big-hit-on-web-1117750209/.

Kaufman, Kevin. 2004. *The 100 Scariest Movie Moments*. DVD. Kaufman Films. New York: Bravo.

Keller, James. 2004. "'Nothing That Is Not There and the Nothing That Is': Language and the Blair Witch Phenomenon." In *Nothing That Is: Millennial Cinema and the Blair Witch Controversies*, edited by Sarah L. Higley and Jeffrey Andrew Weinstock, 53–64. Chicago: Wayne State University Press

Kendrick, Walter M. 1991. *The Thrill of Fear: 250 Years of Scary Entertainment*. New York: Grove Weidenfeld.

Kendrick, James. 2014. "Slasher Films and Gore in the 1980s." In *A Companion to the Horror Film*, edited by Harry M. Benshoff, 310–328. Malden, MA: John Wiley & Sons.

Kenrick, Douglas T. 2013. *Sex, Murder, and the Meaning of Life: A Psychologist Investigates How Evolution, Cognition, and Complexity Are Revolutionizing Our View of Human Nature*. New York: Basic Books.

Kermode, Mark. 2003. *The Exorcist*. Rev. 2nd ed. London: BFI Publishing.

Kerr, Margee. 2015. *Scream: Chilling Adventures in the Science of Fear*. New York: PublicAffairs.

Khader, Jamil. 2013. "Will the Real Robert Neville Please, Come Out? Vampirism, the Ethics of Queer Monstrosity, and Capitalism in Richard Matheson's *I Am Legend*." *Journal of Homosexuality* 60 (4):532–557. doi: 10.1080/00918369.2013.735934.

Khan, Ali S. 2011. "Preparedness 101: Zombie Apocalypse." *Public Health Matters Blog*, May 16. http://blogs.cdc.gov/publichealthmatters/2011/05/preparedness-101-zombie-apocalypse/.

King, Stephen. 1978. "Foreword." In *Night Shift*, 5–19. London: Hodder and Stoughton.

King, Stephen. 1980 [1978]. *The Stand*. London: New English Library.

King, Stephen. 1981. *It*. New York: New American Library.

King, Stephen. 1983. *Christine*. London: New English Library.

King, Stephen. 1983a [1981]. *Danse Macabre*. New York: Berkeley Books.

King, Stephen. 1983b. *Pet Sematary*. Garden City, NY: Doubleday.

King, Stephen. 1986. "The Raft." In *Skeleton Crew*. By Stephen King, 278–306. New York: New American Library.

King, Stephen. 1992. *Needful Things*. New York: New American Library.

King, Stephen. 1999 [1974]. *Carrie*. New York: Pocket Books.

King, Stephen. 2011 [1977]. *The Shining*. London: Hodder & Stoughton.

King, Stephen. 2011. "Afterword." In *Full Dark, No Stars*. By Stephen King, 365–368. New York: Gallery Books.

Kirkman, Robert, and Tony Moore. 2003–. *The Walking Dead*. Berkeley, CA: Image Comics.

Kjeldgaard-Christiansen, Jens. 2016. "Evil Origins: A Darwinian Genealogy of the Popcultural Villain." *Evolutionary Behavioral Sciences* 10 (2):109–122. doi: 10.1037/ebs0000057.

Klein, Joshua. 1999. "The Blair Witch Project." *A. V. Club*. Accessed 3 February 2016. http://www.avclub.com/article/the-blair-witch-project-13607.

Kosofsky Sedgwick, Eve. 1982. Review of *The Literature of Terror: A History of Gothic Fictions from 1765 to the Present Day*. *Studies in Romanticism* 21 (2):243–253.

Kripke, Eric, creator. 2005–. *Supernatural*. CW Channel. Burbank, CA: Warner Bros. Television Distribution.

Kruuk, H. 2002. *Hunter and Hunted: Relationships between Carnivores and People*. New York: Cambridge University Press.

Krzywinska, Tanya. 2002. "Hands-On Horror." In *ScreenPlay: Cinema/Videogames/ Interfaces*, edited by Geoff King and Tanya Krzywinska, 206–223. London: Wallflower.

Kubrick, Stanley, dir. 1980. *The Shining*. DVD. The Producer Circle Company, Hawk Films, Peregrine Productions. Burbank. CA: Warner Bros.

Laland, Kevin N., and Gillian Brown. 2011. *Sense and Nonsense: Evolutionary Perspectives on Human Behaviour*. 2nd ed. New York: Oxford University Press.

Landay, Lori. 2014. "Interactivity." In *The Routledge Companion to Video Game Studies*, edited by Mark J. P. Wolf and Bernard Perron, 173–184. New York: Routledge.

Langan, John. 2008. "A Devil for the Day: William Peter Blatty, Ira Levin, and the Revision of the Satanic." In *American Exorcist: Critical Essays on William Peter Blatty*, edited by Benjamin Szumskyj, 45–70. Jefferson, NC: McFarland.

Lawrence, Francis, dir. 2007. *I Am Legend*. DVD. Burbank, CA: Warner Bros. Pictures.

LeDoux, Joseph E. 1996. *The Emotional Brain: The Mysterious Underpinnings of Emotional Life*. New York: Simon & Schuster.

Levin, Ira. 1997 [1967]. *Rosemary's Baby*. New York: Penguin.

Levin, Ira. 1997b. *Son of Rosemary*. New York: Dutton.

Levin, Ira. 2002 [1972]. *The Stepford Wives*. New York: Perennial.

Levin, Ira. 2012. "Stuck with Satan." *The Criterion Collection*. Accessed 26 June 2015. http://www.criterion.com/current/posts/ 2541-stuck-with-satan-ira-levin-on-the-origins-of-rosemary-s-baby.

Lewis, C. S. 2001 [1940]. *The Problem of Pain*. San Francisco: HarperSanFrancisco.

Lilja, Hans-Åke. 2015. "International King." *Lilja's Library*. Accessed 2 June 2015. http://www.liljas-library.com/internationalking.php

Lima, Robert. 1974. "The Satanic Rape of Catholicism in *Rosemary's Baby*." *Studies in American Fiction* 2 (2):211–222.

Lloyd Smith, Allan. 2004. *American Gothic Fiction: An Introduction*. New York: Continuum.

LoBue, Vanessa, and Judy S. DeLoache. 2008. "Detecting the Snake in the Grass: Attention to Fear-Relevant Stimuli by Adults and Young Children." *Psychological Science* 19 (3):284–289. doi: 10.1111/j.1467-9280.2008.02081.x.

Loewenstein, Adam. 2005. *Shocking Representation: Historical Trauma, National Cinema, and the Modern Horror Film*. New York: Columbia University Press.

Lovecraft, H. P. 1973. *Supernatural Horror in Literature*. New York: Dover.

Luckhurst, Roger. 2005. "Introduction." In *Late Victorian Gothic Tales*, edited by Roger Luckhurst, ix-xxxi. New York: Oxford University Press.

Lynch, Teresa, and Nicole Martins. 2015. "Nothing to Fear? An Analysis of College Students' Fear Experiences With Video Games." *Journal of Broadcasting & Electronic Media* 59 (2):298–317. doi: 10.1080/08838151.2015.1029128.

Macmillan, Malcolm. 1997. *Freud Evaluated: The Completed Arc*. Cambridge, MA: MIT Press.

Madary, Michael, and Thomas K. Metzinger. 2016. "Real Virtuality: A Code of Ethical Conduct. Recommendations for Good Scientific Practice and the Consumers of VR-Technology." *Frontiers in Robotics and AI*. doi: 10.3389/frobt.2016.00003. http://journal.frontiersin.org/article/10.3389/frobt.2016.00003/full

Maddrey, Joseph. 2004. *Nightmares in Red, White, and Blue: The Evolution of the American Horror Film*. Jefferson, NC: McFarland.

Magistrale, Tony. 1990. "Shakespeare in 58 Chapters: *The Shining* as Classical Tragedy." In *The Shining Reader*, edited by Tony Magistrale, 155–168. Mercer Island, WA: Starmont House.

Magistrale, Tony. 2010. *Stephen King: America's Storyteller*. Santa Barbara, CA: Praeger.

Magistrale, Tony. 2013. "Why Stephen King Still Matters." In *A Companion to American Gothic*, edited by Charles L. Crow, 353–365. John Wiley & Sons.

Manchel, Frank. 1995. "What About Jack? Another Perspective on Family Relationships in Stanley Kubrick's *The Shining*." *Literature/Film Quarterly* 23 (1):68–78.

Mar, Raymond A., and Keith Oatley. 2008. "The Function of Fiction is the Abstraction and Simulation of Social Experience." *Perspectives on Psychological Science* 3 (3):173–192. doi: 10.1111/j.1745-6924.2008.00073.x.

Marks, Isaac M. 1987. *Fears, Phobias, and Rituals: Panic, Anxiety, and Their Disorders*. New York: Oxford University Press.

Marks, Isaac M., and Randolph M. Nesse. 1994. "Fear and Fitness: An Evolutionary Analysis of Anxiety Disorders." *Ethology and Sociobiology* 15 (5–6):247–261. doi: 10.1016/0162-3095(94)90002-7.

Maurer, Adah. 1965. "What Children Fear." *The Journal of Genetic Psychology* 106 (2):265–277.

Matheson, Richard. 2006 [1954]. *I Am Legend*. London: Gollancz.

McCauley, Kirby, ed. 1980. *Dark Forces: New Stories of Suspense and Supernatural Horror*. New York: Viking.

McConnell, Mariana. 2008. "Interview: George A. Romero on *Diary of the Dead*." *CinemaBlend*. Accessed 27 April 2015. http://www.cinemablend.com/new/Interview-George-A-Romero-On-Diary-Of-The-Dead-7818.html.

McElhaney, Joe. 2007. "Urban Irrational: *Rosemary's Baby*, Polanski, New York." In *City That Never Sleeps: New York and the Filmic Imagination*, edited by Murray Pomerance, 201–213. New Brunswick, NJ: Rutgers University Press.

McKendry, Bekah. 2013. "The History of Haunted Houses." *America Haunts*. http://www.americahaunts.com/ah/2014/03/the-history-of-haunted-houses/.

Meehan, Michael, Sharif Razzaque, Brent Insko, Mary Whitton, and Frederick P. Brooks. 2005. "Review of Four Studies on the Use of Physiological Reaction as a Measure of Presence in Stressful Virtual Environments." *Applied Psychophysiology and Biofeedback* 30 (3):239–258. doi: 10.1007/s10484-005-6381-3.

Mellmann, Katja. 2002. "E-Motion: Being Moved by Fiction and Media? Notes on Fictional Worlds, Virtual Contacts and the Reality of Emotions." *PsyArt: An Online Journal for the Psychological Study of the Arts*. http://psyartjournal.com/article/show/mellmann-e_motion_being_moved_by_fiction_and_medi. Accessed 4 January 2017.

Mendez, Mike, dir. 2013. *Big Ass Spider!* DVD. Epic Pictures Group. Hollywood, CA: Epic Pictures Releasing.

Meyer, Stephenie. 2005. *Twilight*. New York: Atom.

Meyer, Stephenie. 2006. *New Moon*. New York: Atom.

Meyer, Stephenie. 2007. *Eclipse*. New York: Atom.

Meyer, Stephenie. 2008. *Breaking Dawn*. New York: Atom.

Mikami, Shinji, creator. 1996. *Resident Evil*. Videogame. Capcom. Tokyo: Japan.

Miner, Steve, dir. 1999. *Lake Placid*. DVD. Phoenix Pictures, Rocking Chair. Los Angeles, CA: Fox 2000 Pictures.

Mitchell, David Robert, dir. 2014. *It Follows*. DVD. RADiUS-TWC. New York: Northern Lights Films, Animal Kingdom, Two Flints.

Miyazaki, Hidetaka, creator. 2015. *Bloodborne*. Videogame. FromSoftware. San Mateo, CA: Sony Computer Entertainment.

Morton, Lisa. 2012. *Trick or Treat: A History of Halloween*. London: Reaktion.

Murphy, Bernice M. 2009. *The Suburban Gothic in American Popular Culture*. New York: Palgrave Macmillan.

Murphy, Ryan, and Brad Falchuk, creators. 2011–. *American Horror Story*. FX. Los Angeles, CA: 20th Century Fox Television.

Mustazza, Leonard. 1990. "The Red Death's Sway: Setting and Character in Poe's 'The Masque of the Red Death' and King's *The Shining*." In *The Shining Reader*, edited by Tony Magistrale, 105–120. Mercer Island, WA: Starmont House.

Myrick, Daniel, and Eduardo Sánchez, dirs. 1999. *Curse of the Blair Witch*. Haxan Films, New York: SyFy.

Nakata, Hideo, dir. 1998. *Ringu*. DVD. Omega Project. Japan: Toho.

National Safety Council. 2011. *Injury Facts 2011 Edition*. Itasca, IL: National Safety Council.

Ndalianis, Angela. 2012. *The Horror Sensorium: Media and the Senses*. Jefferson, NC: McFarland.

New, Joshua, Leda Cosmides, and John Tooby. 2007. "Category-Specific Attention for Animals Reflects Ancestral Priorities, Not Expertise." *Proceedings of the National Academy of Sciences* 104 (42):16598–16603. doi: 10.1073/pnas.0703913104.

New, Joshua, and Tamsin C. German. 2015. "Spiders at the Cocktail Party: An Ancestral Threat that Surmounts Inattentional Blindness." *Evolution and Human Behavior* 36 (3):165–173. doi: 10.1016/j.evolhumbehav.2014.08.004.

Newman, Kim. 2011. *Nightmare Movies: Horror on Screen since the 1960s*. Revised and updated ed. London: Bloomsbury.

Ng, Andrew Hock Soon. 2015. "The Inhumanity of Christ: Damnation and Redemption in Richard Matheson's *I Am Legend*." *Studies in the Literary Imagination* 46 (2):91–108. doi: 10.1353/sli.2013.0015.

Norenzayan, Ara, Scott Atran, Jason Faulkner, and Mark Schaller. 2006. "Memory and Mystery: The Cultural Selection of Minimally Counterintuitive Narratives." *Cognitive Science* 30 (3):531–553. doi: 10.1207/s15516709cog0000_68.

Notkin, Deborah L. 1982. "Stephen King: Horror and Humanity for Our Time." In *Fear Itself: The Horror Fiction of Stephen King (1976–1982)*, edited by Tim Underwood and Chuck Miller, 131–142. London: Pan.

Nowell, Richard. 2011a. *Blood Money: A History of the First Teen Slasher Film Cycle*. New York: Continuum.

Nowell, Richard. 2011b. "'There's More Than One Way to Lose Your Heart': The American Film Industry, Early Teen Slasher Films, and Female Youth." *Cinema Journal* 51 (1):115–140. doi: 10.2307/41342285.

Nuttall, Louise. 2015. "Attributing Minds to Vampires in Richard Matheson's *I Am Legend*." *Language and Literature* 24 (1):23–39. doi: 10.1177/0963947014561834.

Nutter, David, dir. 2005. "Wendigo." In *Supernatural*, created by Eric Kripke. Burbank, CA: Warner Bros. Television Distribution.

Öhman, Arne. 2008. "Fear and Anxiety: Overlaps and Dissociations." In *Handbook of Emotions*, edited by Michael Lewis, Jeannette M. Haviland-Jones, and Lisa Feldman Barrett, 709–729. New York: Guilford.

Öhman, Arne, Anders Flykt, and Francisco Esteves. 2001. "Emotion Drives Attention: Detecting the Snake in the Grass." *Journal of Experimental Psychology: General* 130 (3):466–478. doi: 10.1037/0096-3445.130.3.466.

Öhman, Arne, Daniel Lundqvist, and Francisco Esteves. 2001. "The Face in the Crowd Revisited: A Threat Advantage with Schematic Stimuli." *Journal of Personality and Social Psychology* 80 (3):381–396. doi: 10.1037//0022-3514.80.3.381.

Öhman, Arne, and Susan Mineka. 2001. "Fears, Phobias, and Preparedness: Toward an Evolved Module of Fear and Fear Learning." *Psychological Review* 108 (3):483–522.doi: 10.1037//0033-295X.108.3.483.

Onyett, Charles. 2010. "Amnesia: The Dark Descent Review." Accessed January 18 2016. http://www.ign.com/articles/2010/09/03/amnesia-the-dark-descent-review.

Pallesen, Karen Johanne, et al. 2005. "Emotion Processing of Major, Minor, and Dissonant Chords." *Annals of the New York Academy of Sciences* 1060 (1):450–453. doi: 10.1196/annals.1360.047.

Patterson, Kathy Davis. 2005. "Echoes of *Dracula*: Racial Politics and the Failure of Segregated Spaces in Richard Matheson's *I Am Legend*." *Journal of Dracula Studies* 7:19–26.

Pearson, Maisie K. 1968. "Rosemary's Baby: The Horns of a Dilemma." *The Journal of Popular Culture* 2 (3):493–502. doi: 10.1111/j.0022-3840.1968.0203_493.x.

Peli, Oren, dir. 2009. *Paranormal Activity*. DVD. Oren Peli d.b.a. Solana Films, Blumhouse Productions. Hollywood, CA: Paramount Pictures.

Penkunas, Michael J., and Richard G. Coss. 2013. "Rapid Detection of Visually Provocative Animals by Preschool Children and Adults." *Journal of Experimental Child Psychology* 114 (4):522–536. doi: 10.1016/j.jecp.2012.10.001.

Pennington, Jody. 2009. "The Good, the Bad, and *Halloween*: A Sociocultural Analysis of John Carpenter's Slasher." *p.o.v.: A Danish Journal of Film Studies* (28):54–63.

Perron, Bernard. 2009. *Horror Video Games: Essays on the Fusion of Fear and Play*. Jefferson, NC: McFarland.

Phillips, Kendall R. 2005. *Projected Fears: Horror Films and American Culture*. Westport, CT: Praeger.

Pinker, Steven. 1997. *How the Mind Works*. New York: Norton.

Pinker, Steven. 2002. *The Blank Slate: The Modern Denial of Human Nature*. New York: Viking.

Pinker, Steven. 2007. "Toward a Consilient Study of Literature." *Philosophy and Literature* 31 (1):162–178. doi: 10.1353/phl.2007.0016.

Pizzolatto, Nic, creator. 2014. *True Detective*. New York: HBO.

Plantinga, Carl, and Greg M. Smith, eds. 1999. *Passionate Views: Film, Cognition, and Emotion*. Baltimore, MD: The Johns Hopkins University Press.

Platts, Todd K. 2013. "Locating Zombies in the Sociology of Popular Culture." *Sociology Compass* 7 (7):547–560. doi: 10.1111/soc4.12053.

Platts, Todd K. 2014a. "The New Horror Movie." In *Baby Boomers and Popular Culture: An Inquiry into America's Most Powerful Generation*, edited by Thom Gencarelli and Brian Cogan, 147–163. Santa Barbara, CA: ABC-Clio.

Platts, Todd K. 2014b. "The Walking Dead." In *The Zombie Film: From White Zombie to World War Z*, edited by Alain Silver and James Ursini, 294–297. Milwaukee, WI: Applause Theatre & Cinema Books.

Plumwood, Val. 2012. "Meeting the Predator." In *The Eye of the Crocodile: Val Plumwood*, edited by Lorraine Shannon, 9–21. Canberra: Australian National University E Press.

Polanski, Roman, dir. 1968. *Rosemary's Baby*. DVD. William Castle Enterprises. Hollywood, CA: Paramount Pictures Corporation.

Prince, Stephen. 2004. "Introduction: The Dark Genre and Its Paradoxes." In *The Horror Film*, edited by Stephen Prince, 1–11. New Brunswick, NJ: Rutgers University Press.

Publishers Weekly. 2002. "Fiction Book Review: *Hunted Past Reason* by Richard Matheson." *Publishers Weekly*. Accessed 6 May 2015. http://www.publishersweekly.com/978-0-7653-0271-7.

Pulliam, June. 2007. "The Zombie." In *Icons of Horror and the Supernatural: An Encyclopedia of Our Worst Nightmares*, edited by S. T. Joshi, 753–753. Westport, CT: Greenwood.

Punter, David. 1996. *The Literature of Terror: A History of Gothic Fictions from 1765 to the Present Day*. Vol. 1, *The Gothic Tradition*. New York: Longman.

Quammen, David. 2003. *Monster of God: The Man-Eating Predator in the Jungles of History and the Mind*. New York: W.W. Norton.

Quinlan, Sean M. 2014. "Demonizing the Sixties: Possession Stories and the Crisis of Religious and Medical Authority in Post-Sixties American Popular Culture." *The Journal of American Culture* 37 (3):314–330. doi: 10.1111/jacc.12218.

Quirke, Antonia. 2002. *Jaws*. BFI Modern Classics. London: British Film Institute.

Ragona, Ubaldo, and Sidney Salkow. 1964. *The Last Man on Earth*. DVD. Italy, USA: Produzioni La Regina, American International Productions.

Rakison, David H., and Jaime Derringer. 2008. "Do Infants Possess an Evolved Spider-Detection Mechanism?" *Cognition* 107 (1):381–393. doi: 10.1016/j.cognition.2007.07.022.

Ranki, Jyri, and Michael Kasurinen, producers. 2010. *Alan Wake*. Videogame. Remedy Entertainment. Seattle, WA: Microsoft Game Studios.

Raynal, Frédérick, and Bruno Bonnel. 1992. *Alone in the Dark*. Videogame. Lyons, France: Infogrames Entertainment, SA.

Reesman, Jeanne Campbell. 1990. "Stephen King and the Tradition of American Naturalism in *The Shining*." In *The Shining Reader*, edited by Tony Magistrale, 121–138. Mercer Island, WA: Starmont House.

Reeves, Matt, dir. 2007. *Cloverfield*. DVD. Bad Robot. Hollywood, CA: Paramount Pictures.

Revonsuo, Antti. 2000. "The Reinterpretation of Dreams: An Evolutionary Hypothesis of the Function of Dreaming." *Behavioral and Brain Sciences* 23 (6):877–901; discussion 904–1121. doi: 10.1017/S0140525X00004015.

Reyes, Xavier Aldana. 2016. "Introduction: What, Why, and When Is Horror Fiction?" In *Horror: A Literary History*, edited by Xavier Aldana Reyes, 7–17. London: The British Library.

Rice, Anne. 1976. *Interview with the Vampire*. New York: Knopf.

Rockoff, Adam. 2002. *Going to Pieces: The Rise and Fall of the Slasher Film, 1978–1986*. Jefferson, NC: McFarland.

Romero, George A, dir. 1968. *Night of the Living Dead*. DVD/Video. USA: Image Ten, Laurel Group.

Roscoe, Jane. 2000. "*The Blair Witch Project*: Mock-Documentary Goes Mainstream." *Jump Cut: A Review of Contemporary Media* 43: 3–8. https://www.ejumpcut.org/archive/onlinessays/JC43folder/BlairWitch.html

Roth, Eli, dir. 2005. *Hostel*. DVD. Next Entertainment. USA, Czech Republic: Screen Gems.

Rottenberg, Jonathan, Rebecca Ray, and James Gross. 2007. "Emotion Elicitation Using Films." In *The Handbook of Emotion Elicitation and Assessment* edited by James A. Coan and John J. B. Allen, 9–28. New York: Oxford University Press.

Rozin, Paul, Jonathan Haidt, and Clark R. McCauley. 2005. "Disgust: The Body and Soul Emotion." In *Handbook of Cognition and Emotion*, edited by Tim Dalgleish and Mick J. Power, 429–445. John Wiley & Sons.

Rubey, Dan. 1976. "The *Jaws* in the Mirror." *Jump Cut: A Review of Contemporary Media* (10–11):20–23.

Sagal, Boris, dir. 1971. *The Omega Man*. DVD/Video. Walter Seltzer Productions. Burbank, CA: Warner Bros.

Saler, Benson, and Charles A. Ziegler. 2005. "Dracula and Carmilla: Monsters and the Mind." *Philosophy and Literature* 29 (1):218–227. doi: 10.1353/phl.2005.0011.

Salisbury, Mark, and Ian Nathan. 1995. "*Jaws*: The Oral History." *Empire Online*. http://web.archive.org/web/20150525034309/http://www.empireonline.com/interviews/interview.asp?IID=1516

Sánchez, Eduardo, and Daniel Myrick, dirs. 1999. *The Blair Witch Project*. DVD. Orlando, FL: Haxan Films.

Savini, Tom, dir. 1990. *Night of the Living Dead*. DVD. Los Angeles, CA: Columbia Pictures.

Scalise Sugiyama, Michelle. 2001. "Food, Foragers, and Folklore: The Role of Narrative in Human Subsistence." *Evolution and Human Behavior* 22 (4):221–240. doi: 10.1016/S1090-5138(01)00063-0.

Scalise Sugiyama, Michelle, and Larry Scalise Sugiyama. 2011. "'Once a Child is Lost, He Dies': Monster Stories Vis-a-Vis the Problem of Errant Children." In *Creating Consilience: Integrating the Sciences and the Humanities*, edited by Ted Slingerland and Mark Collard, 351–371. New York: Oxford University Press.

"Scary Maze prank—The Original." 2006. Posted by Can't We All Just Get Along. *YouTube*. Accessed 1 May 2015. https://www.youtube.com/watch?v=oh87njiWTmw

Schneider, Steven Jay, ed. 2004. *Horror Film and Psychoanalysis: Freud's Worst Nightmare*. New York: Cambridge University Press.

Schneider, Steven Jay, and Daniel Shaw, eds. 2003. *Dark Thoughts: Philosophic Reflections on Cinematic Horror*. Lanham, MD: Scarecrow.

Scott, Ridley, dir. 1979. *Alien*. DVD. Brandywine Productions, Los Angeles, CA: Twentieth Century-Fox Productions.

Sears, John. 2011. *Stephen King's Gothic*. Cardiff, UK: University of Wales Press.

Seligman, Martin E. P. 1971. "Phobias and Preparedness." *Behavior Therapy* 2 (3):307–320. doi: 10.1016/S0005-7894(71)80064-3.

Serling, Rod, creator. 1959-1964. *The Twilight Zone*. CBS Television Distribution.

Shoemaker, Pamela J. 1996. "Hardwired for News: Using Biological and Cultural Evolution to Explain the Surveillance Function." *Journal of Communication* 46 (3):32–47. doi: 10.1111/j.1460-2466.1996.tb01487.x.

Shteynberg, Garriy, et al. 2014. "Feeling More Together: Group Attention Intensifies Emotion." *Emotion* 14 (6):1102–1114. doi: 10.1037/a0037697.

Shubin, Neil. 2008. *Your Inner Fish: A Journey into the 3.5-Billion-Year History of the Human Body*. New York: Pantheon.

Skal, David J. 2001. *The Monster Show: A Cultural History of Horror*. Rev. ed. New York: Faber and Faber.

Simmons, Dan. 1991. *Summer of Night*. New York: Putnam.

Simmons, Dan. 2009 [1989]. *Carrion Comfort*. New York: St. Martin's Press.

Slater, Mel, David-Paul Pertaub, Chris Barker, and David M. Clark. 2006. "An Experimental Study on Fear of Public Speaking Using a Virtual Environment." *CyberPsychology & Behavior* 9 (5):627–633. doi: 10.1089/cpb.2006.9.627.

Smith, L. J. 1991–2011. *The Vampire Diaries*. New York: Hodder.

Smith, L. J. 1996–1998. *The Night World*. New York: Hodder.

Smith, Murray. 1995. *Engaging Characters: Fiction, Emotion, and the Cinema.* Oxford: Clarendon.

Smuts, Aaron. 2009. "Art and Negative Affect." *Philosophy Compass* 4 (1):39–55. doi: 10.1111/j.1747-9991.2008.00199.x.

Spielberg, Steven, dir. 1975. *Jaws.* DVD. Universal City, CA: Universal Pictures, Zanuck/Brown Company.

Spignesi, Stephen J. 1991. *The Shape Under the Sheet: The Complete Stephen King Encyclopedia.* Ann Arbor, MI: Popular Culture.

Špinka, Marek, Ruth C. Newberry, and Marc Bekoff. 2001. "Mammalian Play: Training for the Unexpected." *Quarterly Review of Biology* 76 (2):141–168. doi: 10.1086/393866.

Steckenfinger, Shawn A., and Asif A. Ghazanfar. 2009. "Monkey Visual Behavior Falls into the Uncanny Valley." *Proceedings of the National Academy of Sciences* 106 (43):18362–18366. doi: 10.1073/pnas.0910063106.

Steen, Francis F., and Stephanie A. Owens. 2001. "Evolution's Pedagogy: An Adaptationist Model of Pretense and Entertainment." *Journal of Cognition and Culture* 1 (4):289–321. doi: 10.1163/156853701753678305.

Stern, D. A. 1999. *The Blair Witch Project: A Dossier.* New York: Onyx.

Stevenson, Robert Louis. 2002 [1886]. *The Strange Case of Dr Jekyll and Mr Hyde and Other Tales of Terror.* London: Penguin.

Stoker, Bram. 1997 [1897]. *Dracula: Authoritative Text, Contexts, Reviews and Reactions, Dramatic and Film Variations, Criticism.* 1st ed. *A Norton Critical Edition.* Edited by Nina Auerbach and David J. Skal. New York: W.W. Norton.

Straub, Peter. 1979. *Ghost Story.* New York: Coward, McCann & Geoghegan, Inc.

Strauss-Schulson, Todd, dir. 2015. *The Final Girls.* DVD. Stage 6 Films. Los Angeles, CA: Sony Pictures Home Entertainment.

Swanger, David. 2008. "Shock and Awe: The Emotional Roots of Compound Genres." *New York Review of Science Fiction* 20 (5):1, 8–18.

The Numbers. 2015. "*Night of the Living Dead*—Box Office Data." *The Numbers.* Accessed 1 April 2015. http://www.the-numbers.com/movie/Night-of-the-Living-Dead-(1968).

The Numbers. 2015a. "The Blair Witch Project—Box Office Data." *The Numbers.* Accessed 15 March 2015. http://www.the-numbers.com/movie/Blair-Witch-Project-The.

The Numbers. 2015b. "The Numbers—Leading Genres." *The Numbers.* Accessed 15 March 2015. http://www.the-numbers.com/market/genres.

The Numbers. 2015c. "The Numbers—Movie Budget and Financial Performance Records." *The Numbers.* Accessed 15 March 2015. http://www.the-numbers.com/movie/budgets/.

The Numbers. 2015d. "*Paranormal Activity*—Box Office Data." *The Numbers.* Accessed 23 April 2015. http://www.the-numbers.com/movie/Paranormal-Activity.

Therrien, Carl. 2014. "Immersion." In *The Routledge Companion to Video Game Studies*, edited by Mark J. P. Wolf and Bernard Perron, 451–458. New York: Routledge.

Tooby, John, and Leda Cosmides. 2001. "Does Beauty Build Adapted Minds? Toward an Evolutionary Theory of Aesthetics, Fiction, and the Arts." *SubStance* 30 (1–2):6–27.

Toprac, Paul, and Ahmed Abdel-Meguid. 2011. "Causing Fear, Suspense, and Anxiety Using Sound Design in Computer Games." In *Game Sound Technology and Player Interaction: Concepts and Developments*, edited by Mark Grimshaw, 176–191. Hershey, PA: Information Science Reference.

Tudor, Andrew. 1997. "Why Horror? The Peculiar Pleasures of a Popular Genre." *Cultural Studies* 11 (3):443–463. doi: 10.1080/095023897335691.

Turner, Peter. 2015. *The Blair Witch Project*. Leighton Buzzard: Auteur.

Twitchell, James B. 1985. *Dreadful Pleasures: An Anatomy of Modern Horror*. New York: Oxford University Press.

Tybur, Joshua M., Debra Lieberman, Robert Kurzban, and Peter DeScioli. 2013. "Disgust: Evolved Function and Structure." *Psychological Review* 120 (1):65–84. doi: 10.1037/a0030778.

Underwood, Ron, dir. 1989. *Tremors*. DVD. No Frills. Universal City, CA: Universal Pictures.

Valerius, Karyn. 2005. "Rosemary's Baby, Gothic Pregnancy, and Fetal Subjects." *College Literature* 32 (3):116–135. doi: 10.1353/lit.2005.0048.

Valli, Katja, and Antti Revonsuo. 2009. "The Threat Simulation Theory in Light of Recent Empirical Evidence: A Review." *American Journal of Psychology* 122 (1):17–38.

Vanaman, Sean, Jake Rodkin, Dennis Lenart, Eric Parsons, Nick Herman, and Sean Ainswort. 2012. *The Walking Dead*. Videogame. San Rafael, CA: Telltale Games.

Velikovsky, J. T. 2014. "Two Successful Transmedia Film Case Studies: *The Blair Witch Project* (1999) and *The Devil Inside* (2012)." In *Transmedia Practice: A Collective Approach*, edited by Debra Polson, Ann-Marie Cook, J. T. Velikovsky, and Adam Brackin, 103–117. Freeland: Inter-Disciplinary Press.

von Gersdorff, Satine Buch Rosenørn. 2016. "What Doesn't Kill You Makes You Smarter: A Biocultural Account of Death in Literature." MA diss., Department of English, Aarhus University.

Vorderer, Peter, Francis F. Steen, and Elaine Chan. 2006. "Motivation." In *Psychology of Entertainment*, edited by Jennings Bryant and Peter Vorderer, 3–17. Mahwah, NJ: Lawrence Erlbaum.

Wade, Nicholas. 2006. *Before the Dawn: Recovering the Lost History of Our Ancestors*. New York: Penguin.

Walpole, Horace. 1996 [1764]. *The Castle of Otranto: A Gothic Story*. New York: Oxford University Press.

Walton, Kendall. 1990. *Mimesis as Make-Believe: On the Foundations of the Representational Arts*. Cambridge, MA: Harvard University Press.

Wan, James, dir. 2010. *Insidious*. DVD. Great Britain, Canada, USA: Haunted Movies.

Wan, James, dir. 2013. *The Conjuring*. DVD. Evergreeen Media. New Line Cinema. Burbank, CA: Warner Bros. Pictures.

Weaver, James B., and Ronald C. Tamborini, eds. 1996. *Horror Films: Current Research on Audience Preferences and Reactions*. Mahwah, N.J.: Lawrence Erlbaum.

Weaver, Angela D., A. Dana Ménard, Christine Cabrera, and Angela Taylor. 2015. "Embodying the Moral Code? Thirty Years of Final Girls in Slasher Films." *Psychology of Popular Media Culture* 4 (1):31–46. doi: 10.1037/ppm0000006.

Wee, Valerie. 2005. "The Scream Trilogy, 'Hyperpostmodernism,' and the Late-Nineties Teen Slasher Film." *Journal of Film and Video* 57 (3):44–61.

Weinstock, Jeffrey Andrew. 2004. "Lostness (Blair Witch)." In *Nothing That Is: Millennial Cinema and the Blair Witch Controversies*, edited by Sarah L. Higley and Jeffrey Andrew Weinstock, 229–244. Chicago: Wayne State University Press.

Wengrow, David. 2014. *The Origins of Monsters: Image and Cognition in the First Age of Mechanical Reproduction*. Princeton, NJ: Princeton University Press.

Whale, James, dir. 1931. *Frankenstein*. DVD/Video. Universal City, CA: Universal Pictures Corporation.

Wiater, Stanley. 1996. "A Shockingly Brief and Informal History of the Horror Writers Association." *Horror Writers Association*. http://horror.org/aboutus.htm.

Wiater, Stanley, ed. 1997. *Dark Thoughts on Writing: Advice and Commentary from Fifty Masters of Fear and Suspense*. New York: Underwood.

Wilde, Oscar. 2003 [1890]. *The Picture of Dorian Gray*. New York: Penguin.

Willits, Tim, dir. 2004. *Doom 3*. Videogame. Activision. Austin, TX: Aspyr Media.

Wilson, Edward O. 1984. *Biophilia*. Cambridge, MA: Harvard University Press.

Wilson, Edward O. 1998. *Consilience: The Unity of Knowledge*. New York: Knopf.

Winter, Douglas E. 1984. *Stephen King: The Art of Darkness*. New York: New American Library.

Winter, Douglas E. 1988. "Introduction." In *Prime Evil: New Stories by the Masters of Modern Horror*, edited by Douglas E. Winter, 11–21. New York: New American Library.

Winter, Douglas E., ed. 1988. *Prime Evil: New Stories by the Masters of Modern Horror*. New York: New American Library.

Winter, Douglas E. 1990 [1985]. "Richard Matheson." In *Faces of Fear: Encounters with the Creators of Modern Horror*, edited by Douglas E. Winter, 37–52. London: Pan Books.

Winter, Douglas E. 1998. "The Pathos of Genre." *Dark Echo Horror*. http://www.darkecho.com/darkecho/darkthot/pathos.html.

Wisker, Gina. 2005. *Horror Fiction: An Introduction*. New York: Continuum.

Wood, Robin. 1979. "An Introduction to the American Horror Film." In *American Nightmare: Essays on the Horror Film*, edited by Andrew Britton, Richard Lippe, Tony Williams and Robin Wood, 7–28. Toronto: Festival of Festivals.

Wood, Robin. 1987. "Returning the Look: *Eyes of a Stranger*." In *American Horrors: Essays on the Modern American Horror Film*, edited by Gregory A. Waller, 79–85. Urbana: University of Illinois Press.

Wood, Robin. 2004. "Foreword: 'What Lies Beneath?'" In *Horror Film and Psychoanalysis: Freud's Worst Nightmare*, edited by Steven Jay Schneider, xiii–xviii. Cambridge, UK: Cambridge University Press.

Wright, Geoffrey, dir. 1999. *Cherry Falls*. DVD. Rogue Pictures. USA, London: October Films.

Youngstrom, Eric, and Carroll E. Izard. 2008. "Functions of Emotions and Emotion-Related Dysfunction." In *Handbook of Approach and Avoidance Motivation*, edited by Andrew J. Elliot, 367–384. New York: Psychology Press.

Zacks, Jeffrey M. 2015. *Flicker: Your Brain on Movies*. New York: Oxford University Press.

INDEX

CPSIA information can be obtained
at www.ICGtesting.com
Printed in the USA
BVHW09s2259260718
522661BV00003B/4/P